'A moving Rhetoricke'

MANCHESTER
UNIVERSITY PRESS

'A moving Rhetoricke'

Gender and silence
in early modern England

CHRISTINA LUCKYJ

Manchester University Press
Manchester and New York

distributed exclusively in the USA by Palgrave

Published by Manchester University Press
Oxford Road, Manchester M13 9NR, UK
and Room 400, 175 Fifth Avenue, New York, NY 10010, USA
www.manchesteruniversitypress.co.uk

Distributed exclusively in the USA by
Palgrave, 175 Fifth Avenue, New York,
NY 10010, USA

Distributed exclusively in Canada by
UBC Press, University of British Columbia, 2029 West Mall,
Vancouver, BC, Canada V6T 1Z2

British Library Cataloguing-in-Publication Data
A catalogue record for this book is available from the British Library

Library of Congress Calaloging-in-Publication Data applied for

ISBN 0 7190 6156 3 *hardback*

First published 2002

10 09 08 07 06 05 04 03 02 10 9 8 7 6 5 4 3 2 1

Typeset by
D R Bungay Associates, Burghfield, Berks

Printed in Great Britain
by Bookcraft (Bath) Ltd, Midsomer Norton

Contents

For my father George Luckyj
1919–2001

gone into the world of light

Preface and acknowledgements

The main argument of this book is, I hope, founded on common sense as well as historical research. That there is a difference between being silent and being silenced, that silence can be used for different purposes and read in different ways by different audiences – all these are ideas which may seem perfectly obvious. They are also, I think, developed in particular ways under specific historical pressures in early modern England, and this book aims to adumbrate some of them. In *Echoes of Desire* Heather Dubrow noted that the 'complexities of speech and silence in English Petrarchism gesture towards the need for further work' (275), and I hope this book fulfils some of that need in more general terms. One of my aims is simply to make it more difficult to refer unthinkingly to early modern women as 'chaste, silent and obedient'.

I am fortunate to have received a number of significant research grants to complete this project: a Killam Postdoctoral Fellowship, a Social Sciences and Humanities Research Council of Canada standard research grant and a grant from the Research and Development Fund of Dalhousie University. A significant portion of this book was written whilst I was a Fellow at the Centre for Renaissance and Reformation Studies at Victoria College in the University of Toronto, and I am grateful for the support I received from the staff there.

This book has emerged out of a long silence. Over the years a number of people have had great faith that it was a silence of plenitude rather than lack. Chief among these were Lynne Magnusson, Jennifer Panek and Lynn Shakinovsky. Among my colleagues at Dalhousie I am especially thankful to John Baxter, Ron Huebert and Daniel Woolf, all of whom read sections of this book and offered useful advice; a random remark made by Victor Li changed the course of my thinking about the project years ago; Trevor Ross, Rohan Maitzen and Judith Thompson offered friendship at critical junctures. Dialogue with graduate students – in particular with Reina Green,

Lyn Bennett and Colleen Shea – was very important. Once again I must acknowledge some of my wonderful teachers of early modern drama, above all Alexander Leggatt and Sheldon Zitner. My parents, George and Moira Luckyj, have patiently sustained me through everything. As for my husband Keith and my children Julia and Stefan, 'I am sure my love's / More richer than my tongue'. If there is anything worthy here, it belongs to them.

Earlier versions of two sections of this book have appeared in print: 'Volumnia's Silence' appeared in *Studies in English Literature 1500–1900* 31 (1991): 327–42, and '"A moving Rhetoricke": Women's Silences and Renaissance Texts' was published in *Renaissance Drama* n.s. 24 (1993): 33–56. I am grateful to both of these journals for allowing this material to reappear here, albeit in altered form.

When I have quoted directly from early modern sources I have preserved the spelling of the original, though I have translated some letters into their modern form: *u* to *v*, *i* to *j*, and long *s* to *s*.

Introduction: 'A moving Rhetoricke'

My title is both a direct quotation from and a wilful misappropriation of Richard Brathwait's description of feminine silence in his *English Gentlewoman* (1631): 'Silence in a *Woman* is a moving Rhetoricke, winning most, when in words it wooeth least' (90). At first glance Brathwait's dictum looks familiar, another call for feminine silence and submission in the patriarchal world of early modern England. At second glance it is not so simple. The notion of silence as a powerful rhetoric in itself and an alternative form of eloquence can be traced back to classical sources and is just as frequently gendered male.[1] Indeed the larger discussion of the virtue of feminine silence in Brathwait's text is lifted from his previously published *English Gentleman*. Its reappearance here destabilises Brathwait's attempt to equate feminine silence with the 'modesty' he otherwise recommends, hinting as it does at established masculine virtues. Furthermore, this 'moving Rhetoricke' of silence, when gendered feminine, may suggest not subordination but suspect feminine powers of seduction – that 'prone and speechless dialect / Such as move men' which Claudio attributes to his sister Isabella in Shakespeare's *Measure for Measure* (1.2.160–1). If Brathwait's prescriptive formula for women is meant to hold them in their place, it rapidly becomes a 'moving' rhetoric, though not precisely in the sense that he intended. Even as Brathwait attempts to stabilise woman with the trope of silence, the complex, polyphonous history of silence (on which he draws) works to destabilise her. This book is an attempt to map that history and explore its implications for early modern literary texts.

Unlike many recent critics, who give 'silence' the widest possible conceptual space, ranging from the 'not said' as the suppressed Other in discourse[2], to gaps and semiotic eruptions in the symbolic sphere, this book eschews vague and potentially all-inclusive definitions to focus on what classical and early modern authors meant or thought they meant when they discussed or defined 'silence'. The *Oxford English Dictionary* begins by

defining silence as 'the fact of abstaining or forbearing from speech or utterance' (sb. 1). From this relatively stable point a myriad of interpretive shifts occur, just as they do in early modern Latin dictionaries such as Thomas Thomas's *Dictionarium Linguae Latinae et Anglicanae* (1587). For example, Thomas glosses the verb *sileo* as: 'To keep silence, to speake nothing, to hld his peace, not to say a word, to make no noyse, to be still and calme', and translates the noun *silentium* as 'Silence, quietnes, no noyse making, also patient, saying nothing, stilnes, solitarines'. Such translations reveal the inevitable slippage away from strict denotation into connotation (to not speaking *as a sign of* calm and patience). Because, in Thomas's dictionary, distinct, sometimes antithetical, Latin originals are translated not by their 'hard word' Latinate English equivalents but rather by the plain 'silence', the latter accumulates a wide range of meanings. Glosses on the following Latin words in Thomas's dictionary suggest multiple referents for 'silence': *conticeo*: 'To holde ones peace, to keep silence, to become dumbe, to cease, *to decaie or be out of use*'; *faveo*: 'To favour, to beare good will, *to agree to*, to follow, to be still and keepe silence'; *obscuro*: 'To make darke or dimme: to shadow, to cloake, *to hide*, to keepe in silence, or from the knowledge of men, to make not to be seene'; *obticeo*: 'To keepe silence, not to speake, to holde his peace as he were domme, *to keepe in such things as we be ashamed of*'; *reticentia*: 'Silence, when one holdeth his peace, and uttereth not the thing that he should tell: *a concealing or keeping of counsell*'; *taciturnitas*: 'Silence, taciturnity, *secretness of tongue*, keeping of counsell' (Thomas; emphases all added). The astonishing semantic elasticity of the English word 'silence', as it glosses terms ranging from consent to secrecy, from impotence to shame, may thus be due in part to the diverse etymological origins of its Latin roots.[3] Such embedded richness and instability were also extraordinarily useful in an age of enormous linguistic and social change.

It is important to recover the richness and instability of early modern notions of silence in order to complicate the simple binarism of contemporary popular and academic notions which continue to influence critical judgements.[4] On the one hand, because Western humanist discourse represents speech as the field of human agency, silence in common parlance becomes simply erasure, negation, repression. Bruce Smith points out that 'The whole enterprise of Western philosophy, especially since Descartes, has granted superior power to speech, to the speaker's ability to construct

rational arguments and to impose them on objects in the world around him' (22). As a result contemporary critics often use silence as a metaphor for oblivion: the epigraph to Jean Elshtain's *Public Man, Private Woman* cites Richard Hooker: 'Posterity may know that we have not through silence permitted things to pass away as in a dream'; the editors of *New French Feminisms* dedicate their work to 'all the writers and translators of these texts, without whom silence and absence would continue'. Silence is absence, vacancy, death itself – the hated antithesis of consciousness, freedom, presence. The civil rights movement has always staged its assault on silence, as women and minorities struggle for a 'voice'. On the other hand, perhaps because of its associations with Eastern mysticism, silence is also frequently constructed as plenitude. In fact contemporary critical approaches to literature of the nineteenth and twentieth centuries increasingly reflect the latter trend, spawning recent books with titles such as *Reclaiming the Tacit Dimension* (Kalamaras), *Listening to Silences* (Hedges and Fishkin), *Articulate Silences* (Cheung), *Eloquent Reticence* (Toker) and *Strategies of Reticence* (Stout).[5] 'While silence may smother and obliterate', writes King-Kok Cheung, 'it can also minister, soothe and communicate' (114). Goldberg points out: 'What we cannot hear may be a sign of depletion, or of a reserve that is impenetrable' ('Shakespearean' 132). These divergent constructions of silence do not originate in contemporary criticism, however. Both views of silence – as lack and as plenitude – are deeply rooted in a cultural history far more complex than this simple opposition suggests.

This book aims to recover that cultural history in order to interrogate some current critical orthodoxies about gender and silence in early modern England. It is almost obligatory for scholars who write about early modern women to begin with a nod in the direction of the triple feminine virtues of chastity, silence and obedience.[6] 'Perhaps the most dominant prescription for the ideal woman in the Renaissance was the triad of chastity, silence, and obedience' (8), declares Kim Walker at the opening of her study of early modern women writers. Similarly Wendy Wall identifies 'silence as a feminine ideal' (280), Ann Rosalind Jones writes that 'female silence was equated with chastity' (1) and Dympna Callaghan asserts, 'Chastity, silence and obedience were the three cardinal and synonymous feminine virtues' (*Woman and Gender* 79). The opening remarks of Anthony Fletcher's

Gender, Sex and Subordination in England 1500–1800 elaborate this critical truism:

> Men's control of women's speech, an aspect of their potency, was at the heart of the early modern gender system. Speech takes us to the centre of the issues of patriarchal authority, for it proposes and initiates. Speech represents personal agency. The woman who speaks neither in reply to a man nor in submissive request acts as an independent being who may well, it is assumed, end up with another man than her husband in her bed. (12)

Replicating the logocentric assumptions of the early modern texts he cites, Fletcher, like other critics, assumes that speech is subjectivity, voice agency, in a move which exemplifies what Heather Dubrow describes as a 'curiously uncritical return to a type of positivistic social history' (46). As Karen Newman points out, 'to see subjectivity as constituted through speech is problematic: it gives priority to presence and privileges identity; it rehabilitates immediacy, intentionality, and performance' (*Fashioning* 68). Derrida is particularly eloquent on what he sees as the illusions of presence and agency fostered by speech: 'The "apparent transcendence" of the voice thus results from the fact that the signified, which is always ideal by essence ... is immediately present in the act of expression. This immediate presence results from the fact that the phenomenological "body" of the signifier seems to fade away at the very moment it is produced' (77). This 'complicity between sound and ideality, or, rather, between voice and ideality' (77), means that speaking gives merely the illusion of subjectivity, immediacy, control – an illusion which, Michel Foucault shows us, is actually crucial to the operations of institutionalised authority which would limit personal agency (male and female). Indeed Foucault claims that the 'incitement to discourse' is a prime instrument of authority: 'The obligation to confess is now relayed through so many different points, is so deeply ingrained in us, that we no longer perceive it as the effect of a power that constrains us' (60). Throughout his work Foucault challenges the notion that the instrument of power has always been repression, a reduction to silence. Countering the prevailing view, for example, that taboos have surrounded discourse about sexuality since the eighteenth century, he writes: 'more important was the multiplication of discourses concerning sex in the field of exercise of power itself: an institutional incitement to speak about

it, and to do so more and more; a determination on the part of the agencies of power to hear it spoken about, and to cause *it* to speak through explicit articulation and endlessly accumulated detail' (18). Though Derrida and Foucault appear far removed from the historicist readings of early modern culture proposed by Fletcher (and many others), their work problematises his assumptions. If speech bears traces not of personal agency but of institutional constraint, are the men who can speak freer than the women who keep silent? If discourse is a site of the most insidious, internalised social controls, might silence offer a rival, less highly regulated space?[7]

Further to contemporary theorists' profound critiques of language as a site of subjectivity or agency, feminist critics have pointed out that the bodies and minds of *women* in particular have long been regulated and shaped by systems of discourse which serve the interests of male-dominated culture. Monique Wittig's heroines' lament for woman is representative:

> Unhappy one, men have expelled you from the world of symbols and yet they have given you names, they have called you slave, you unhappy slave. Masters, they have exercised their right as master. They write, of their authority to accord names, that it goes back so far that the origin of language itself may be considered an act of authority emanating from those who dominate ... the language you speak is made up of words that are killing you. (cited Gilbert 517)

For man, writes Luce Irigaray, 'The really urgent task is to ensure the colonization of this new "field" [of the Other], to force it, not without splintering, into the production of the same discourse' (*Speculum* 137). In the theories of French feminists such as Irigaray and Kristeva, woman finds release from the tyranny of masculine discourse by maintaining 'a resonant silence that, in its deployment of "blank pages, gaps, borders, spaces ... holes in discourse," speaks (to initiated listeners) louder than words' (Gilbert and Gubar 518). Yet an escape from the prison house of language into silence appears to be a dubious one at best. Gilbert and Gubar speak for a majority of feminists when they object that 'As long as women remain silent or speak in a body language of freely fluent multiple referentiality, "they will be ... outside the historical process"'(519). And the danger of applying French feminist theory to early modern women emerges particularly clearly in an essay such as Gary Waller's 'Struggling into Discourse:

The Emergence of Renaissance Women's Writing'. Acknowledging that 'it is only through discourse that a society's speaking subjects may enter and participate in it', Waller muses: 'So how do oppositional forces speak when the dominant language refuses them words? How are the voices of silence heard?' ('Struggling' 245). His answer is simply that they don't speak and aren't heard: 'Within such a language situation, the woman can speak only as a blank space, a hole in discourse' (250). The silence of women in early modern England – read as impotence and repression – licenses the intervention of the critic, whose responsibility it is to 'make those silences speak' (247). Ironically, Waller's 'history of eloquent silence or of woman's struggle into discourse' (251) reinscribes the hegemony of language he seeks to interrogate.

On the one hand feminine silence appears to offer no meaningful point of entry into literary history. On the other hand, as soon as woman uses language, she can be defined and controlled. To return to Fletcher, a woman who speaks in early modern culture can hardly be described as an independent being, if in speaking she enters male discourse only to be simultaneously labelled a whore. Lisa Jardine notes that 'Both gossiping and scolding give [the Renaissance wife] a semblance of power, which threatens disorder without actually freeing her from her multiple obligations and constraints' (*Still Harping* 107). And in early modern England, as Chapter 2 will demonstrate, the greatest weapon in the patriarchal arsenal was the demand not for women's silence but for women's speech. What Foucault says of sex could well be said of women in the seventeenth century; both were 'driven out of hiding and constrained to lead a discursive existence' (33). Considered as alternative forms of repression and control, neither speech nor silence initially appears to be a promising approach to early modern women.

How can silence then offer any alternative to male-dominated discourse? The answer, I think, lies in a thorough investigation of the philosophical and political history of silence in Western thought and of its strategic deployment in texts by early modern authors. Such an investigation suggests that silence offered significant alternatives to speech in early modern England. As early as Plato silence was associated with truth, wisdom and eloquence; later, in the hands of neo-Stoics and recusants, silence became a recommended form of strength and defiance literalised in

the rejection of the *ex officio* oath in Tudor England. As an expression of open defiance silence could thus become a rhetoric parallel to speech. In addition silence was increasingly associated in early modern England with the unreadable, 'inscrutable', private subject who cannot be fathomed or decoded. This 'emergent' kind of silence fundamentally interrogated speech's promises of intelligibility and social meaning, and sometimes conjured up spectres of the mute savage and the beast.[8] In a rhetorical culture which generated increasingly antirhetorical forms of dissent, the silence trope could be appropriated by men and women alike with surprising and varied results. In response to those 'otherwise acute scholars [who] continue to repeat the bald assertion that women were silenced in early modern England, neglecting ... complexities' (Dubrow 46), this book will argue that both speech and silence in early modern culture were in fact far more vexed and complex for both genders than has been hitherto acknowledged.

Indeed claims such as Fletcher's (above) entail ignoring not only the caveats of contemporary theory but also the complex gendering of silence in Western thought. Peter Stallybrass's influential 1986 essay, 'Patriarchal Territories: The Body Enclosed', for example, cites Francesco Barbaro's early fifteenth-century treatise *On Wifely Duties*: 'the speech of a noble woman can be no less dangerous than the nakedness of her limbs'. From this Stallybrass concludes that 'Silence, the closed mouth, is made a sign of chastity. And silence and chastity are, in turn, homologous to woman's enclosure within the house' (255). Yet the passage Stallybrass cites from Barbaro is followed in the original by another: 'Silence is often praised in the finest men. Pindar heaped praise on that outstanding Greek ruler Epaminondas because, though he knew much, he said little' (205). Whilst Barbaro's text is clearly patriarchal, its evocation of masculine silence renders its apparently misogynist dictum more complex and multivalent than Stallybrass claims. Stallybrass's essay has, moreover, had considerable impact on feminist critics: its equation of feminine silence with subjection is cited *as fact* by Boose (255), by Lamb (5–6) and by Jones (204 n.13). Yet his argument that the scold and the whore are coextensive is not borne out by his own examples, which take pains to distinguish between them. His first piece of evidence is that 'A man who was accused of slandering a woman by calling her "whore" might defend himself by claiming that he meant "whore of her tonge," not "whore of her body"' (255). Whilst

Stallybrass finds in this clear evidence of analogy between the sins of the tongue and those of the body, the man in question is clearly anxious to deny such an analogy. The same goes for Stallybrass's next citation, from Tofte's translation of Varchi's *The Blazon of Jealousie*: 'A Maide that hath a lewd Tongue in her head, / Worse than if she were found with a Man in bed' (255). The former example apparently locates more serious transgression in the body than the tongue, and the latter comically inverts this, but both texts in fact *deny* that a loose tongue is the same as a loose body.

If feminine silence cannot be conflated with chastity and obedience in every instance, neither can masculine speech necessarily be seen as an unproblematic site of authority in early modern culture. To illustrate her argument about the early modern double standard, Linda Woodbridge cites George Webbe's denunciation of 'Husbands tongues which are too bitter against their wives; Wives tongues too sharp against their Husbands' (43), and goes on to comment: 'Wives tongues are very often, in Renaissance literature, said to be sharp; the submerged metaphor suggests a weapon … The tongues of men, especially of husbands rebuking their wives, are often called "bitter," suggesting unpalatable but necessary medicine' (208). Yet Webbe's catalogue of abuses indicts men and women equally: for both genders the tongue is a dangerous weapon, 'for this very Tong is *a sharpe Sword*' (Webbe, *Araignment* 52). Indeed, in the same year that Webbe's text was published, Whately provides pointed counter-evidence for Woodbridge's claim, enjoining husbands: '*Be not bitter to your wives*', and explaining further:

> Who ever kept a bitter thing for any other purpose, than to make a medicine? and is not that a bad husband, that is good for little, but to be his wives purgation? … If he be gaule and aloes in her mouth, is it any wonder, though she strive to spit him out? This bitternesse shewes folly, and workes hatred, and therefore must needs be a great underminer of authoritie. (*A Bride-bush* 102)

From these early modern texts it is not clear either that speech is a privileged site of authority or that silence is a site of gendered oppression. It is clear, however, that early modern scholars have not sufficiently interrogated their own assumptions about gender and silence.

Chapter 1 of this book begins with a broad investigation of divergent constructions of silence in Western philosophical thought. In early modern

England, for various political and cultural reasons, inherited cultural notions of silence as impotence or as eloquence were complicated by a growing association of silence with the inscrutable and potentially dangerous subject. The complex history of silence in the masculinist philosophical tradition thus becomes an important, multifaceted lens through which to examine its gender politics, as Chapter 2 does. Chapters 3 and 4 apply the results of these investigations to early modern playtexts which reveal silence in action and to women writers of the period who exploit the 'moving Rhetoricke' of silence to their own ends.

Notes

1 Kim Walker cites this line from Brathwait as evidence for the early modern double standard of eloquence for men and silence for women (10). Yet her note goes on to account for Brathwait's construction of feminine silence as eloquence by aligning it with the strand of Renaissance moral philosophy which maintains that 'men and women have identical virtues, but these differ in expression according to their different roles' (207–8). This important qualification, however, is not incorporated into her argument, and she goes on to assert 'the foundational triad of chastity, obedience and silence in the model woman' (11). A similar problem arises in Catherine Belsey's argument about patriarchal ideology, which rests on the same quotation from Richard Brathwait's *English Gentlewoman* followed by a subsequent line: 'More shall we see fall into sinne by speech than silence.' Yet Belsey neglects to indicate that the pronoun in the second sentence in Brathwait's text is gender-neutral (179) – surely a significant complication in the case for early modern misogyny.

2 See, for example, Dympna Callaghan's chapter 5 entitled 'The Construction of Woman Through Absence, Silence and Utterance' (*Woman and Gender* 74), in which she argues that women constitute the 'Machereyan absence' at the centre of Renaissance tragedy: 'Silences, then, are a dramatic imperative without which there can be no play, and which are structured through constructions of mute femininity' (84). In her view Cordelia in *King Lear* becomes 'the lacuna of the text' (79). Similarly, Hilary Hinds applies Macherey's and Foucault's theories of silence to seventeenth-century radical sectarian women's writing because they urge us 'to look at silence as a condition and factor of all writing: it is not only those texts that allude to forms of silencing in relation to their authors that yield up these silences, but all the others, too, bear witness to their own "unsaid" in the gaps or omissions of their "said". Furthermore, the unsaid is as productive, as communicative, as constitutive of the meanings of the texts as is the said' (66).

3 It is also important to remember that both Latin words and inkhorn terms derived from Latin (such as the 'reticense' and 'taciturnitie' listed in Henry Cockeram's

English Dictionarie: or, An Interpreter of Hard English Words (1623) existed in the language learned mainly by boys, whereas the vernacular or 'mother tongue' (to which 'silence' belonged, though originally derived from Latin as well) was, at least for a time, gendered feminine (Fleming 190). Thus the kind of linguistic control possible because of the fine semantic distinctions in Latin and Latinisms was impossible in the vernacular, although the multiplicity and layering of meaning available in Latin terms for different kinds of silence remained latent in the English word.

4 I do not wish to imply that all recent critics have the wrong idea about silence. Other critics have hinted at some of my concerns with their own observations about the complex potentialities of silence – most notably Katharine Maus, Heather Dubrow, Hilary Hinds and Megan Matchinske. However, there has to date been no systematic attempt to explore the complex history of silence and examine its implications for early modern literary texts.

5 Since early modern scholars tend to read feminine silence primarily as oppression, they might benefit from reading literary critics who hold a different view. Indeed Heather Dubrow has argued that 'feminists specializing in medieval and early modern literature could fruitfully borrow, and in so doing refine, many theoretical concepts from students of later texts' (279). The strategic, shifting indeterminacy of feminine silence in nineteenth-century fiction identified by some critics may suggest alternative approaches to scholars of early modern texts. Of the inscrutable Lucy Snowe in Charlotte Brontë's *Villette*, for example, Karen Lawrence writes: 'Brontë presents the enigma of Lucy Snowe not from the male point of view but as a complex, shifting nexus of meaning and deferral of meaning that, like the sign itself, never refers to an ultimate and stable identity. Lucy doesn't "disappear"; increasingly, we begin to understand that the cypher as blank is the cypher as a mysterious sign of meaning never fully disclosed in this text' (91). Lucy Snowe's 'strategy to avoid being textualized or read' (88), which requires both silence and invisibility, hints at a subversive reappropriation of conventional feminine decorum which bears further investigation in relation to early modern literature as well.

6 This triumvirate (triumfeminate?) has become a cliché since the 1982 publication of Suzanne Hull's *Chaste Silent and Obedient*, though there is no early modern precedent for it. Apart from those critics mentioned in the text see Henderson 54, Goldberg, *Desiring* 165 and 170, Woodbridge, 'Dark Ladies' 66 and Lamb 5.

7 The suggestion is mine, not Foucault's. Foucault sees silence as complicit with speech: 'Silence itself – the things one declines to say, or is forbidden to name, the discretion that is required between different speakers – is less the absolute limit of discourse, the other side from which it is separated by a strict boundary, than an element that functions alongside the things said, with them and in relation to them within over-all strategies' (27).

8 For a complex theoretical treatment of silence see MacKendrick's *Immemorial Silence*, which argues – intriguingly – that even the 'easy, gracious' silence of ordinary conversation is never 'simple or wholly legitimate' because it 'open[s] a space of interrogation' (20) and conjures up the void: 'The pause constituted by silence is a break, and in it language is indeed broken; in the silence of madness it is cut open, put into question' (21). Following Blanchot, MacKendrick insists that even the civil conversational pause participates in 'the inherent violence of the most quiet, which is silence' (21).

1 Silence: a history

Perhaps the most distinctive feature of early modern humanism was its revitalisation and redeployment of classical rhetoric. Rhetoric, according to Cicero and others, was inseparable from moral philosophy and could persuade men to virtue, establish order in the commonwealth and bond society. To the orator, writes Cicero, 'belong the broad estates of wisdom and of learning' (3.31.122). Thus, as the *Cambridge History of Renaissance Philosophy* tells us, 'the Ciceronian image of the orator as culture-hero, whose power was exercised in defence of justice and ethics, had an enormous influence on the Renaissance' (727). Early modern guides to rhetoric and domestic conduct repeat the Ciceronian emphasis on the civilising power of speech. In his *Art of Rhetorique*, for example, Thomas Wilson posits a myth of fallen men who 'lyved Brutyshlye in open feldes' until 'these appoynted of God called theim together *by utteraunce of speache*, and perswaded with them what was good, what was badde, and what was gainefull for mankynde' (18; emphasis added). Thomas Elyot in *The Governour* tells us that 'speche [was] specially gyven to man, wherin he is moste discrepant from brute beastis, in declaring what is good, what viciouse, what is profitable, what improfitable' (264). The proper use of language thus leads not only to ethics but to good government. Added to the socialising function of rhetoric is its expressive function. Thomas Palmer's early emblem book, *Two Hundred Posees* (1565?) illustrates 'The force of eloquence' with an image of Orpheus and comments: 'So speche dothe sever us from beastes, / fyne speche from man and man' (15–16). Many early modern writers cite the Bible: 'out of the abundance of the heart the mouth speaketh' (Matthew 12.34). 'Without *Speech* can no society subsist', declares Richard Brathwait in *The English Gentlewoman* (1631): 'By it we express what we are, as vessels discover themselves best by their sound' (7). 'Words represent most exactly the very image of the minde and soule: wherefore *Democritus* calleth speech ... the image of life; for in words, as in a glasse may bee seene a mans

life and inclination.' So writes Thomas Wright in *The Passions of the Minde* (105). In *A Godlie Forme of Householde Goverment* John Dod and Robert Cleaver agree: 'a man or a womans talking, is the mirrour and messenger of the minde, in the which it may commonly be seene without, in what case the man or woman is within' (104). While Puritans tend to shift the emphasis from language as persuasive and controlling art to speech as uncontrolled emanation of the inner man, Steven Guazzo reconciles the two in his *Civile Conversation* (1581): 'the tongue serveth us to teache, to demaunde, to conferre, to traffike, to counsaile, to correct, to dispute, to judge, and to expresse the affection of our hearte: meanes whereby men come to love one another, and to linke themselves together' (1.35). Whether language is an instrument of the ruler / orator or a shared bond among like-minded and peaceable men, it is seen as both distinctively human and civilising. There is, of course, an implicit tension between the highly developed and conscious art of the rhetorician and the unwilled self-revelation of the private man, but both – according to these treatises – make social control possible. If speech allows one to rule effectively, it allows the other to be ruled because known. Such ideas of language which ignore the latent potential for tyranny in the ruler and duplicity in the subject may seem to us naive,[1] but they clearly reflect cultural investment in language as a stable signifier to which political power was indissolubly linked.

The widespread valorising of speech in the early modern period led to two divergent constructions of silence in mainstream (that is, masculinist) thought. On the one hand silence was frequently denounced or rejected as antisocial, barbarous or foolish; on the other silence was appropriated as a superior form of speech, or its necessary complement.[2] Where silence was concerned, the notorious conflict between the Ciceronians and the anti-Ciceronians, between 'Asiatic' and 'Attic' styles, between the *genus grande* and the *genus humile*, was frankly illusory since both were ultimately *rhetorical*. As Morris Croll comments, 'There is only one rhetoric, the art of the beauty of spoken sounds' (61). Defined in relation to speech, silence could only be excluded as its antithesis or appropriated as its corollary.

Language, however, like politics, was far from stable in early modern England. Wayne Rebhorn argues that cultural anxiety and ambivalence about rhetoric as an instrument of absolutist control and civil strife led to notions of the rhetorician as a trickster and a liar; a corollary of this

widespread suspicion of rhetoric was a new consideration of the uses of silence, both as a protected, private space and as a staging of protest. If speech was a mirror of the mind, then in a time of religious and political persecution one might do well to avoid speaking. If speech was an instrument of political control, then silence might be a site of resistance. Indeed, Katharine Maus argues for a new cultural obsession in the period with what she calls 'the strategic difference between thought and utterance, secret conviction and external manifestation' (19). And, as silence began to suggest notions of privacy and interiority, it also threatened traditional gender distinctions of male/female, command/obedience, speech/silence.

This chapter begins with an account of two prevailing models of silence, as impotence or as eloquence, both defined by and contained within the rhetorical paradigm. Following these, and distinct from them in their open rupture of the bond with speech and intelligibility,[3] are notions of silence as inscrutability and silence as chaos. Whereas 'inscrutable' silence (as Thomas Wright calls it in his *Passions of the Mind* 27) refuses to be simply decoded or 'read', the silence of the wild or the dead exceeds and threatens the stability of the known and the human. Both of these latter models destabilise the simple binarism of speech/silence.

'Speaking in effect': the rhetoric of silence

Silence and impotence

After emphasising that the orator is inseparable from the philosopher, Cicero goes on to reject both silence and garrulity as means to wisdom: 'neither the tongue-tied silence of the man who knows the facts but cannot explain them in language, nor the ignorance of the person who is deficient in facts but has no lack of words, is deserving of praise' (3.35.142). Similarly, Petrarch, Cicero's disciple in humanist Italy, declares thought and language to be mutually necessary, and 'anticipates many later writers in denouncing silence or withdrawal from society' (*Cambridge History* 730). Although, as Siegel points out, Petrarch sometimes spoke with admiration of *veritas in silentio* as 'an ideal of life on a higher plane' (45), and Cicero in the same passage expresses a preference for silence over garrulity, the union of eloquence with active wisdom that was advocated so firmly left little room for the silence that traditionally accompanied the *vita contemplativa*. In this strain

of humanism silence becomes the simple antithesis of speech, frequently
mocked as the last resort of fools incapable of using language. In keeping
with his rhetorical project, for example, George Puttenham is scornful of the
figure of *aposiopesis* – the 'figure of silence' – as 'fit for phantasticall heads
and such as be sodaine or lacke memorie' (139). Silence is again construed
as deficiency of wit or ability by Thomas Wright in the *Passions of the Minde*.
In his discussion of 'taciturnitie' Wright comments that 'This silence may
proceed sometimes of sottishnesse, because a man knowes not how to
reason, and so you see clownes, or dull persons, not able to speake in a wise
company' (108). In Ben Jonson's *Volpone* Androgyno is both hermaphro-
dite and fool (1.2.50), and both are loquacious transmigrations of the soul of
Pythagoras's 'dogmatical silence' (1.2.35). The author of the preface to *The
Queene of Navarres Tales* (1597) describes a fool thus: 'his countenance so
graced, as a man might see a dicker of fools in his face, his salutation to such
as passed by was a nod with his head, and his hand clapt over his lips, which
they do call the *Bassiles* manus' (Preface). Similarly, in *The Merchant of
Venice* Gratiano exalts his own garrulity when he declares that 'silence is only
commendable / In a neat's tongue dried, and a maid not vendible'
(1.1.111–12). Gratiano's assertion, while clearly undermined by the 'infi-
nite deal of nothing' (114) he speaks, none the less draws on a traditional
association of silence with effeminate impotence and sottishness.

Silence and eloquence

It was equally axiomatic that fools might remain silent to give the appearance
of wisdom: so Jonson writes in *Timber*: 'It was wittily said upon one that was
taken for a great and grave man, so long as he held his peace: This man might
have been a Counsellor of *State*, till he spoke: But having spoken, not the
Beadle of the Ward' (575). In Sidney's *Countess of Pembroke's Arcadia*, when
the foolish Dametas is cultivated by the misguided prince Basilius,
'[Dametas's] silence grew wit, his bluntness integrity, his beastly ignorance
virtuous simplicity' (19). Geoffrey Whitney's motto describing Alciati's
emblem 'Silentium' reads: 'The foole, is thought with silence to be wise, /
But when he prates, him selfe he dothe bewraye' (61). Such writers find
precedent in the Bible: 'He that hath knowledge, spareth his wordes, and a
man of understanding is of an excellent spirit. Even a foole (when he holdeth
his peace) is counted wise, and he that stoppeth his lippes, prudent'

(Proverbs 17.27–8). At the opening of Shakespeare's *The Merchant of Venice* Gratiano attempts to identify the inexplicably melancholy Antonio with this long tradition of silent fools:

> There are a sort of men whose visages
> Do cream and mantle like a standing pond,
> And do a wilful silence entertain
> With purpose to be dressed in an opinion
> Of wisdom, gravity, profound conceit
>
> (1.1.88–92)

Of course, Gratiano's attempt (like Jonson's) to expose silence as the refuge of fools relies on a closely allied counter-tradition of silence as a sign of wisdom. Indeed these apparently antithetical notions are often found together since both actually rely on what Frank Whigham terms 'the general hypertrophy of rhetorical consciousness' (51) in early modern culture.

It may have been Plato's attack on Sophistic rhetoric that led to the essential shift from a view of silence as 'quasi-religious intimation of philosophic truth to the directly rhetorical context of silence as a form of eloquence' (Waddington 252). Only with Plato's demand for a rhetoric grounded in truth, and therefore in silence, does the influential fusion of silence and rhetoric emerge. Thus, in classical philosophy, silence becomes a metonymy for 'an eloquence of truth, rather than an eloquence of mere style' (Waddington 251). 'That truth should be silent I had almost forgot' (2.2.113), says the rashly garrulous Enobarbus in mock penitence to Antony, wittily reconfiguring the Pythagorean ideal as oppression. The *locus classicus* for the notion of silence as true eloquence that was readily available to early modern authors is Plutarch's essay *De garrulitate* in his *Moralia*. As its title indicates, the essay is largely a critique of the abuses of speech by excessive talkers. In his view 'speech, which is the most pleasant and human of social ties, is made inhuman and unsocial by those who use it badly and wantonly' (411). Silence, in Plutarch's scheme, becomes the epitome of the desired qualities in human communication; not antisocial or defective, but thoughtful and succinct, 'profound and awesome and sober' (407). Sometimes Plutarch praises silence as essential to listening, to 'the merits of hearing and being heard' (502) – as the background for judicious speech, silence must punctuate and give meaning to conversation. At other

times Plutarch uses silence as a figure for plain and direct speech itself. Admonishing his readers to remember 'the solemn, holy and mysterious character of silence', for example, Plutarch advocates 'terse and pithy speakers and those who can pack much sense into a short speech' (443). Silence is for Plutarch an antidote not to speech but to garrulousness, and can denote by contrast the best qualities of speech itself. Thus the 'aphoristic speech' (445) he admires in the Spartans is both an eloquent silence and 'the fruit of much silence' of thought. Many early moderns cite the discipline of Pythagoras, who required his pupils to observe at least two years' silence before being allowed to speak. Guazzo remarks:

> Seeing then to stay the tongue, and use the eare, are the hardest things that may bee, it behooveth our patient to frame him selfe to brydle his appetyte, withstanding his owne will, and inuring himselfe by little and little, to keepe the mouth more shut, and the eares more open ... our sicke man shall beginne by holding his peace, to recover his health, and to bee well thought of, of the wise. It was therefore that Pithagoras bounde his schollers to keep silence, for the space of three yeeres. (2.120)

As Affinati explains in *The Dumbe Divine Speaker* (1605), 'this so long silence was to no other end, but to teache them to speake the better, and with wisedome, so that his intent was not they shoulde bee alwayes silent, but whensoever they spake, to speake wisely'(7). In Geoffrey Whitney's *Choice of Emblems* (1589) the emblem entitled 'Silentium' shows a scholar sitting at a desk with finger to his lips, indicating, as Orgel points out, 'not only that wisdom keeps its counsel, but also ... that the mark of the scholar is his ability to read silently' (144). The motto begins: 'Pythagoras, unto his schollers gave, / This lesson firste, that silence they should keepe.' While Whitney appears at first to exalt literal silence, saying 'Silence yet, did never make me sad', he quickly makes the leap to speech, adding 'And Cato sayeth: That man is next to God / Whoe squares his speache, in reasons rightfull frame' (60). Silence here is thus a preparation for right rhetoric, rather than its substitute. Francis Bacon appropriates Cicero himself to underwrite this popular trope, citing his letter to Atticus on the eloquence of silence (*De augmentis* VIII, i; cited Waddington 253) – ironically, since Bacon elsewhere considered the imitation of Cicero 'the first distemper of learning, when men did study words and not matter'[4] (*Advancement* 26).

And while Jonson, true to his age, consistently praises speech as 'the only benefit man hath to expresse his excellencie of mind above other creatures' (*Timber* 620-1), he also praises silence (612) and condemns garrulity (573). Hallahan points out that in *Epicoene* Jonson reveals that 'silence and proper speech – eloquence – are important attributes of the effective man. In Achille Bocchi's *Symbolicarum quaestionum* Hermes, god of eloquence, has his finger to his lips' (18–19). Far from undermining spoken rhetoric, silence here is clearly its complement.

It is no doubt due in part to this new emphasis on 'antirhetorical' (anti-Ciceronian) rhetoric that the vast majority of allusions to silence in early modern texts depend on its 'Attic' association with eloquence. In many of Shakespeare's plays, for example, silences are said to 'speak' or persuade and are thus treated as forms of rhetoric. Rebhorn remarks that Shakespeare's 'Machiavellian kings and princes also know that silent spectacles can often accomplish as much as a torrent of words' (*Emperor* 56). In *As You Like It*, for example, Duke Frederick worries about Rosalind's appeal to the commoners since 'her very silence, and her patience / Speak to the people, and they pity her' (1.3.72–3). His concern here, however neurotic and unfounded, draws on the notion of silence as persuasive eloquence which can be 'heard' – or read – by the audience. Like a playwright who fears the uncontrollable dimension of performance, the Duke posits a counter-rhetoric of silence which threatens his own linguistic power. In Marlowe's *Tamburlaine (Part I)*, a play in which rhetorical power *is* political power, silence becomes an equally powerful weapon when the hero, '*looking wrathfully on Agydas, and say[ing] nothing*' (3.2.65 s.d.) quickly drives him to thoughts of suicide. Agydas himself may be 'most astonied / To see [Tamburlaine's] choler shut in secret thoughts / And wrapp'd in silence of his angry soul' (3.2.69–71), but an early modern audience would recognise this taciturnity as an alternative form of discursive power.[5] In *Troilus and Cressida* Cressida imagines Troilus's silence as a powerful manipulative tool which elicits her speech: 'See, see, your silence, / Cunning in dumbness, in my weakness draws / My very soul of counsel from me' (3.2.120–2). Ironically, it is later Troilus who echoes this speech to warn Cressida about the Greeks, in whose accomplishments 'There lurks a still and dumb-discoursive devil / That tempts most cunningly' (4.5.91–2). In *Measure for Measure* Claudio praises Isabella's silence above her speech, remarking to

Lucio that 'in her youth / There is a prone and speechless dialect / Such as move men' (1.2.159–61). While these are clear instances of silence conceived as a rhetoric of persuasion (to virtue or to evil), other moments simply treat silence as a form of expressive speech. Prospero's spirits in *The Tempest* are admired for 'expressing – / Although they want the use of tongue – a kind / Of excellent dumb discourse' (3.3.37–9). And in *The Winter's Tale*, in the final joyous reunion, 'There was speech in their dumbness, language in their very gesture' (5.2.11–12). Such dramatic moments, while they certainly make sense in a text which animates itself in the silent spaces of theatrical gesture and expression, ultimately owe their conception to the philosophical conflation of silence with wisdom and eloquence.

This conflation is also responsible for the treatment of silence in a genre which itself privileged silent interiority over spectacle, that of the sonnet. Samuel Daniel apostrophises in *Delia*:

> And you mine eyes the agents of my hart,
> Told the dumbe message of my hidden griefe:
> And oft with carefull turnes, with silent art,
> Did treate the cruell Fayre to yeelde reliefe.

(8.5–8)

While, as Wall points out, sonneteers encode speech and publication as forms of betrayal (193), they none the less appropriate silence as a superior but parallel form of *utterance*. As Spenser declares to his mistress in the *Amoretti*: 'You stop my toung, and teach my hart to speake' (8.10). Likewise, Shakespeare's *Sonnets* clearly reveal the poet's containment of silence within a rhetoric of power. If the speaker's friend's eyes 'taught the dumb on high to sing' (78.5), inspiring articulation in the otherwise silently impotent admirer, the poet's verse gives lasting voice to his silent corpse:

> The earth can yield me but a common grave
> When you entombed in men's eyes shall lie:
> Your monument shall be my gentle verse,
> Which eyes not yet created shall o'er-read,
> And tongues to be your being shall rehearse
> When all the breathers of this world are dead.
> You still shall live – such virtue hath my pen –
> Where breath most breathes, even in the mouths of men.

(81.9–14)

The tongue and the pen work together to dispel the horror of silence and annihilation, much as the orator rouses men from the oblivion of speech-lessness. Yet speech ('in the mouths of men') will work more effectively than silent reading in preserving the young man's memory; as Vendler observes, 'silent reading can only *intomb* the young man in print', whereas 'actual living existence for him comes about through sound, as the poem is uttered aloud and heard by an audience' (361–2). In Sonnet 80 the speaker finds himself silenced and emasculated by a rival:

> O, how I faint when I of you do write,
> Knowing a better spirit doth use your name,
> And in the praise thereof spends all his might
> To make me tongue-tied, speaking of your fame!
>
> (80.1–4)

But Shakespeare's meditation on silence does not end with the impotence trope. In Sonnet 83 the speaker begins a counter-turn which reconfigures his silence as his 'glory':

> This silence for my sin you did impute,
> Which shall be most my glory, being dumb;
> For I impair not beauty, being mute,
> When others would give life, and bring a tomb.
> There lives more life in one of your fair eyes
> Than both your poets can in praise devise.
>
> (83.9–14)

The dispute about the meaning of the poet's silence (Vendler 368) is resolved: the poet's silence mirrors the inexpressible, self-sufficient beauty of the friend. Finally, Sonnet 85 completes the turn by recuperating silence, rescuing it from its associations with impotence and submission and autho-rising it as a form of eloquent male speech. Beginning with the first line, 'My tongue-tied Muse in manners holds her still', which aligns the speaker's silence with decorous, humble submission, the sonnet moves to a triumphant association of silence with eloquence:

> Hearing you praised I say "Tis so, 'tis true,'
> And to the most of praise add something more;
> But that is in my thought, whose love to you,

> Though words come hindmost, holds his rank before.
> Then others for the breath of words respect,
> Me for my dumb thoughts, speaking in effect.
>
> (85.9–14)

Though here as elsewhere 'the speaker may be both a powerful rhetorician and a powerless victim' (Dubrow 203), his deployment of the silence trope invariably moves from powerlessness to mastery, from vacancy to plenitude. Despite the modest disclaimers, speech, masculinity, and power finally reconfigure the silence that continually threatens to engulf and annihilate 'dull and speechless tribes' (107.12).[6] As the speaker says in Sonnet 101:

> Because [beauty] needs no praise wilt thou be dumb?
> Excuse not silence so, for't lies in thee
> To make him much outlive a gilded tomb,
> And to be praised of ages yet to be.
>
> (101.9–12)

Shakespeare's *Sonnets* often invoke the inexpressibility topos (Curtius 159–62), an important variation on the eloquent silence trope; language is inadequate to deep feeling, which can be felt and expressed *only* in silence. Speaking of visual art, Jonson declares that 'It is it selfe a silent worke: and always of one and the same habit: Yet it doth so enter, and penetrate the inmost affection ... as sometimes it orecomes the power of speech, and oratory' (*Timber* 610). Here silence is constructed as a site which potentially undermines rhetoric, if it were not that paradoxically – one might say hypocritically – this site is articulated through language. Puttenham sceptically describes the rhetorical trope *occupatio* or *paralepsis*, with its false protestations of inexpressibility, as like 'the maner of women, who as the comon saying is, will say nay and take it'. He follows his description with a jingle: 'I hold my peace and will not say for shame, / The much untruth of that uncivill dame'(194). This clearly evokes 'the gossiping "maner of women" who, whatever they protest, never refrain from speaking what they want heard' (Parker, *Literary* 109), yet it is significant that female garrulousness articulates itself here through representing silence. It is hard not to recall here the unctuous rhetoric of Goneril in *King Lear* when she claims to love her father 'more than words can wield the matter' (*Tragedy* 1.1.53), with 'A love that makes breath poor and speech unable' (58). Silence here becomes

not a form of eloquence but a means of exposing the inadequacy of speech. It is, of course, also a paradoxical articulation of the unutterable which signals the ultimate appropriation of silence by speech. Goneril illustrates, in fact, the strategy of containment that underlies the silence / eloquence trope: since speech denotes both power and social order, silence, its antithesis, far from being allowed to threaten that order with its overtones of death, disorder and impotence, is simply assimilated to the rhetorical master trope. Only when Cordelia literalises silence, in those two great pauses that reverberate after 'nothing' has been said, is its anarchic, subversive potential fully realised (as Chapter 3 will argue).

While the silence / eloquence trope appears to be securely contained within the humanist rhetorical project, it always risks slippage from power to impotence, from linguistic control to instability. Silence may be eloquent, but it still has to be interpreted – as such, it ultimately becomes the property of the interpreter. Like any rhetorical move, remaining silent in company had no stable signifying value and was entirely contingent on the vagaries of audience ratification. In the eyes of this audience, Whigham points out, 'If the humble individual invites by his silence the epithets of "sot" and "fool," the silent aristocrat may ipso facto confirm his own status' (51). On the one hand the nobleman's silence could signify his (elaborately staged) indifference to the necessity of establishing himself through rhetorical manoeuvring, and so figure the contained, self-limiting classical aristocratic body so opposed to the potential monstrosity of rhetorical copiousness (Rebhorn, *Emperor* 235ff.). On the other hand silence could be read either as servile imitation of the nobleman's lofty and privileged indifference or as a fearful retreat from the self-defining, performative challenges of conversation. Guazzo suggests the benefits of just such a retreat by circumscribing the occasions for speech:

> in companie everie one ought to observe two speciall times to speake: the one, when thinges come in question which hee understandeth perfectly well, and hath at his fingers endes as it were: the other, when such matters arise, as hee must needes speake of. In these twoo cases, it is better to speake then to bee silent, in all other, hee that shall use silence shall choose the best way. (152)

Yet such performative advice may have actually made silence in rhetorical courtly culture a less viable alternative by offering it as a sign of disguised

insufficiency. If 'the courtier must often have quailed before the decision whether to risk speech or to sit quietly', Whigham points out that 'Vigorous speech probably often seemed the best avenue' (50). The overdetermined, passive nature of silence made it undoubtedly a less convenient means of self-promotion than the combative, phallic modes of courtly speech.

In the end silence epitomises the impotence of all rhetorical modes: for ultimately 'Speech and other significations reveal not power but powerlessness, a pleading with the audience for a hearing, for recognition, for ratification' (Whigham 39). Considered as just another rhetorical performance in the courtier's repertoire, designed to win friends and influence people, silence recedes into impotence before the potentially wilful, self-interested misconstructions of the omnipotent, fallible audience for which the performance is intended.

This initial loss of control from the silent object to the reading subject is mirrored in a further loss of control, when one considers the multiplicity of referents for silence in early modern literature. 'I like your silence', says Paulina in *The Winter's Tale*, 'it the more shows off / Your wonder' (5.3.21–2). For Richard II it is 'unseen grief / That swells with silence in the tortured soul' (4.1.287–8); for Orlando in *As You Like It* it is a lover's 'passion' which 'hangs these weights upon [his] tongue' (1.2.224). If, in many of these cases, silence is eloquently shaped to reinforce the speaker's discourse, its very elasticity also potentially undermines its stable reference. Only when silence cuts itself off from rhetoric, however, can it exploit its own multivalency as a source of power.

Antirhetorical silence[7]

'Inscrutable' silence

One need not consult its critics to find Renaissance rhetoric frequently tied to deception and tyranny rather than benevolent persuasion or virtue. Inherent in the Renaissance redeployment of classical rhetoric was a mine of potential abuses. Indeed Rebhorn points out that in Renaissance rhetoric, with its distinctive emphasis on 'the connection between rhetoric and ruling: rhetoric becomes ideological as it is granted a distinctly political character and purpose'. As a result, 'if these emphases turn the rhetorician into a political figure, they also turn him into a trickster at the same time'

('Emperour' 45). Rebhorn goes on to argue that, unlike classical oratory – usually described in terms of a combat with other orators – Renaissance rhetoric is invariably identified not merely with moving the listener but with *conquering* the audience. Unlike republican Roman orators such as Cicero, Renaissance rhetoricians thus see rhetoric in practical terms, 'as an art to be used by rulers, offered to them as a means to shape and control their subjects and ensure their thrones and titles' ('Emperour' 57–8). Henry Peacham, for example, asserts that the orator 'may prevaile much in drawing the mindes of his hearers to his owne will and affection: he may winde them from their former opinions, and quite alter the former state of their mindes, he may move them to be of his side, to hold with him, to be led by him, … and finally to be subject to the power of his speech *whither soever it tendeth*' (*Garden of Eloquence* 121; emphasis added). And the 'will and affection' of the Renaissance rhetorician, as Rebhorn points out, is both his *ethos*, the outward manifestation of his inward disposition, and his style or technique; indeed, his *ethos* becomes dangerously identified with his technique, as if the self he projects is identical to the self he strives to project. Rebhorn comments that 'the orator's display of emotion allows him to rule his subjects and project an identity, but since his emotions function effectively whether feigned or genuine, they clearly fail to anchor his discourse in some sort of authentic ground of being' ('Emperour' 60–1). New to Renaissance rhetoric, according to Rebhorn, is the construction of the orator as ruling and deceiving his listeners by means of speech. And rhetoric could be used for ill as well as good; thus 'eloquence is absolutely ambiguous: it creates civil strife just as easily as it defends the state or imposes peace' (*Emperor* 131). Examples of this trickster rhetorician are abundant in Renaissance literature, of course: one thinks not only of Richard III himself but also of Iago, Lady Macbeth, Edmund and Volpone. As Brian Vickers points out, 'in *Macbeth* as in *King Lear* Shakespeare shows men and women using language to realise their own ambitions … man, the speaking animal, reverts to the level of beast: chaos is come again, but this time through persuasion' (433). This is speech as a social, communicative act gone terribly awry – or perhaps acting out its repressed demonic opposite.

However subject Renaissance rhetoric was to manipulation and abuse in practice, its theoretical reliance on the tenets of classical philosophy

made it frequently seem blind to its own vulnerabilities. Vickers cites Thomas Wilson's closing line to the *Arte of Rhetorique*: 'the wicked can not speake wel' and comments that the 'amazing optimism about the innate goodness of speech and rhetoric is typical of much European Renaissance theorizing' (422). However, recent studies such as Rebhorn's reveal that the hyperbolic optimism of writers of rhetoric handbooks betrays their ideological project of attempting to eradicate and contain rhetoric's demonic doubles – of Circean witch and copious, grotesque beast (Rebhorn *Emperor* 133ff.). Whereas the humanist rhetorical tradition constructed speech as both the origin and the instrument of the common good, new philosophical movements such as Ramism, neo-Platonism and Puritanism combined with political realities to construct a far less optimistic picture of all forms of rhetoric as well as a new validation of silence. Far from another hegemonic move to recuperate silence as a rhetorical strategy equivalent to speech, however, its new exponents championed silence as antisocial, multivalent and profoundly subversive – as, in short, 'inscrutable' and thus potentially ungovernable.

Calvinist and Puritan treatises such as William Perkins's *Direction for the Government of the Tongue* (1597) and George Webbe's *Araignment of an Unruly Tongue* (1619) posit a rhetorical counter-myth in which the God-given blessing of speech has been so far abused by fallen men that silence is the only remedy. Perkins explains: 'The pure heart is most necessarie, because it is the fountaine of speech, and if the fountain be defiled, the streames that issue thence can not be cleane.' And because, in his view, 'the heart of man by nature is a bottomlesse gulfe of iniquitie' (2), the language which emerges from it is a filthy mixture of '*Swearing, blaspheming, Cursed speaking, Railing, Backbiting, Slandering, Chiding, Quarrelling, Contending, Jesting, Mocking, Flattering, Lying, dissembling, Vaine and Idle talking*' (Perkins, 'To the reader' A2r). Similarly, whilst Webbe initially echoes Thomas Wilson in praising the tongue as 'A sweet Organ or organon of delightfull speech; a glorious Trumpet to sou[n]d out the praises of the Creator, a faithfull interpreter of the *hidden Man*' (5–6), he rapidly moves to an account of the tongue's role in the Fall (8) and its subsequent degeneration: 'the quality of it is now so perverted and depraved, so that of a necessarie good, it is become *an unruly evill*' (9). The rest of Webbe's treatise is devoted to a catalogue of the tongue's abuses, as well as

to the remedy: 'a silent tongue' (177). For such radical Protestants silence was certainly a preferred alternative to the hated verbal equivocation, the 'lying dissembling', recommended and practised by notorious Catholic recusants (Zagorin 193–8). It is a small step from Perkins and Webbe to the Quakers of the mid-century, who believed that 'Silence ... was not an end in itself, but a means to the attainment of the defining spiritual experience of early Quakerism, the direct personal experience of the spirit of God within oneself' (Bauman 23).

Unsurprisingly, Calvinists and Puritans were attracted by the ideas of Peter Ramus (Ong 287), turning away as they were by creed from the public, mediated text as well as frequently adopting by necessity the silence of suspected and condemned conspirators against orthodoxy. Ramus, a particularly vocal critic of Ciceronian rhetoric, overtly declared 'his view that rhetoric, like prudential method, is, in the last analysis, dissimulation' (Ong 284). Ramus attacked Cicero for overvaluing rhetoric, which was to him (and to subsequent generations) merely an appendage on the silent body of thought. In his *Brutinae quaestiones* Ramus accuses Cicero directly:

> You describe a magnificent house of eloquence and designate its parts as philosophy, law, history, and rhetoric. But when the house is to be started, you actually put up a rhetorical wall and establish the least of all the arts instead of the many. (Murphy 13)

Whereas rhetoric was for Cicero, as for Aristotle, a large and exalted art indivisible from dialectic, for Ramus rhetoric was 'appliqué work' (Ong 282) quite inferior to the abstract silences of thought. Terence Hawkes comments:

> where Rhetoric had formerly embraced the totality of the verbal arts, that is, the requirements for logical thought *together* with those for beautifying ornament, Ramus's division, reducing rhetoric to Elocution and Delivery, made of it a mere cosmetic repertoire of 'figures' or trimmings that could be added to discourse. (38)

The Ramist prejudice against speech as the ephemeral, deceptive and unstable residue of a barbaric age acted as a catalyst for widespread discomfort with the abuses and excesses of rhetoric (Rebhorn, *Emperor* 239) and led to a new valorising of silence, this time not as communication but

as closure. Pointing to Ramus's own temperamental 'lack of interest in dialogue, as evinced by his silence in company', Ong maintains that Ramists were 'deeply distrustful of words' (287):

> Speech is no longer a medium in which the human mind and sensibility lives. It is resented, rather, as an accretion to *thought*, hereupon imagined as ranging noiseless concepts of 'ideas' in a silent field of mental space. Here the perfect rhetoric would be to have no rhetoric at all. Thought becomes a private, or even an antisocial enterprise. (291)

Whilst the Ramist distrust of dialogue, and of the Tudor rhetoric of argument *in utramque partem* in particular, was motivated in part by a desire for the apparently greater fixity and certainty of spatial diagrams and the printed word, in fact – as Ong points out – it led paradoxically to the inscrutable and indefinable silences of the closed and private self. Indeed the practice of silent reading which had become widespread among educated laymen by the fifteenth century contributed to the formulation and dissemination of heterodox and subversive ideas which made civil war possible (Saenger 264–76). Wendy Wall argues that early modern culture constructed reading as a voyeuristic intrusion into the private, silent space of the author: 'the force of making something public (publication) could even create the sense of an inner space, privacy becoming an acknowledged or even privileged category in opposition to the formulation of publicity' (177). Print culture encouraged the production and consumption of texts in silence.

The silences of Ramist philosophy and of Puritan theology had significant equivalents in the political realm. Ramus's objections to rhetorical tyranny were matched by widespread resistance to Tudor absolutism; both these movements became identified with the silence of the emergent private subject. The religious turbulence of the preceding fifty years had led to sustained attempts to enforce silence on both Protestants and Catholics; Maus points out that such 'Attempts to enforce religious conformity can become lessons in the advisability of keeping one's opinions – or the fact that one has no opinion – to oneself' (19). As a result, silence itself was frequently viewed as *enforced* and therefore suspect. The Henrician Treason Act of 1534, for example, made not only overt acts of sedition but also speech which 'call[ed] the King, in express writing or words, slanderously and maliciously, a heretic, schismatic, tyrant, infidel, or a usurper of the

crown' (Elton, cited Patterson 394) treasonable offences. In a country in which Henry's expedient divorce and excommunication had occasioned widespread criticism, people might well feel that they were endangering their lives by holding casual conversations, and therefore held their peace. Geoffrey Whitney's 1586 book of emblems articulates what must have been a widely shared experience of oppressive, enforced silence: 'Whoe serves must please, and heare what other saye, / And learne to keepe HARPOCRATES his lawe: / Then bondage is the Prison of the minde: / And makes them mute, where wisedome is by kinde' (101).

The result of all this was to invest the silence of the subject with, at least, a new fearfulness and, at most, a seditious power. Maus points out that 'the awareness of a secret interior space of unexpressed thoughts and feelings does not require commitment to a particular theology. It is an almost inevitable result of religious oppression' (16). And religious oppression is the distinguishing feature of Tudor and Stuart England. In his *Collection of Emblems* George Wither offers the image of a friar armed with a staff and a closed book to represent 'They that in Hope and Silence live / The best Contentment, may atchive'. He goes on to explain:

> The *clasped-Booke*, doth warne thee, to retaine
> Thy *thoughts* within the compasse of thy breast;
> And in a quiet *silence* to remaine,
> Untill, thy minde may safely be exprest.
>
> (73)

Wither then goes on to offer puritanical criticism of 'those wrongs, and sufferings, which attend thine *Age*':

> For, whensoere *Oppression* groweth rife,
> *Obscurenesse*, is more safe than *Eminence*;
> Hee, that then keepes his *Tongue*, may keepe his *Life*,
> Till Times will better favour *Innocence*.

Wither's weary Stoic advice rejects not only the humanist doctrine of civilising eloquence but also the notion of silence put forward half a century earlier by his predecessor Whitney. Whereas Whitney denounces 'evell wordes' which 'pierce sharper then a sworde', and advises eloquent silence or judicious speech as a means of enhancing social exchange, for Wither

silence is clearly a means of protecting the inward self from danger by making it unreadable. Similarly, in *The Passions of the Mind* (1604) the imprisoned Catholic Thomas Wright describes 'some [who] are so secret, that they never will open any thing, almost, touching their owne affaires' and goes on to comment: 'this offense may well be tollerated in this mischievous world, and declining age, wherein profit is prized, and friendship despised' (119). While Wright's book is apparently dedicated to decoding the inner man from outward signs of speech or gesture, it actually commends those who cannot be so easily deciphered, who are *'inscrutable* and onely open unto God' (27, emphasis added). Discussing 'taciturnitie', for example, Wright allows that 'Others use it for prudence and policie, because in conservation [*sic*], when men either would conceale their owne affections, or discover others; prudence and policie require a space of silence' (108). Similarly, Richard Brathwait in *The English Gentleman* (1630) advises his gentlemen readers to choose male companions

> of such singular discretion, as they wil preferre silence before discovery of their ignorance. These know for what end or purpose the *bars* and *gates* of the *lips* and *teeth* (like a double ward) were ordained to limit or restraine the *Tongue*. These observe, how man hath two *eyes* to see with, two *nosthrills* to breathe with, two *hands* to labour with, two *feet* to walke with, but one *Tongue* to talk with; implying, that one *Tongue* requires as much government as any two members of all the body. (276–7)

The sagacious silence of the friend is instructive; Brathwait expounds at length on 'how dangerous it is to discover the secrets of our heart, even to those to whom we have engaged our heart: for wee ought not to give our *friend* power over us' (280). 'Let us always talke with *Harpocrates*', he concludes, 'at the signe of the finger on the mouth; and learne of *Anacharsis*, that the tongue hath need of more strong restraint than Nature' (281).[8] Whilst he invokes Harpocrates, Brathwait clearly limits his signifying function: this is the god of Silence, not of Eloquence.

Silence was for some a source not merely of safety but of sedition. Bacon's recommendation of *'Closenesse, Reservation,* and *Secrecy'*, for example, emphasises their advantages not for self-insulation but for powerful knowledge, for 'if a man be thought *Secret*, it inviteth Discoverie; as the more Close Aire, sucketh in the more Open … so *Secret* Men come to

the Knowledge of Many Things, in that kind' ('Of Simulation' 21). Moreover, Bacon admits, 'Dissimulation … followeth many times upon *Secrecy* by a necessity', since other men insist on interpreting silence (21). In his essay 'Of Histories' (1601) Robert Jonson goes further to describe 'how rage is suppressed with silence, treason disguised with innocence' (cited Salmon 175) and openly advocates such subterfuge: 'Counsels if they be wrapped up in silence are very fortunately powerful in civil actions, but divulgated lose their force' (cited Maus 29). The well-known English Jesuit Robert Parsons compared 'mental reservation', a form of equivocation practised by Catholic recusants in which the spoken was qualified by the unspoken, with the rhetorical figures of reticence and *aposiopesis* (Zagorin 209–10). And in his discussion of *aposiopesis* in *The Garden of Eloquence* (1593) Henry Peacham conflates silence as Stoic self-control ('to stay the vehemency of our immoderate affections, proceeding to some excesse or outrage') with silence as seditious threat. The figure of interruption, he explains, raises 'a sufficient suspicion without danger of the adversary … not unlike to a truce in war', a veiled threat which is lost 'if [the sentence] be continued too long [which] maketh that manifest that should be secrete and shadowed with silence' (118). Silence is thus constructed as both threat and refuge, combat and retreat.

Whilst it was reformulated under the particular pressures of Tudor politics, this construction of silence found some classical precedent in Stoicism. With his publication of *De constantia in publicis malis* in 1584, Justus Lipsius with his unique brand of Christian Stoicism exerted a strong influence on many English men and women who sought an anchor in the sea of troubles that was Tudor England. Neo-Stoicism offered, according to Lipsius, '*a right and immoveable strength of the minde, neither lifted up, nor pressed downe with externall or casuall accidentes*' (79); this strength was frequently associated with strategic and inscrutable silence. Lipsius writes: 'thy tongue alone is bridled, not thy mind. Thy judgment is not restrained, but thy acts … How many could I recount unto thee, who for their unadvised tongues have suffred punishment of al their senses under tyrantes?' (196). Mark Matheson argues that 'the contemporary humanist discourse of neo-Stoicism … carries with it the institutional authority of the state' (387); yet in his *Basilikon Doron* future King James attacked 'that Stoick insensible stupiditie that proud inconstant LIPSIUS perswadeth in

his *Constatia*' (156), for neo-Stoicism – especially of the Tacitean and
Senecan varieties – had been identified with rebels such as Essex as well as
dangerously discontented courtiers.[9] The classical Stoic ideal of impervi-
ous immutability – of men who refuse to be 'passion's slave' (*Hamlet*
3.2.71) – which often 'performed a conservative ideological function by
projecting an unchanging reality to which the individual subject must
adapt' (Matheson 387) – was clearly susceptible to radical reappropriation,
especially in its Senecan and Tacitean manifestations. As Straznicky sug-
gests, 'The political implications of the stoic ethic are ... genuinely sub-
versive' (114). 'Stoicism in its most powerful forms is not about actual
withdrawal from the world but about the meaning of action and the manip-
ulation of anger for political ends' (3), Shifflett agrees.

In the culture of early modern England, then, retreat into silence could
be a potentially dangerous and aggressive posture. Writers such as Wyatt
reconciled Stoic withdrawal with defiant anger; accounting for the appar-
ent paradox, Graham points out that 'As different as the extremes of with-
drawal and aggression are ... both seek to reach unanimity, the end of
dialogue, one by exercising its will to exact conformity, the other by with-
drawing to create a society of one' (35). In the section of the *Anatomy of
Melancholy* dealing with 'Symptomes in the Minde' Robert Burton reports
on sufferers '*pauciloqui*, of few words, and oftentimes wholly silent', and
goes on to cite the case of 'a young man, of 27 yeares of age, that was fre-
quently silent, bashfull, moped, solitary, that would not eat his meat or
sleepe, and yet againe by fits, apt to be angry' (394). While silence here is a
symptom of severe physiological disturbance, it is also indispensable to the
'deepe reach' (391) of melancholics that Burton praises elsewhere. When
Lear promises to be 'the pattern of all patience' and to 'say nothing'
(3.2.37–8) in his trials, his stoic endurance is a thin veil for his rage
(Graham 201). In *Titus Andronicus* the villainous Aaron draws attention
to the threat inherent in his silence, as he asks Tamora:

> What signifies my deadly-standing eye,
> My silence, and my cloudy melancholy,
> My fleece of woolly hair that now uncurls
> Even as an adder when she doth unroll
> To do some fatal execution?
>
> (2.3.32–6)

It is fitting that, at the end of the play, a defeated Aaron vents his rage in futile words, crying 'why should wrath be mute, and fury dumb?' (5.3.183); speech dissipates the power he retained in silence.

The power of silence is illuminated also in contemporary legal history. Roman law did not consider silence a manifestation of will and, in most cases, construed it as tacit consent (*qui tacet consentire videtur*).[10] 'But that you shall not say I yield being silent, / I would not speak' (2.3.90–1) says Imogen to Cloten in *Cymbeline*. Rachel Speght repeats the commonplace in justifying her reply to Swetnam: 'seeing that *Tacere* is, *quasi consentire*' (3). The legal status of silence however, underwent an abrupt shift in the sixteenth century. In the 1535 treason trial of Thomas More, for example, Attorney General Christopher Hales attacked More's refusal to speak on the subject of Henry's legitimacy as Head of the Church: 'Sir Thomas', said Hales, 'though we have not one word or deed of yours to object against you, yet we have your silence, which is an evident sign of the malice of your heart: because no dutiful subject, being lawfully asked this question, will refuse to answer it' (Cobbett 1.389). More pointed out that 'this Statute, nor no other law in the world, can punish any man for his silence, seeing they can do no more than punish words or deeds; 'tis God only that is the judge of the secrets of our hearts'. More's invocation of a silent inner space containing the heart's secrets accessible only to a rival, divine monarch was considered a threat to the ruling one. In 1541 Parliament passed a new statute stating that those who

> obstinatlye refuse to answere directly to the same offences … or … stande muett and will not speake, then such pson or psons so refusing to answere or standinge muett shalbe convicte judgd and demed guyltie of the thinge … and shall have judgment to have like paynes of Death, and other paynes punysh-ment execucons forfeytures losses and seisures of landes … as he or they oughte or shoulde have had for suche like offenses, [as] yf he or they were or sholde be founde guyltie thereof by the verdicte of twelve men. (33o Hen VIII c. 12 p. 847)

At first glance the new statute seems merely to formalise the *peine forte et dure* or 'pressing to death' that had been law in England since the thirteenth century whereby 'the defendant who refused to plead to his indictment was subjected to physical coercion so terrible that it killed him if he did not

relent and enter his plea' (Langbein 75). The latter, however, was never
used to extract information or gather evidence, and therefore could not be
considered torture; because the defendant refused to plead, *he could not be
convicted* and his estate could not be seized. The Henrician statute, on the
other hand, treated the 'obstinately' silent defendant as guilty, and silence
itself as a punishable crime. Strictly speaking, this was directly counter to
common law, which defended a man's right not to incriminate himself by
being forced to speak.

Indeed, in the late sixteenth century, the right to silence became a site
of intense contestation between the rival authorities of ecclesiastical and
common law. Since the thirteenth century, canon law had used the *ex offi-
cio* oath as a means of investigating alleged heretics. The oath, a sworn state-
ment to give true answers to whatever questions might be asked, had to be
taken although the accused had no knowledge of the charges against him;
it was followed by 'a series of interrogatories whose purpose was to extract
a confession' (Levy 47). Until 1641, when it was finally abolished, the *ex
officio* oath was used not only by the ecclesiastical courts but also by the
King's Council and later the Court of High Commission, instituted by
Mary in 1557 as an ecclesiastical arm of the Star Chamber and Privy
Council. There were numerous protests against the oath from its inception,
since it allegedly violated the twenty-ninth chapter of the Magna Carta's
famous 'law of the land', which 'guaranteed to every subject an indictment
by grand jury and trial by jury in a common-law court by common-law pro-
cedure' (Levy 51). Probably the most influential protest in Tudor England
came from William Tyndale, whose popular 1525 translation of the Bible
contained an explicit refutation of the oath (Levy 63). More himself refused
to take the oath when he was tried for treason (Levy 70). Yet it was not until
the inquisition and terror of the reign of Queen Mary that there was wide-
spread resistance to the *ex officio* oath. In 1554, for example, John Bland,
a Protestant minister, refused to answer his inquisitor, saying 'I perceive
that ye seek matter against me … I think thus I am not bound to make you
an answer' (cited Levy 77). The obstinately silent were burned. Although
fewer than ten per cent of the Puritan clergy directly refused the oath and
were stripped of their ministry (Zagorin 228), the whole affair focused
public attention on the individual choice of conscience between duplici-
tous speech (equivocation) and outright silence. Most chose the middle

ground of objecting to the oath on legal grounds (Zagorin 228), and 'the refusal on the part of suspected heretics to accuse themselves became commonplace' (Levy 79). Many of these objections to the oath were recorded and celebrated in Foxe's *Book of Martyrs*, for many years the most important book in England next to the Bible.

During Elizabeth's reign this dispute about the right to silence was rekindled with the inception in 1583 of the High Commission under John Whitgift, Archbishop of Canterbury, himself committed to wiping out Puritan recusancy. Whitgift's innovation of the judicial use of the *ex officio* oath was to make it mandatory. Whilst prior to 1583 Puritans regularly refused to take the oath, after 1583 a refusal was treated as guilt, and the defendant was treated as if he or she confessed and was convicted (Levy 132). Richard Cosin, Dean of Arches and a member of the Commission, justified the oath by claiming that 'by such oathe, the partie is drawn to discover his owne *dolum malum* [evil deeds], *covine* [secret conspiracies], *fraude*, or *mal-engine* … penall to himselfe' (Levy 133). Whitgift's procedures did not, however, go unchallenged. Responding to an appeal by recently suspended ministers, Lord Burghley roundly condemned Whitgift in a now-famous letter in which he compared the Commissioners to 'Inquisitors of Spain', and the entire initiative to the 'Romish inquisition' (cited Levy 137). Robert Beale, Clerk of the Privy Council, published and delivered Parliamentary speeches on the Commission's improper use of the *ex officio* oath. Because the oath was supported by both Queen Elizabeth and King James at different times, it remained a highly explosive public issue.

What is the significance of the use and abuse of the *ex officio* oath for the history of silence in early modern England? On the one hand the authorities attempted to wrest incriminating speech from their victims while at the same time maintaining their own silence about the charges levelled against them: as Bacon pointed out, 'men are enforced to accuse themselves, and, that what is more, are sworn unto blanks, and not unto accusations and charges declared' (*Certaine Considerations* 1604). Thus power shrouded itself in silence and indefiniteness – accusations must have been more terrifying for being unarticulated and vague – while it demanded speech and definition from those it sought to punish. On the other hand, the recusants found a rival power in the silence with which they defied their interrogators – a silence which imitated not that of their accusers but the secret of the heart which

they believed no crime. Their silence is clearly more complex, since it is both imposed and voluntary, the badge of the silenced victim and the resistant martyr alike. Indeed what is significant is the defendant's reappropriation of an official sign of contempt and guilt as a trope of subjective freedom. As James Morice said to Parliament in 1593: 'Yf the Party convented standinge uppon his lawfull libertie refuse to take this indefinite Oathe, then as for a heynous contempt ageinst God and hir Ma[jes]ties he is comytted to hard and miserable Imprisonment' (cited Levy 196). Silence in the late sixteenth century was a site of conflict between the authorities who paradoxically both enforced and outlawed it and the subject who found in it both oppression and licence. This silence may also have been a form of eloquence, but it was eloquence quite different from that recommended by Plutarch, since it resisted social intercourse and state power in favour of the inward secret spaces of the self, however dramatically these were staged. Father John Mush's life of Catholic martyr Margaret Clitherow, for example, notes approvingly that, in response to reprimands, 'without all contention, [she would] keep silence, and return to the comfort of her inward mind and conscience'; later, during her trial for priest-harbouring, she 'takes up the platform of silence in her defense' by refusing to plead, suffering instead pressing to death (Matchinske 70).[11] The 'inscrutable' inward silence and secrecy of recusancy finds its eloquent public expression in the courts. In short the political resistance of the emerging subject had become firmly associated with silence in early modern England.

The association of rhetoric with political tyranny and religious persecution thus increasingly led beleaguered groups and individuals to a revaluation of silence – not as a traditionally valued form of civil eloquence and plain speaking but as a closed and private site of resistance. Sometimes, as in the widespread rejection of the *ex officio* oath, that silence was staged publicly and dangerously; more often silence was a retreat paradoxically both endorsed and feared by the authorities as an unreadable and potentially unmanageable interior space.

Silence, chaos and the devil

The rhetorical insistence on repudiating or containing silence outlined at the beginning of this chapter may perhaps be partly explained by its threatening connections with chaos, death and the demonic, for silence

frequently represented a threat to the civilising power of speech celebrated by the humanists. Ben Jonson declares: 'Language most shewes a man: speake that I may see thee. It springs out of the most retired, and inmost parts of us, and is the Image of the Parent of it, the mind' (*Timber* 625). Speech, that God-given, distinctively human faculty, both expresses individual subjectivity and allows it to be apprehended by others. Silence, from this point of view, is at best antisocial, at worst dangerously anarchic. Mowbray in *Richard II* sees banishment from his 'native English' tongue as a 'speechless death' (1.3.154, 166); Sir John Daw views silence as a 'masculine vice' (*Epicoene* 2.3.116); Ajax in *Troilus and Cressida* is, according to Thersites' description, 'languageless, a monster' (3.3.254). Implicit in many of the humanist paeans to speech is a view of silence as antisocial bestial disorder from which men must be roused. Thomas Wilson, for example, evokes a postlapsarian world, 'destitute of Gods grace' in which

> al thinges waxed savage, the earth untilled, societye neglected, Goddes will not knowen, man againste manne, one agaynste another, and all agaynste order. Some lived by spoyle, some like brute Beastes grased upon the ground, some wente naked, some romed lyke woodoses, none did anye thing by reason, but most did what they could, by manhode. None almoste considered the everlivynge God, but all lived moste communely after their own luste. (17)

These fallen men lived in brutish silence until 'these appoynted of God called theim together *by utteraunce of speach*e' (18). Rebhorn points out that in such a myth 'human beings are assumed to be animals by nature: hard, uncharitable, irrational creatures driven by savage appetites and separated from one another by antisocial indifference or mutual hatred' (*Emperor* 26). Pre-verbal humankind in this vision is truly a dystopia of 'whores and knaves' (*Tempest* 2.1.166) This imaginary prelinguistic Wild Man, frequently eroticised and identified with the dangers – and pleasures – of unregulated desire, inhabits a silent space teeming with projected fantasies of fear and desire, an 'id [which], according to Freud, is without language' (Greenblatt, *Learning* 22).

If early modern rhetoricians reiterate classical notions of silence as foolish and inept, these notions are often underwritten by tropes of silence

as dangerously savage, demonic and barbarous, in keeping with a more negative Christian view of fallen human nature (Rebhorn, *Emperor* 27).[12] Thomas Wilson, for example, associates prelinguistic barbarousness with foolishness in his mythic account of men who 'throughe follye fell into erroure' (17) and then 'became through nurture and good advisement, of wilde, sober: of cruel, gentle; of foles, wise; and of beastes, men' (18). To be silent is to return to the state of the uncivilised beast – or, worse, to fall into the grasp of the devil, for 'Christ is the word of the eternal father: contrary to a word is silence or to be mute … The devill evermore opposeth himselfe against God, therefore at the presence of the word, he speakes not' (Affinati 118). Affinati's work, *The Dumbe Divine Speaker or Dumbe Speaker of Divinity*, translated into English in 1605, begins as '*a pleasing controversie, whether Silence or speaking, merits most praise*' but predictably concludes '*that there is more securitie in silence, then indisceete talking*' (B1r). In attempting to recommend silence as a virtue, however, its author spends a good deal of space puzzling over the muteness of the devil in Luke 11.14: 'How could so great a talker, an accuser, a detractour & a defamer, hold his peace, and observe silence?' (112). He comes up with several answers: that Satan's silence could still be considered a speech act, defined as 'the first tongue, that is, to thinke evill in the heart' (112); that Satan's silence is different in kind from the 'holy taciturnity' (136) of contemplative men as from the 'mute voice' (115) used by angels to communicate with God; and, finally, that the muteness attributed to demonic influence may well be a divine instrument: 'And who knows, whether (to this end or no) God permitted the divel to bind up the tongue, as seeing, how ready it was to many evill offices? wherfore, for amendment therof, God suffered the divel to enter the mans body, so to strike dumb the overlavish tongue' (136). In striving to recuperate silence for the divine, this writer illuminates its potential to characterise the demonic. In Milton's *Paradise Lost* Satan and his rebellious crew are consigned to 'horrid silence' (I.83) by the Almighty.

 In addition to hellish chaos and savagery, silence hinted at grief and death: early modern writers were fond of repeating and adapting Seneca's famous lines, from *Hippolytus* (607): '*Curae leves loquuntur, ingentes stupent.*' In early modern versions Seneca's speechless sorrows have the power to overwhelm or destroy their victim: so in *Macbeth* Malcolm urges

Macduff to 'Give sorrow words. The grief that does not speak / Whispers the o'erfraught heart and bids it break' (4.3.210–11). In Webster's *The White Devil*, after her husband has rejected her, Isabella declares in an aside: 'Unkindness do thy office, poor heart break / Those are the killing griefs which dare not speak' (2.1.276–7); in the next scene she is murdered. And in *Richard II*, shortly before his death, the deposed king refers to his 'unseen grief / That swells with silence in the tortured soul' (4.1.287–8). Here the inability to express anguish renders its victim powerless, and vulnerable to the ultimate silence – that of death.[13] At the end of Shakespeare's *Hamlet* Horatio may imagine flights of angels singing his friend to rest, but Hamlet himself knows, 'The rest is silence' (5.2.300).

It is now perhaps clear that it is misleading and historically inaccurate to locate power in speech alone – or even to construct speech and silence as binary opposites. This chapter has suggested that silence in early modern England was an unstable and highly contested site. Despite traditional moves to align silence with rhetoric – either to treat it as a form of eloquence or to reject it as the last recourse of fools – alternative paradigms constructed silence as an antirhetorical space of resistance, inscrutable, unreadable and potentially unruly and chaotic. Both the emerging suspicion of rhetoric and the political unrest in Tudor England made these other paradigms of silence attractive and susceptible to further appropriation. The following chapter will explore the implications of this 'moving Rhetoricke' of silence for gender construction in early modern England.

Notes

1 Rebhorn remarks that the ideological myth of the orator as civiliser 'presents the orator as the master of language and depicts the people, by contrast, as essentially mute'. He goes on to comment: 'What such a reading of the myth ignores, of course, is the possibility not only of the people's active resistance but of interpreting the orator's behavior as coercion and domination' (*Emperor* 26).

2 In this respect early modern notions of silence resemble attitudes to native Indian populations in the New World, whose linguistic otherness was either treated as no language at all or assimilated to the dominant culture: Greenblatt claims that 'Indians were frequently either found defective in speech, and hence pushed toward the zone of wild things, or granted essentially the same speech as the

Europeans' (*Learning* 28). Thus the colonisers 'push the Indians toward utter dif-
ference – and thus silence – or toward utter likeness – and thus the collapse of their
own, unique identity' (Greenblatt, *Learning* 31).

3 Bruce Smith notes a similar ambivalence about silence for the 'Cartesian writer':
 'On the one hand, he exploits silence: writing secures the truth by voiding the
 voice, by turning ideas into disembodied ciphers. On the other hand, he distrusts
 silence. Out of silence might come resistances, blockages, and diversions' (27).
 Smith, however, locates the appropriation and managing of silence in the act of
 writing as opposed to speaking, in which 'something might remain hidden,
 unseen, unsaid' (26). He thus associates the early modern suspicion of rhetoric
 with an increased desire for certainty and fixed meaning available in the written
 word. I argue the opposite: the threatening potential of silence is defused by being
 turned into a form of speech or eloquence; early modern distrust of rhetoric coin-
 cides with – and in part produces – a valorisation of the subversive possibilites of
 both silent speakers and silent readers or writers.

4 In the *Advancement of Learning* Francis Bacon gives voice to an increasing disil-
 lusionment with Ciceronian rhetorical art: the 'affectionate study of eloquence
 and copie of speech, grew speedily to an excess; for men began to hunt more after
 words than matter; and more after the choiceness of the phrase, and the round and
 clean composition of the sentence, and the sweet falling of the clauses, and the
 varying and illustration of their works with tropes and figures, than after the weight
 of matter, worth of subject, soundness of argument, life of invention, or depth of
 judgment' (190).

5 Andrew Gurr draws attention to this silence, commenting: 'Real silences are truly
 noteworthy' in a theatre in which 'Speech was almost non-stop' (161).

6 I find myself in agreement here with Ekbert Faas, who discusses what he calls 'a
 new poetics of silence' in the *Sonnets* (130). In Faas's view the speaker recognises
 on the one hand that, because 'no poetry … can ever be a totally unmediated
 enactment of thought', 'in an ultimate sense … poetry, or the kind advocated in
 the Sonnets, is condemned to silence' (130). On the other hand this recognition
 does not hinder the speaker's self-confidence or self-expression: 'For all that, Will,
 despite some histrionic disclaimers to the contrary, remains fully confident of his
 artistic achievement. In fact, his new poetics of silence has only increased this con-
 fidence' (131).

7 I use the terms 'rhetorical' and 'antirhetorical' silence to distinguish between
 silence as a 'readable' form of discourse and silence as unfathomable and non-dis-
 cursive space. This is entirely different from Kenneth Graham's distinction
 between 'rhetorical' and 'antirhetorical' plainness: whilst the former is 'a model of
 plain, ordinary speech that is nonetheless quintessentially rhetorical' which
 includes 'the orthodoxy of received wisdom' (18), the latter ranges from polite
 indications 'that the limit of debate has been reached' to 'the "rude" species of pri-
 vate plainness, a blunt integrity that speaks its mind and refuses to flatter' (11).

Both are, however, readable forms of rhetoric, however different their underlying assumptions.

8 Brathwait's advice recalls Steven Guazzo's: 'as it is a great fault to disclose the secrets of other: so contrariwise, it is a notable vertue to know how to holde ones peace, and to bridle his tongue' (1.71).

9 See Adriana McCrea's study of the influence of Lipsius on early modern English writers and politicians, including Essex (35–6), as well as Andrew Shifflett's important revision of Quentin Skinner's view of Stoicism as politically conservative.

10 This was apparently the favourite maxim of Pope Boniface VIII (c. 1300), recorded in the *Book of Decretals*, Bk V, ch. 12, sec. 43.

11 I am indebted to Matchinske's study for bringing Clitherow's life to my attention. Matchinske also notes that 'Ironically, Clitherow's reticence to speak before her accusers illustrates a topos of ideal female behavior during Elizabeth's middle years' (70). She further remarks on the mixture of deference and resistance in her silence. Clitherow's refusal to plead, for example, both avoids implicating her husband and male priests and inscribes her as martyr. 'Her silence, then, reinforces her domestic, spiritual, economic, *and* social commitments simultaneously' (193n.). On the whole Matchinske identifies these diverse positions as awkward disjunctions in Mush's narrative (70–1) rather than as multiple possibilites embedded in the trope of silence itself.

12 Rebhorn distinguishes Cicero's account of the origins of rhetoric from later ones: 'Cicero may say that humans lived like savages initially, but he claims that they possessed a capacity for civilized behavior which eventually allowed them to rule themselves. By contrast, Renaissance treatments of the myth ignore or downplay such a notion: not only do human beings need to be led into civilization, but their natural depravity requires their constant monitoring lest they return to their natural, postlapsarian condition' (*Emperor* 27).

13 Watson makes a convincing and intriguing case for the fear of mortality (the silence of the grave) as an essential early modern impulse motivating literary genres such as revenge tragedy.

2 Silence and gender

And what of women in early modern England? Thus far I have ignored the gendering of silence, as do many classical and early modern texts, which thereby implicitly gender their discussions male. And most of the historical material I have discussed pertains to men: the prevailing configurations of silence, defined by a male-dominated rhetorical culture, reject it as impotence or appropriate it as a superior form of eloquence; antirhetorical paradigms either reformulate silence as a trope of resistant, unreadable subjectivity or construct it as bestial chaos. Women, it seems, were a different matter altogether. To illustrate the figure *conversio in eadem* ('comprehension') in his *Arte of Rhetorique*, Thomas Wilson casually offers the following example:

> What becometh a woman best, and first of al? Silence. What seconde? Silence. What third? Silence. What fourth? Silence. Yea if a man should aske me til dowmes day, I would stil crie, silence, silence, without the whiche no woman hath any good gifte, but having the same, no doubt she must have many other notable giftes, as the whiche of necessitie do ever folow suche a vertue. (400–1)

Whilst it may seem to us absurdly paradoxical for a male author to cry repeatedly for female silence, his sentiments are echoed gravely by his contemporaries, who tirelessly repeat variations on the biblical injunction: 'Let the woman learn in silence with all subjection. But I suffer not a woman to teach, nor to usurp authority over the man; but to be in silence' (1 Timothy 2.11–12). In Thomas Salter's *Mirrhor Mete for all Mothers, Matrones and Maidens* (1579) a young girl is advised not 'to be a babbler or greate talker'(D2r) but rather to keep silent. 'Doubtlesse a simple woman holding her peace shal have more honour, than one of more wit, if shee bee full of tongue', asserts William Whately in *A Bride-bush* (203). '*Silence* is farre better … then such unsavorie talke', say John Dod and Robert Cleaver

emphatically in their advice to young women (95). 'What is spoken of
Maids, may be properly applyed by an usefull consequence to all women:
They should be seene, and not heard: A Traveller sets himselfe best out by dis-
course, whereas their best setting out is silence', declares Richard Brathwait
(*Gentlewoman* 41). These writers all confirm what has become a cliché
about the early modern woman as 'chaste, silent and obedient' (as the title of
Suzanne Hull's bibliography of books for and about women has it). In the
case of women, at least, silence appears to be a simple and monolithic patri-
archal injunction, designed to place women in the position reserved for fools
in Ciceronian rhetoric – firmly outside the discursive realm of power. Other
possible masculine constructions of silence – as eloquence, resistance or
bestial disorder, to name a very few – are simply elided. The double standard
is a familiar one to feminists.[1]

 This double standard is based on a dominant gendered ideal of active,
shaping power as male and passive receptivity as female, a binarism often
imaged as male speech/female silence. This binarism was firmly
entrenched in early modern culture by a combination of classical, biblical
and physiological discourses associating men with active and women with
passive virtues. In Aristotle,

> The male principle in nature is associated with active, formative and perfected
> characteristics, while the female is passive, material and deprived, desiring the
> male in order to become complete. The duality male/female is therefore par-
> alleled by the dualities active/passive, form/matter, act/potency,
> perfection/imperfection, completion/incompletion, possession/deprivation.
> (Maclean 8)

It therefore seemed 'natural' in a rhetorical culture that the potent, shap-
ing power of speech should be gendered male, while its subordinate yet
necessary opposite, silence, should be gendered female. Karen Newman
points out: 'Religious handbooks and sermons, as well as secular works,
all represent sexual roles in binary terms: men love, women submit; men
speak, women are silent; men provide through work outside the home,
women are confined to the home' (19). Early modern texts provide abun-
dant examples of this binarism. Dod and Cleaver write, 'the dutie of the
man is, to bee skilfull in talke: and of the wife, to boast of silence' (168).
In Ben Jonson's *Epicoene, or the Silent Woman* John Daw claims that

'Silence in woman, is like speech in man' (2.3.111) – speech, a 'female vice should be a virtue male' and silence, a 'masculine vice [should] a female virtue be' (115–16). Daw's jingle sums up the moral logic of the traditional double standard: speech, a male virtue, is a female vice, as silence, a female virtue, is a male vice. Cleaver reiterates that 'a man or a womans talking, is the mirrour and messenger of the minde, in the which it may commonly be seene without, in what case the man or woman is within … Now silence is the best Ornament of a woman' (104). The formulaic ideal of feminine silence wins out over the humanist privileging of speech – or so it appears.

The (en)gendering of male speech and female silence is due in part to myths of origin which stand in direct opposition to one another. Henry Peacham provides yet another version of the male myth of restorative rhetoric in his *Garden of Eloquence* (1593):

> Now lest so excellent a gift of the divine goodnesse (as wisedome here appeareath to be, and is) should lye *supprest by silence, and so remaine hid in darknesse*, almightie God the deepe sea of wisedome, and bright sunne of maiestie, hath *opened the mouth of man*, as the mouth of a plentifull fountaine, both to powre forth the inward passions of his heart, and also as a heavenly planet to shew foorth (by the shining beames of speech) the privie thoughts and secret conceites of his mind. ('Epistle Dedicatorie' AB3; emphases added)

Drawing on the negative associations with silence as primordial chaos ('hid in darknesse'), this myth primarily foregrounds the active, formative agency imputed to male speech. Even here a double standard is at work: the image of the flowing fountain (suggestive of seminal fluid)[2] for the male speaker is the privileged term whose obverse is the feminine 'leaky vessel' of which Gail Kern Paster has written (*Body* 23–63). Indeed, if in this account man is delivered from anarchic silence into the order and civility of speech (and its corollary, eloquent or active silence), in other accounts woman is delivered from uncontrolled language and garrulity into the subordination of silence. Women's silence is thus defined as an *absence* of uncontrolled speech (the only kind of which women are capable, according to the myth of origin) and hence as a sign of subordination to man. The pervasive cultural link between women and verbal fluency may originate with the female

body's excessive production of fluids (Paster, *Body* 25), with the 'moovable' harlot of Proverbs 7, who is 'full of babling and loude woordes, and ready to dally' (Patricia Parker, *Literary* 104) and with Eve, who 'brought sin into the world by unwise speaking' (Spacks 41), or with the vernacular 'mother tongue', constructed as unruly at the historical moment when men were attempting to regulate and order it according to fixed rules of rhetoric (Fleming 190–1). Whatever its origin, in early modern England 'female speech is less rational than male speech in general; authors' diction often characterises female speech as meaningless sound, babbling, prating, chattering' (Woodbridge, *Women* 210). Such cacophony was considered not only irritating but also dangerous, since it threatened the order of the household and ultimately of the state. Because of the 'relation between a potentially uncontrollable female sexuality, a woman speaking in public, and a woman usurping her proper place' (Patricia Parker, *Literary* 106), female garrulousness had to be firmly managed. Or perhaps it is more accurate to say that the strength of the stereotypes of scold, whore and gossip testifies already to such management, since these were constructed to justify the 'naturalness' of a gendered hierarchy mandating feminine silence and enforcing a seemingly unquestioned double standard.

The meaning of silence clearly shifted to suit the politics of gender. On the one hand inchoate, silent matter was often imagined as feminine (Richard Hillman, *Shakespearean* 35–6); paradoxically enough, women's silence alternately signified both the cause and the result of women's subordination: the formlessness of chaos and the subservience of desired order. On the other hand masculine silence was often invested with the active qualities of speech, as we have seen, becoming a form of eloquence or resistance; except when associated with the fool or the beast (both potentially effeminate), masculine silence was presence and possession, rather than deprivation or lack. And, as the copiousness of masculine eloquence was rescued – almost – from its possible contamination by feminine garrulousness,[3] so the reserve of masculine silence was saved – almost – from its potential association with passive feminine submission. Its force was quite often validated by an association instead with silent, eloquent action in contrast to feminine words: according to the proverb '*Fatti maschii, parole femine*': 'Women are words, men deeds'.[4] Thus Hamlet abuses himself for unpacking his heart with words 'like a whore' (2.2.581)

instead of taking swift and silent action; Troilus is praised as 'speaking in deeds and deedless in his tongue' (4.5.98). A similar double standard was reflected in different approaches to male and female garrulousness (Spacks 39): if men were enjoined to avoid talking too much to safeguard their own secrets and avoid victimisation, women had to be discreet to protect their *husbands'* secrets and avoid undermining their authority. Thus if masculine silence was prudence, policy, even resistance to female gossip, then feminine silence was simple obedience to authority. When contingent on the rigid binarism of gender, silence initially appeared to shed its complex philosophical history to become yet another means of enforcing the gender hierarchy.

This gender hierarchy can be traced back to Aristotle, whose cogent account in the *Politics* significantly identifies silence as a marker of sexual difference:

> The temperance of a man and of a woman are not the same, nor their courage and justice, as Socrates thought, but the one is the courage of command, and the other that of subordination, and the case is similar with the other virtues … it is misleading to give a general definition of virtue, as some do, who say that virtue is being in good condition as regards the soul or acting uprightly; those who enumerate the virtues of different persons separately … are much more correct than those who define virtue in that way. Hence we must hold that all of these persons have their appropriate virtues, as the poet said of woman:
> Silence gives grace to a woman –
> though that is not the case likewise with a man. (*Politics* 1.13)

It is important to note, however, that the double standard defended by Aristotle is potentially unstable. As Ian Maclean notes, the text engenders 'confusion' since Aristotle seems to suggest, first, 'that virtues are different only in scale or mode of expression and that the same virtue can have contrary manifestations' (54–5) and, second, that masculine and feminine virtues, speech and silence, are as different as the binary principles cited in the Pythagorean table of opposites.[5] Aristotle himself raises – at least initially – the interesting possibility that the same virtue (courage) may give rise to command and speech in man, silence in woman, thus undoing the apparent binarism between them. However unintentionally, Aristotle here reflects a classical debate, renewed in the Renaissance, about the nature of

the differences between the virtues of the sexes. Whilst Plato and Plutarch argue more radically that male and female virtue is identical, Aristotle usually attempts to distinguish between them (Maclean 54–6). Whilst such views rarely subvert the status quo, they do associate silence (at least potentially) with gender-neutral virtues such as courage and temperance rather than with submission and make the exercise of such a virtue contingent on social role rather than sexual difference. This is an important distinction at a time when social roles (especially men's) were changing rapidly, and (as Chapter 1 argued) many men found that careful, self-protective silence was a more reliable virtue than traditional eloquence in an unstable and dangerous world.

Silence and androgyny[6]

Despite a firmly entrenched double standard, the 'inscrutable' silence in which many early modern men apparently took refuge bore a strong and sometimes unsettling resemblance not to masculine action but to self-enclosed, impenetrable and potentially 'passive' female silence. A man speaks to exhibit his best qualities and take part in public life; a man who does not speak beats a fearful retreat from the self-defining, combative, phallic modes of courtly speech (Whigham 50), and risks appearing as a woman. If, as Laura Levine has argued, early modern masculinity had to be 'enacted and compulsively re-enacted in order to exist ... because the woman is always the *feared* thing, the thing one is in danger of regressing or slipping into' (71), men who do not assert themselves through speech – or through public action – risk slipping into that 'default position' (Levine 8) through silence. Silence could thus intimate a feminising reduction in male power, and evoke considerable anxiety in early modern texts. If masculinity was no longer invested primarily in the agency and authority of *speech* (or the trope of silent, powerful deeds), inscrutable male silence revealed its affinities with traditional ideas of interior *female* space. Typically, feminine silence was associated with 'hiddenness', as Maus points out:

> The womb is the private space of thoughts yet unuttered, or actions yet unexecuted. It is a container, itself concealed deep within the body, with something further hidden within it: an enclosed and invisible organ, working by means

unseeable by and uncontrolled from the outside … Both men and women have 'secret parts,' but women's are genuine secrets. (190)

Similarly, Paster argues that gestation figured woman's inscrutability: 'Perceivable as a complex of constantly changing symptoms, pregnancy was a rare type of bodily event knowable as to cause and desired effect but radically unknowable even in its visibility for the long months in between' (*Body* 182). Men who withheld themselves in inactive silence risked imitating not only idealised feminine closure but also unmanageable feminine indeterminacy.

Despite, or perhaps because of, the anxiety such gender-blending produced, early modern England produced an abundance of male-authored conduct literature apparently devoted to justifying and recommending the feminine virtue of silence not as subservience but as self-reliance – for both men and women. As Edmund Tilney writes in *The Flower of Friendship* (1568): 'I would have this married man to embrace secrecie as a virtue, and thinke it is a great shame not to be so secret, as a woman' (120). Similarly, in *The Dumbe Divine Speaker* (1605), Affinati constructs the virtue of silence for men in entirely feminine terms:

> in a young man it is an ornamente so fayre and beautifull, as the curling hayres doe not more embellishe a delicate virgine, the chaine of golde about her necke, the pendentes at her eares, the bracelettes about her wristes, the jewell on her breast, and the unvaluable gemme on her finger; as gratious modesty, and sweetly beseeming silence, doth decorate and set forth a civill young man. (12)

Iconographically, silence was frequently represented as female. In Pierre Coustau's *Pegme* (1555) the Roman goddess Angerone (also known as Muta or Tacita and depicted with her mouth bound) is the goddess of Silence worshipped by the ancients, 'estimans la gloire de seler & taire les choses etre si grande, qu'elle meritoit d'etre mise en la protectio & sauvegarde de quelque Dieu' (145). And in Cesare Ripo's *Iconologia* Secrecy is represented as 'A very grave lady all in black, carrying a Ring to her mouth, as if she intended to seal it up [; she is] Grave, because there is no greater sign of lightness than to divulge a Friends secrets' (68).

Indeed the traditional gendering of speech as male and active, silence as female and passive, is merely one formulation among many in early

modern culture. It appears in its purest and most extended form in texts such as Thomas Becon's *New Catechism* (1560), which takes the form of a dialogue between father and son. When the father demands his son prove his proposition 'that wives ought to be in subjection to their husbands' (340), the son responds by invoking all the biblical passages enjoining women's silence as submission. Later, in his description of the 'duty of maids', Becon cites the proverb, 'A maid should be seen, and not heard', and further elaborates: 'Except the gravity of some matter do require that she should speak, or else an answer is to be made to such things as are demanded of her, let her keep silence. For there is nothing that doth so much commend, avance, set forth, adorn, deck, trim, and garnish a maid, as silence' (369). Whilst Becon does allude to the importance of decorous speech for women (a central tenet of the dominant ideology), his rhetorical emphasis falls on the residual ideal of silence as an unproblematic sign of subjection. Both garrulousness and silence are gendered female: 'the godly married woman maketh peace and quietness wheresoever she becometh: the whore causeth strife and dissension and setteth men together by the ears' (342–3). In his *Christian State of Matrimony* (1543) Becon makes explicit his adherence to the double standard: 'It is unseemly for a man to use unclean talk: but for a woman to use it, it is more than twice unseemly, seeing that there is nothing that so garnisheth a woman as silence' (Aughterson 112). Becon's formulation borrows directly from Erasmus's well-known adage, '*mulierum ornat silentium*', rendered in English by Taverner as 'Silence garnysheth a woman. Assuredlye there is no tyre, no apparayl that better becometh a woman then sylence'(*Proverbes* fol. lr [50]).

Ironically, the counter-argument to Becon is made much earlier by Erasmus himself in attacking garrulousness in his *Lingua* (1525): 'I would address myself especially to women, who commonly are reproached on this score,' he writes, 'if I did not see all around me so many foul-tongued men that women appear subdued and restrained in comparison' (264). Humanists such as Erasmus recuperate a classical tradition of gendering abuses of the tongue male rather than female, displacing an alternate tradition of misogynist stereotypes of female shrew and saint.[7] Erasmus himself, of course, remains firmly committed to 'rhetoric, the noblest of arts' (275), exalting 'the tongue of the spirit' over 'the tongue of the flesh' (371). If he

approves of silence, it is, like Plutarch's model, based on the merits of social exchange; if 'no one speaks properly unless he has first learned to be silent' (360), an 'economy of speech' (376) remains the ideal. If injurious speech is 'a sword dipped in venom, a dagger, an arrow', judicious speech is 'a remedy against all the diseases of the mind' (411). From this perspective, 'nothing is more disgraceful for anyone than ... to be silent when the situation calls for speech' (269). Thus, if Erasmus recuperates both unruly speech and eloquent silence for masculinity,[8] he remains as firmly committed to the rhetorical agenda (manifested in his famous *De copia verborum*) as his classical forebears.

Erasmus's successors, some of them Puritans, reiterate his masculinising of abuses of the tongue. Both William Perkins's *Direction for the Government of the Tongue* (1597) and George Webbe's *Araignment of an Unruly Tongue* (1619) catalogue verbal vices such as '*Swearing, blaspheming, Cursed speaking, Railing, Backbiting, Slandering, Chiding, Quarrelling, Contending, Jesting, Mocking, Flattering, Lying, dissembling, Vaine and Idle talking*' (Perkins, 'To the reader' A2r), but do not identify these as specifically feminine. On the contrary Perkins's text is almost entirely ungendered (and thus implicitly gendered male), except where he equitably urges 'yong men and women ... in silence to heare their betters' (24). Webbe distributes sins of speech among men and women equally: 'It is the *tongue* which breaketh the peace betweene neighbours, giveth shrewd wives sharpe weapons to fight against their husbands, breedes quarrels among servants, and setteth men together by the eares' (28). Although the tongue was 'the first corrupting instrument', it belonged not to Eve alone but to the Serpent, since 'By the *tongue* of the *Serpent* was *Eve* seduced' (8), and to Satan, since 'the Serpent was but the instrument abused by Sathan to deceive man' (77). If this hierarchy of responsiblity in fact inscribes woman as 'the weaker vessel',[9] it also mitigates the dangers of female eloquence by attributing them to both genders. Webbe's tract in fact personifies the tongue as '*a little man*, or rather *member*; not very large, but a great Reacher' (51), who is armed with '*a Sword*; for this very Tong is *a sharpe Sword*' (52). The tongue clearly figures the phallus, not as the *sine qua non* of masculine identity and prowess but as a dangerous fleshly rebel against the rightful reason of the head.[10] Affinati's *Dumbe Divine Speaker* (1605) declares: 'A bad creditour is this tongue with so rich a treasure, as

is the pretious and unvaluable jewell of life: it being a member so voluble, soft, unstable, without boane (which might give it more firmnesse) and hazarding life continuallye to infinite daungers' (19). Modern critics too often assume that male authority is invested in the phallic tongue, and for this reason women are not tolerated when they speak; yet, as a mutinous fleshly member, the tongue is potentially inappropriate in the mouths of men and women. As Webbe puts it, '*hic & haec Homo*, both the *Man* and the *Woman* may be … together guiltie of this crime, and culpable of the cause of this unquietnes' (*Practice of Quietnes* 109).[11]

A corollary of this universalising of unruly speech was a notion of silence as a desirable subjective space for both men and women.[12] In his *Mirrhor Mete for all Mothers, Matrones and Maidens* (1579) Salter recommends that women read '*Erasmus* his golden booke [*Lingua*], the whiche he hath leaft written full of the vices and vertue of the toung' (D3r) to reinforce the lesson of 'nature, that wise woorke woman [who] ordained the toung to bee inclosed as with a hedge within twoo rowes of teeth' (D3v). Erasmus's humanist treatise underwrites Salter's programme of female education, redefining it as less gender-specific than at first appears.[13] Indeed many went further than Erasmus to recommend silence as an antidote to ill speaking: Perkins asserts that 'Wise and godly silence is as excellent a vertue as holy speech' (59), and he also recommends silence as prudent self-containment: 'thou art to conceale thine owne secrets … That which thou wouldest not have knowen, tell no man' (61–2). Webbe writes that 'a property of *Patience is a silent tongue*, when wee are evill spoken of, to make no reply' (177). 'There is no higher philosophie in the world, then to be silent, and know how to restrayne the tongue' (26), declares Affinati. Such writers might also have found ample precedent in the Bible: 'He that hath knowledge, spareth his wordes, and a man of understanding is of an excellent spirit. Even a foole (when he holdeth his peace) is counted wise, and he that stoppeth his lippes, prudent' (Proverbs 17.27–8). Indeed one of the biblical passages frequently used to authorise women's silence (1 Corinthians 14.34: 'Let your women keep silence in the churches: for it is not permitted unto them to speak; but they are commanded to be under obedience') stands in close proximity to another passage recommending masculine silence (1 Corinthians 14.28: 'But if there be no interpreter, let him keep silence in the church; and let him speak to himself, and to God').

Once silence has been endorsed as a strategic strength for both genders, it can no longer be held simply a sign of submissive inferiority.

English emblem books chart the increasing androgyny of silence. Whitney's 1589 emblem 'Silentium' shows a scholar seated before an open book with a pen at his hand (the refuge of his study preparing him for public life), and the motto endorses silence as 'spare' and judicious speech (60); the emblem is perfectly in keeping with traditional notions of masculine silence allied with wisdom, action and rhetoric. However, Wither's 1635 emblem 'In Silentio et Spe' shows a friar in long robes living in '*retyrednesse*', holding a clasped book representing thoughts kept 'within the compasse of [his] breast' and wearing a bridle (73). Wither's representation of male silence in fact resembles less Whitney's careful scholar than his virtuous wife, who remains 'at home' in 'modest' silence while her husband 'goe[s] where he please' (92). Yet Wither's androgynous, silent male is designed to evoke not anxiety but admiration. His emblem provides a visual gloss for a text like George Webbe's *The Practice of Quietnes* (1615), which borrows from Scripture (especially Psalm 39.1) to construct this description of the quiet man: '*A quiet man is a creature made of a milde nature, and true Christian temper, swift to heare, slow to speake, slow to wrath ... His mouth is farre from cursing and bitternesse, kept in as with a bridle, that his mouth should not offend*' (14–15).

Many seventeenth-century conduct books directed at women reflect this androgyny by conflating gendered prescriptions for silence. Richard Brathwait's *English Gentlewoman* (1631), for example, frequently alternates between standard notions of masculine silence as prudence and feminine silence as submission so as to blur and undermine gender distinctions. Brathwait begins his advice to young women with the Ciceronian desideratum: 'Without *Speech* can no society subsist. By it we express what we are, as vessels discover themselves best by their sound.' Predictably enough, however, he soon shifts to an anti-Ciceronian attack on garrulousness: 'That sage Stagirian [Aristotle] debating of the convenience and propriety of discourse before *Alexander*, maintained, that none were to be admitted to *speake* ... but either those that mannaged his warres, or his Philosophers which governed his house'(88). Having established the benefits of silence (and judicious speech) with a strikingly masculine example (lifted directly out of his *English Gentleman* (277), published the

previous year), Brathwait then goes on to gender resistance to this silence as female: 'This Opinion tasted of too much strictnesse (will our *women* say) who assume to themselves a priviledge in arguments of discourse.' After gathering rhetorical momentum from the misogynist topos of women giving 'too free scope to that glibbery member', the tongue, Brathwait launches into a surprisingly gender-neutral exhortation: 'To give liberty to the tongue to utter what it list, is the argument of an indiscreet person' (88). The advice he then gives echoes Plutarch: 'In much *Speech* there can never want sinne, it … leaves some tincture of vainglory, which discovers the proud heart, from whence it proceeded … a well-disposed mind will not speake before it conceive; nor deliver ought by way of expression, till it be prepared by a well-seasoned deliberation' (88–9). This notion of sagacious masculine silence underwrites and subtly reconfigures Brathwait's asser-tion that 'Volubility of tongue' in women is 'grounded on arrogancy of con-ceit' as well as his advice to women to '*observe* rather than *discourse*' (89). Misogynist tropes of feminine silence are elided with notions of masculine prudence. While Brathwait does attempt to contain his rhetorical slippage by qualifying the silence of '*young women*' as 'bashfull' (89) and turning to the safer topic of appropriate speech for women, he never fully recuperates his patriarchal project. 'Silence in a *Woman* is a moving Rhetoricke, win-ning most, when it words it wooeth least', he writes in a standard misogy-nist trope. Yet he follows this with a distinctly gender-neutral observation: 'Now to give *Speech* and *Silence* their distinct attributes or personall Characters: wee may gather their severall tempers by the severall effects derived from them. More shall we see fall into sinne by *Speech* than *Silence*: Yea, whosoever intendeth himselfe to *speake much*, seldome observes the course of doing what is just' (90). Here speech and silence are gendered male, and silence signals judicious sagacity as opposed to the sins of speech.[14] Brathwait's text thus both underwrites and confounds tradi-tional gendered paradigms of silence.

Similarly, in an earlier text, Robert Greene's *Penelope's Web* (1587), masculine paradigms redefine apparently conventional feminine ideals of silence. Penelope paradoxically makes her 'discourse of silence' (220) by delivering a long narrative tale about the virtue of silence to her women. Initially she recommends silence as the cardinal female virtue, 'compre-hending under this word all other vertues' (221). Yet the exempla she

produces are derived not from Pauline or Aristotelian sources but rather from Plutarch's writings on masculine silence. Thus Plutarch's account of male babblers as 'emptie vessels, which give a greater sound than they which are full' (399) is transferred to women in Greene's text (221). And another passage from *De garrulitate* is the source for Penelope's extended metaphor here:

> It seemeth (saith *Bias*) that Nature by fortefying the tongue, would teach how precious and necessarie a vertue silence is: for she hath placed before it the Bulwarke of the teeth, that if it will not obey reason, which being within ought to serve in steade of a bridle to stay it from preve[n]ting the thoughts, we might restraine and chastice such impudent babling by byting. (221)

Here is Plutarch:

> And yet Nature has built about none of our parts so stout a stockade as about the tongue, having placed before it as an outpost the teeth, so that when reason within tightens 'the reins of silence', if the tongue does not obey or restrain itself, we may check its incontinence by biting it till it bleeds. (403)

Greene thus appropriates an overtly *masculine* trope of heroic prudence and resistance – with its recollection of Zeno's Stoic self-mutilation – to express the virtue of *feminine* silence. Far from signalling submission to authority, this silence indicates (according to Caesar) 'a profound wise-dome, a sober and modest thing and full of deepe secrets' (222). Even a text as early as the *Instruction of a Christen Woman* (trans. 1557) anticipates this trend; Juan Luis Vives admonishes all women to follow the example of the Virgin, who 'was but of fewe wordes, but wonderous wyse'; he follows this injunction with an allusion to 'Theano Metapontina *a poet, and a maide excellent cunnynge,* [who] rekened that Silence was the noblest ornament of a woman' (43; emphasis added). When wisdom, knowledge and authorship all coexist with silence, one begins to wonder whether 'scilence' (as it is sometimes spelled during the period, as in the margin of Vives' text) has been conflated by some false etymology with 'science', knowledge or wisdom.

Jacques Du Bosc's *The Compleat Woman* (trans. 1639) exemplifies just how far constructions of feminine silence could depart from submission and still remain contained. In his discussion 'Of Conversation', Du

Bosc begins with a sigh of nostalgia: 'Verily, if we lived yet in the time of that first simplicity, where it was enough but to have a tongue to give content … a genuine playnesse (I confesse) were enough, and prudence were superfluous.' Times have changed, however, and men must exercise discretion:

> But since we are in a cunning age, where it seemes that words, invented to expresse thoughts, serve no more then to hide them handsomly; we must acknowledge that even Innocence it self hath need of a maske, or veile, as well as faces, and that it is no lesse a folly to shew ones heart openly to those who stand alwayes in ambush then to walk naked among armed enemies whom we cannot offend, and from whom we cannot defend our selves. (17)

Du Bosc thus opens his advice to women with a jaundiced air, reflecting the age's deep distrust of speech and its cultivation of silence as necessary protection in a 'cunning age'. Silence, as a 'maske, or veile' in a dangerous world, is so far from the traditional notion of feminine subservience that Du Bosc can recommend it as a moral virtue for women, one of 'the three perfections which *Socrates* desired in his disciples, *Discretion, Silence*, and *Modesty*' (18). While, like Brathwait, Du Bosc genders garrulousness feminine (21), the silence he urges upon women is not submission but wisdom and self-awareness: for 'those who speake so much with others, do never as it were *speake with them selves*, that *they see not their thought*' (19, emphasis added). In the next section he praises silent (gender-neutral) Melancholics who

> always reserve to themselves a privat roome, where to the tempests of Fortune cannot reach. There it is, where the soule retires, to maintaine herself in an eternall serenity; where she gaines an absolute command upon her judgements, and where she solitarily entertaines her self, even in the midst of companies, without interruption of the tumults of the world, to break her rest or silence. (40–1)

Silence as inward truth is conflated with silence as Platonic eloquence: 'though all sciences were in one person, they would all be unprofitable without silence; and in vaine should they learne the Art to speak, if they know not the Art to hold their peace' (19). In the context of an advice book for women, Du Bosc writes a treatise on virtue to which gender is virtually irrelevant.

One might argue, of course, that masculine paradigms of silence are summoned up to dignify and mask the really demeaning prescription of silence for women, and that these are merely retooled weapons in the patriarchal arsenal. But this raises the further question of why so many clearly felt the residual formulation – the 'chastity-silence equation', as Jones puts it (2) – required such elaborate justification. There are at least two possible explanations for this. First, if ideals of feminine silence begin to sound a great deal like masculine ones, it is probably because men were increasingly adopting traditionally feminine virtues such as discretion and modesty, thus elevating them by association. And, as Dubrow observes, 'as many studies of androgyny have indicated, when men are repeatedly portrayed in relation to a state normally gendered female or vice versa, binary gender categories may be challenged as well as, or rather than, asserted' (34). Second, Brathwait's *English Gentlewoman*, 'the first conduct book directed specifically at the female sex' (Fletcher 380) clearly signals an important transitional phase in gender construction. While, as Fletcher observes, the 'ancient scriptural and medical basis' of early modern patriarchy was slowly being replaced by 'a new secular ideology of gender' (283), the well-formulated, Restoration ideology of 'a more fully internalised female personality' (Fletcher 383) had not yet emerged. As the largely negative prescriptions for female silence and submission offered by Scripture were wearing thin, writers were clearly searching for a more secular basis for gender construction – and what came to hand was really based on men. The early seventeenth-century material may thus mark a transitional phase between two modes of gender construction, one based on historical or scriptural difference and the other rooted in essential biological difference (Fletcher 385).

The use of masculine paradigms for women is far from egalitarian, of course: it may well be that the construction of feminine silence as wisdom rather than submission was designed to forestall and contain other, more threatening possibilities that were culturally available. However, once feminine silence is constructed as a subjective rather than subjected space, it can no longer be read in only one way. Current monolithic notions of patriarchal speech enforcing feminine silence may in fact replicate the most extreme misogyny of the period, without taking into account the shifting multivalency of silence and its potential advantages for women. That

unknowableness and prudent self-containment had become something to
which men too aspired thus meant not only that masculine silences might
be gendered female but that feminine silences might take on the active,
present characteristics normally gendered male. Whether because 'peace-
time diminishes the distinction between the sexes' (Woodbridge, *Women*
168) or because the discourse of Protestantism advocated the tradition-
ally feminine virtues of patience and suffering for both men and women
(Mary Beth Rose 123–4), this cross-gendering could produce hybrids of
silence and confound traditional categories. Far from the simple ideal of
feminine submission so tirelessly invoked by the conduct books, women's
silence could be associated both with 'masculine' virtue and with feminine
vice – thus subverting the apparently stable signifiers of morality and of
gender.

 Of course, in the 'dominant' ideology of early modern England, it was
common to try to have it both ways. In many advice books silence is exalted
as a feminine ideal because it is *both* subjection and subjectivity, a marker
of gendered inferiority and of ungendered discretion and wisdom, mirror-
ing what Gouge terms 'a voluntary subjection' (27). In Guazzo's *Civile
Conversation*, for example, Anniball responds to Guazzo's own allusion to
the misogynist proverb 'that three women make a mercat' with this sober
dictum: 'I knowe also that it is commonly sayde, That where is least heart,
is moste tongue. And therefore silence in a woman is greatly commended:
for it setteth her forth muche, and maketh her thought to be verie wise'
(2.69v); later, a woman is told to 'hold her peace' at her husband's chiding,
'for the answere of wise women is scilence' (3, 39). In *A Preparative to
Marriage* (1591) Henry Smith parrots the residual ideal of womanly
silence: 'As it becommeth her to keepe home, so it becommeth her to keep
silence, and alway speake the best of her head', he writes (61). Yet he goes
on to reveal some discomfort with his own hierarchical agenda: 'Therefore
although she be a Wife, yet sometime she must observe the servants lesson,
*Not answering again*e, & hold her peace to keep the peace' (83). The resid-
ual notion of submissive silence comes under strain: the wife should not
really be a servant,[15] he implies, though she may have to act like one. But
in fact the wife's silence is *not* the servant's, however similar they may
appear: the servant's is simple subjection, but the wife's is careful pru-
dence. And such careful prudence is urged on husband and wife alike in

Puritan marriage guides. In *A Bride-bush* (1619) William Whately denounces indiscreet talk in both partners: 'That man and woman are worse natured than the poore curres, that eate the crummes of their table, which must needs be bawling and barking each against other' (78). And if 'reverence [for her husband] doth injoyne the woman silence, when her husband is present' (200), the husband should 'strive with silence so much as is possible, and where it is lawfull to be silent (*viz.* in common weake-nesses and infirmities) to worke their amendment' (166). Similarly, in *A Looking-glasse for Maried Folkes* (1631) Robert Snawsel recommends: 'if your wife commit not such ugly offenses, how much more ought you to keepe silence' (114). Whilst notions of silence are clearly grafted on to a fixed gender hierarchy which mandates indulgent authority in the husband and tactful obedience in the wife, they become indistinguishable in lived experience, as masculine virtues increasingly emulate traditionally feminine ones.

Silence as an ideal of self-containment which draws on both Stoic and Christian doctrine is thus not necessarily subversive. While it may act as a potentially subversive defense against interpretation and appropriation by sanctioning an obfuscation of the self, it may equally endorse a quiet retiredness or conjugal harmony which offers no resistance to hegemonic power. For this reason the subjective space opened up for women by emergent notions of silence was not openly in conflict with residual notions of feminine subservience. However, the pressure on those residual notions could and did reveal itself at those points when feminine silence became a focus for anxiety and defied easy containment.

Silence and (dis)obedience

In *Of Domesticall Duties* (1622) William Gouge declares simply that a woman's 'silence, on the one side implieth a reverend subjection, as on the other side too much speech implieth an usurpation of authoritie' (282). Yet he immediately goes on to qualify and complicate this time-worn dictum. 'Then belike a wife must be alwayes mute before her husband', objects his disputant. 'No such matter,' explains Gouge, 'for silence in that place is not opposed to speech, as if she should not speake at all, but to loquacitie, to talkativenesse, to over-much tatling' (282). Here woman's ideal silence

becomes not absolute, but relative; not literal, but figurative. And Gouge
goes even further to evince suspicion of women who *do* keep silent.
'[S]ilence, as it is opposed to speech, would imply stoutnesse of stomacke,
and stubbornnesse of heart, which is an extreme contrarie to loquacitie'
(282). He develops an antithesis between the silent woman and the
loose-tongued shrew that is no longer a morally polarised one; rather, both
are equally horrifying, if apparently for different reasons. On the one hand
Gouge condemns those women 'who must and will have all the prate. If
their husbands have begun to speake, their slipperie tongues cannot expect
and tarrie till he have done: if (as verie hastie and forward they are to
speake) they prevent not their husbands, they will surely take the tale out
of his mouth before he have done' (282). When one remembers the popu-
lar pun on 'tale' and 'tail',[16] Gouge's horror of the loquacious woman is
clearly linked with castration anxiety. A woman who overindulges 'that
glibbery member', the tongue (Brathwait 88), usurps masculine sexuality
as well as masculine discourse. Satiric abuse directed at talkative women is
thus designed to defuse this threat; as Linda Woodbridge puts it, 'a woman
… cannot take a moral stand without suspecting that her auditors consider
her a scold, cannot hold a simple conversation without wondering whether
she is talking too much' (31). This kind of control through comic stereo-
typing must have been very effective. The silent woman, on the other hand,
is a less accommodating butt for satire. Indeed, if talkative women are seen
as phallic usurpers, silent women occupy a space which has always been
traditionally conceived of as feminine and is thus less easily assaulted. Yet
Gouge and his contemporaries persistently show their discomfort with
feminine silence. 'Stoutnesse of stomacke and stubbornnesse of heart' sug-
gest a recalcitrance which is far removed from the free-flowing prolixity of
the loose-tongued shrew, and perhaps more difficult to control. Even the
enlightened Thomas More requires of a woman that she 'be neither too
talkative nor too silent', and challenges the traditional dictum 'by describ-
ing the silence as "rusticum silentium," a silence of ill-grace and ignorance,
not obedience, that may even indicate that rebellion is fomenting under the
silence' (Benson 159).[17]

 Like Brathwait, William Whately follows his recommendation of
silence for women with the hasty qualifier: 'I meane not an utter absti-
nence from speech, but using fewer words (and those mild and low) not

loud and eager' (*Bride-bush* 200). In a later work he includes both 'talkative' and 'tongue-tied' in a list of vices found in women (*Care-cloth* 44). He maintains also that 'Both good and bad dispositions have more waies of uttering themselves, than by the tongue ... her whole behaviour, with the gestures of her whole body, may proclaime contempt, though her tongue bee altogether silent' (*Bride-bush* 204). And he proceeds to enumerate these offensive gestures: 'To swell and pout, to lowre and scoule, to huffe and puffe, to frowne and fume, to turne the side towards him, and fling away from him, in a mixture of sullennesse and disdaine, be things that doe breake the bridle of feare' (205). Bridling the tongue is not enough, he implies; the bridle must be internalised. The shrew is still a shrew, even when silent; the tongue is simply replaced by the body's whole movement. Better than any contemporary acting manual, Whately here describes a semiotic of performance in which silence is anything but neutral. Contrary to its own agenda of keeping woman and silence in their places, early modern misogyny invests feminine silence with significant power and danger. When Desdemona defends her friend Emilia by pointing out that 'she has no speech' (2.1.106), the misogynistic Iago declares that she 'chides with thinking' (2.1.111). Feminine silence can be constructed as a space of subjective agency which threatens masculine authority.[18]

Of course this construction of feminine silence as resistance to authority has a long classical and scriptural lineage. Brathwait holds up the example of Judith, who 'discomfits a *daring* foe with cautelous silence' (46). Plutarch recounts the story of Laena, a courtesan whose courage in refusing to reveal her fellow conspirators was celebrated in Athens by the erection of a statue of a tongueless lion, 'representing by the spirited courage of the animal Laena's invincible character, and by its tonguelessness her power of silence in keeping a holy secret' (417). Vives follows Plutarch in recounting the tale of 'that womanne of Pythagoras schole and secte, that bit of hyr owne tonge, and spytte out in the face of the tirane that did tourmant hir, least she should bee compelled of necessitie, to tell that shee woulde not' (44). This he offers as an explicit refutation of the misogynist premise that women cannot keep secrets. He goes on to advise women: 'Holde thou thy peace as boldly as other speake in courte: and so shalt thou better defend the matier of thy chastitee, whiche

afore juste judges shall be stronger with silence than with speeche' (43).
If silence can be a woman's weapon against patriarchal authority in the
courts, the reticence which was supposed to guarantee subjection could
clearly signal an independent and defiant mind. 'If thou marriest a still
and a quiet woman, that will seeme to thee that thou ridest but an ambling
horse to hell' (35), remarks the notorious misogynist Joseph Swetnam, in
his *Arraignment of Lewd, Idle, Froward and Unconstant Women* (1615).
Thomas Heywood comments in *Englands Elizabeth* (1630) that 'it may
be said of women in generall, that they are spare in their answeres, and
peremptory in their demands & purposes' (50). And George Webbe wist-
fully recalls a golden age when 'Speech was then rare and precious, and
the tongue could well discerne how to bee silent without sullennesse'
(*Araignment* 6). One can well imagine that silence then, as now, could
provide women with a handy domestic weapon.

Perhaps because of this inherited association with resistance, feminine
silence often becomes a particular source of suspicion in dramatic texts. In
Epicoene, for example, Morose, the comic misogynist who seeks a silent
wife, reveals that not even he can bear too much silence in a woman. In his
first meeting with Epicoene he tests her vow of silence with long speeches
designed to trick her into speaking without reserve; at first she answers him
only with curtsies, but he persists in demanding submissive speech. When
she finally does speak, however, her voice is so low that he cannot hear her,
and is forced to ask her repeatedly to 'rise a note' (2.5.81). The scene's
comedy resides in Morose's inability to get reassurance from the silence he
so values. When, immediately after their marriage, Epicoene turns into a
scolding shrew, feminine silence is revealed to be covert manipulation.
While the play thus justifies male anxieties about women, it also pokes fun
at men who exalt women's silence but underestimate its subversive poten-
tial. That potential is understood and exploited by Shakespeare's Cressida,
who determines to remain silent about her love for Troilus, both to protect
herself and to attract his desire (1.2.272–3). After she does confess her love
to him, she cries regretfully: 'Why have I blabbed? Who shall be true to us,
/ When we are so unsecret to ourselves?' (3.2.113–14). This is a more sym-
pathetic interpretation of feminine reticence, not as deceit but as a neces-
sary refuge in a world of male treachery. Speech allows men to appropriate
women's inner space; silence excludes men even as it attracts them. A

source of anxiety for misogynists, silence may have remained a source of power for women.

To avoid both this dumb-show of disobedience and the dreaded verbal fluency, the dominant ideology of the conduct books recommends for women not silence but carefully circumscribed speech. 'The meane betwixt both [silence and loquacitie]', writes Gouge, 'is for a wife to be sparing in speech, to expect a fit time and just occasion of speech' (282). According to Dod and Cleaver, a wife should be 'not full of words ... that were more fitter to be concealed, but speaking upon good occasion, and that with discretion' (94). In his *English Gentlewoman* (1631) Brathwait advocates a 'seasonable discourse' for women (88), consisting of 'arguments as may best improve your knowledge in household affaires' (89). Whately desires that women should 'suffer the due and reverent esteeme of their husbands, to worke in them a speciall moderation of speech' (*Bride-bush* 203). That a woman's 'silence' should be figurative rather than literal is especially clear from Philip Stubbes's account of his ideal wife Katharine, who 'obeyed the Commandement of the Apostle who biddeth women to be silent', yet 'would most mightily justifie the truth of God against blasphemous untruths and convince them, yea, and confound them by the testimonies of the word of God' (A3v).[19] 'Silence' as it appears in many texts is a code word for women's acquiescence to patriarchal ideology.[20] This ideology often attempts to elide the unruly sign of actual silence to reinscribe women within a universe of male discourse; Ann Rosalind Jones points out that Gouge's 'attention to language is a vivid instance of an early recognition that language *constructs* subjectivity, that the installation of a certain discourse, an institutionalized style of speech, produces the attitudes written into that particular speech' (26). In Sidney's *Astrophel and Stella* a *blazon* carefully aestheticises Stella's silence as a traditional feminine virtue: if Stella's face is 'Queene *Vertue's* Court', then her mouth 'The doore by which sometimes comes forth her Grace, / Red Porphir is, which locke of pearle makes sure' (9.1, 5–6). Yet throughout the sequence it is Stella's speech, 'which wit to wonder ties' (85.11), rather than her silence which is desired – only to be appropriated, distorted or ventriloquised,[21] as in sonnet 63, when Astrophel wilfully misconstrues Stella's double negative as an affirmative. As Foucault maintains, repressive ideologies work by enforcing not silence, but speech.

Silence and (un)chastity

Male anxiety about quiet women may not have been confined to their
potential for rebellion. When regarded favourably by the authors of con-
duct books, women's silences are invariably linked with the preservation of
chastity. In his treatise *On Wifely Duties* Francesco Barbaro writes that 'the
speech of a noble woman can be no less dangerous than the nakedness of
her limbs'(205). In *The Monument of Matrons* Thomas Bentley admon-
ishes, 'There is nothing that becommeth a maid better than sobernes,
silence, shamefastnes, and chastitie, both of bodie and mind. For these
things being lost, shee is no more a maid, but a strumpet in the sight of God'
(Hull 142). But silence, that traditional outward sign of feminine modesty,
could also be just that – an outward sign, a seductive strategy in an age when
marriage was the primary objective of most young girls. In *Haec-Vir*, a
pamphlet of the early modern controversy about the nature of women, the
'man-woman' defends her use of speech by associating feminine silence not
with chastity but with lascivious acquiescence: 'Because I stand not with
my hands on my belly like a baby at Bartholomew Fair ... that am not dumb
when wantons court me, as if, Asslike, I were ready for all burdens ... am I
therefore barbarous or shameless?' (Henderson 284). In *The Taming of the
Shrew* it is Bianca who first attracts, then defies, Lucentio with her silence
(1.1.70; 5.2.80). In Ben Jonson's *Epicoene, or the Silent Woman* (1609)
John Daw tosses off these lamentable verses:

> Silence in woman is like speech in man;
>> Deny't who can.
>> ...
>> Nor is't a tale
> That female vice should be a virtue male,
> Or masculine vice, a female virtue be:
>> You shall it see
>> Proved with increase,
> I know to speak, and she to hold her peace.
>
> (2.3.111–19)

Daw's 'ballad of procreation' (2.3.125) has a bawdy design: he 'would lie
with' Epicoene (1.3.14) and so construes her silence as an open space
ready to be filled up by phallic 'speech' for the purpose of 'increase'. Her

silence he takes for a sign of consent: 'she says nothing, but *consentire videtur*, and in time is *gravida*' (2.3.123–4). But other characters puzzle over why Daw 'desires that she would talk and be free, and commends her silence in verses' (1.3.15–16); they know that, traditionally, silence signifies chastity. The confusion exposes a real ambiguity in early modern texts, which demand that a woman be both inviolable and available, both carefully locked-up treasure and goods for barter in the marriage trade. How could a man expect a woman's silence to signify a closed space – her chastity – if he himself wanted to fill it up? How could he trust that her reticence was anything more than an appropriation of traditional symbolism for the modern purposes of winning a husband?[22]

The conduct books of the late Tudor and early Stuart periods both contribute to and reflect this ambivalence. Their authors urge young women to concentrate not on what others think of them but on their inward being, all the while instructing them on how to comport themselves. In his *English Gentlewoman* Brathwait includes a section entitled 'How *Estimation* may be discerned to be *reall*' (106 margin), in which he exhorts: '*Be indeed what you desire to be thought*. Are you Virgins? dedicate those inward Temples of yours to chastity; abstaine from all corrupt society; inure your hands to workes of piety, your tongues to words of modesty' (106). But his discomfort with having to instruct virgins on how to appear to be virgins soon surfaces in a meditation on the ease of hypocrisy: 'Many desire to appeare most to the *eye*, what they are least in *heart* ... These can enforce a smile, to perswade you of their affability; counterfeit a blush, to paint out their modesty; walke alone, to express their love to privacy' (114). While he struggles valiantly against it, Brathwait's attempt to distinguish '*reall Estimation*' from '*Superficiall Esteeme*' (114) in women is doomed to failure, since both depend on performances of femininity: Brathwait's text is a guide to precisely those signs of 'vertuous demeanour ... In *Gate*, by walking humbly: in *Looke*, by disposing it demurely; in *Speech*, by delivering it moderately; in *Habit*, by attiring your selves modestly' (94). In *A Discourse, of Marriage and Wiving* (1620) Alexander Niccholes begins his chapter 'How to choose a good wife from a bad' with a sigh of despair: 'This undertaking is a matter of some difficulty, for good wives are many times so like unto bad, that they are hardly discerned betwixt, they could not otherwise deceive so many as they doe, for the divell can transforme himselfe into an Angell of Light, the

better to draw others into the chaines of darknesse' (8). Silence in woman
may indeed be the 'ornament' Becon and others claim it is – but in the unin-
tended sense of an outward accretion or decoration which entices and
deceives the eye.

In early modern texts the woman who keeps silence may be not only
commodifying and parleying the traditional sign of chastity, but also risk-
ing or even inviting violation. In denouncing women who attend plays,
John Northbrooke writes in 1577: 'what safeguard of chastity can there be,
where the woman is desired with so many eyes, where so many faces look
upon her, and again she upon so many?' (Cerasano and Wynne-Davies
161). In the public space of the theatre, with its specular economy, silence
offers not protection but exposure and immodest exchange. Similarly, in
Thomas Middleton's *Women Beware Women* Bianca remains conspicu-
ously silent for the first 125 lines of the scene, her silence confirming her
new husband Leantio's exultation in 'that which lies locked up in hidden
virtues, / Like jewels kept in cabinets' (1.1.55–6). Yet Bianca's silent sign
of inward chastity is also paradoxically presented by the vulgar Leantio as
an exhibit open to our gaze: 'here's my masterpiece,' he cries, 'do you now
behold her! / Look on her well, she's mine, look on her better' (1.1.41–2).
Later, when Bianca appears above the stage at a 'window' (2.2.8), Leantio's
metaphor comes to full theatrical life: by being thus 'framed', she becomes
not only available to the male gaze but also a powerfully silent rhetorician,
'winning most, when in words it wooeth least', as Brathwait has it (90). She
has only to appear at the window to cause Leantio's resolve to depart for
work to weaken (1.3.12–20) and, later, to fire the Duke with a 'rapture'
(2.2.9) that culminates in his act of rape. Thus Bianca's silence, which ini-
tially advertises her 'hidden virtues' of marital chastity and obedience
(however they are commodified by Leantio), in fact becomes the powerful
attractive force which assures their ruin. Commenting on Montaigne's
observation that 'according to womens conditions ... inhibition enticeth,
and restraint enviteth', Breitenberg observes:

> From Montaigne's male perspective, the patriarchal 'rules of life prescribed
> to the world' produce an erotic economy based on the valorization of female
> chastity, virginity, modesty, and so on. This economy encourages male con-
> cupiscence and, paradoxically, the desire among women to transgress the
> restriction placed upon them. (130)

Middleton's drama plays out an economy of male desire that is more overtly expressed in narrative poems such as Samuel Daniel's *Complaint of Rosamond* (1592) and Shakespeare's *Rape of Lucrece*. In Daniel's poem Rosamond's silent gaze is powerfully seductive:

> Ah beauty Syren, fayre enchaunting good,
> Sweet silent rethorique of perswading eyes:
> Dombe eloquence, whose powre doth move the blood,
> More then the words, or wisedome of the wise.
>
> (I2v)

In Shakespeare's *Lucrece* the narrator repeats this version of the eloquent silence trope to castigate Collatine for his public advertisement of Lucrece's gifts: 'Beauty itself doth of itself persuade / The eyes of men without an orator' (29–30). The narrator then goes on to ratify Collatine's logic with his own description of Lucrece's wordless blush as a conquering army:

> This silent war of lilies and of roses
> Which Tarquin viewed in her fair face's field
> In their pure ranks his traitor eye encloses,
> Where, lest between them both it should be killed,
> The coward captive vanquished doth yield.
>
> (71–5)

In both poems the woman's silence is constructed as an inviting, coercive force rather than as a barrier to male desire.[23]

Silence as a sign of female chastity is further destabilised when one recalls the common early modern euphemism for the female genitals as 'nothing' – made notorious in Hamlet's obscene remark to Ophelia (3.2.106–9). For, like silence, the 'nothing' which is 'no-thing' (no phallus) is in fact *something*, however hidden it is beneath clothes and folds of flesh.[24] In *1 Henry IV* Kate Percy pleads with Hotspur to 'be still' and listen to the Welsh Lady's song; he replies: 'Neither. – 'tis a woman's fault' (3.1.235–6). While on one level he is simply shunning silent passivity as feminine, his description of silence as a 'fault' in woman both registers cultural anxiety and associates it with the hidden female pudendum (for which 'fault' is a common euphemism; Rubinstein 98).[25] In her discussion of

Othello Karen Newman remarks that 'Desdemona is presented in the play as a sexual subject who hears and desires, and that desire is punished because the nonspecular, or nonphallic, sexuality it displays is frightening and dangerous' (*Fashioning* 86). If the woman's tongue figures the phallus she can never possess, her vagina suggests a mouth without a tongue, engulfing, devouring, consuming – in silence.

The silence which should signal the closed body, the sealed vagina, can thus often represent the secret intimacy of the act itself. Silence frequently shrouds illicit sexual intercourse in the drama, as in *The Revenger's Tragedy* (1607), where 'a dame / Cunning, nails leather hinges to a door / To avoid proclamation' (2.2.139–41), or in *The White Devil*, where Flamineo urges Brachiano and Vittoria to 'Couple together with as deep a silence / As did the Grecians in their wooden horse' (4.2.196–7). Indeed Flamineo glosses Vittoria's retreat into silence before her lover not as chaste closure but as a *lack* of sexual resistance, telling Brachiano: 'A quiet woman / Is a still water under a great bridge. / A man may shoot her safely' (4.2.176–8). Given the obscene double entendre on 'shoot' as 'penetrate sexually', it is clear that the residual meaning of feminine silence as chastity has shifted into its antithesis. Moll Cutpurse in Middleton's *The Roaring Girl* asserts that 'Better had women fall into the hands / Of an act silent than a bragging nothing' (3.1.86–7). Otto van Veen's *Amorum Emblemata* (1608) depicts a winged Cupid with finger to his lips, indicating 'the importance of silence in keeping the secrets of love' (Hallahan 118–19). Far from an unproblematic sign of decorous conformity to the patriarchal will, as most critics claim, silence can – at least potentially – offer space for dangerous subversion.

Thus, while critics frequently conflate the open mouth of the shrew with the open vagina as a threat to male control, in many popular folktales the shrew is relatively harmless or even beneficial, sometimes associated with good huswifery,[26] in contrast to the cuckolding wife who commits her sins in secret.[27] This may explain the proverb cited by J. Howell (1659): 'If you are disposed to marry, marry a shrew rather than a sheep for a fool is fulsome yet ye run risk also in the other, for a shrew may so tie your nose to the grindstone that the grey mare will prove the better horse' (Fletcher 15). If shrews could make hardworking wives, outwardly obedient 'sheep'

could prove 'fulsome' not only as 'cloying, wearisome' companions but also as abundant, copious and uncontrollable wantons. As Fletcher remarks, 'It was a commonplace that women were much closer to nature and the brute creation than men' (72); silence brought them even closer. In the popular *Historie of Euralius and Lucretia*, for example, a fifteenth-century tale by Aeneas Sylvius which ran to five editions between 1500 and 1639, Lucretia is an ideal wife distinguished for her 'modesty and sweetness' (Mish 292) who carries on a torrid secret affair with Euralius without her husband's knowledge. A good deal of the narrative is devoted to the need for silence; her old servant declares: 'Let my mistress love; if her love be secret it cannot but be secure' (311). Euralius in his turn decides that 'Lucretia must not be discovered; she entertained me, she saved me, and my silence is the least reward I can pay her for her fidelity' (319). Moreover the silence surrounding the affair is replicated within it: Euralius vows to Lucretia that 'my pleasure had something in it more copious and significant than language' (321), while she is rendered 'speechless' (332) at their last meeting. If adultery is associated with the woman's silence rather than her shrewishness in this tale, it is probably due both to the demands of the narrative (deferring disclosure) and to the inarticulate space of desire, which, as Catherine Belsey says, 'is the unuttered residue which exceeds any act that would display it' ('Desire's Excess' 93). Such subversive silences rely also on early modern notions of feminine libidinousness, bestiality and hypocrisy.

The gap between the humanist championing of speech (for men, by implication) and the recommendation of silence for women led to discontinuities and outright contradictions in some conduct books. According to Dod and Cleaver, a woman's suitability as a wife can be judged by

> her *Talke* or *speech*, or rather her silence; For a man or a womans talking, is the mirrour and messenger of the minde, in the which it may commonly be seene without, in what case the man or woman is within … Such as the man or woman is, such is their talke.
>
> Now silence is the best Ornament of a woman. (104)[28]

The anxious bachelor can be forgiven some confusion at this point. The authors seem to recommend two mutually exclusive means of evaluating a virtuous woman: she can be discovered as a human individual through her

speech, or revealed as a generic type through her silence. Catherine Belsey argues that silence thus negates the subjectivity briefly accorded to women through speech (*Subject* 179). But the competing discourses may also suggest underlying discomfort with the silence that is so predictably recommended. Whilst silence should ensure subjection, a man must have something to go on in his search for a properly submissive wife: a woman who speaks allows herself to be known, hence controlled; by implication, the silent woman, though conventionally supposed chaste, confounds knowledge and hints at the hidden and perhaps even the bestial. The suppressed, silent connective in the passage, of silence as the dark, anarchic underside of human speech, opens a space for the potential subversiveness of women's silence.

Feminine silence is in fact associated with dangerous bestiality in some contemporary medical texts. Edward Jorden's treatise entitled *A Briefe Discourse of a Disease Called the Suffocation of the Mother* (1603), for example, describes the symptoms of female hysteria as '*suffocation* in the throate, croaking of Frogges, hissing of Snakes, crowing of Cockes, barking of Dogges, garring of Crowes, frenzies, convulsions, hickockes, laughing, singing, weeping, crying' (2r). The suffocation allegedly caused by the rising of the womb could and apparently did also lead to speechlessness; he later explains that 'the voice is taken away, because the matter of it which is breath, is either not sufficiently made, or is carried another way, or not competently impelled to the organs of voyce' (8r). Denied the faculty of speech, hysterical women emitted bestial noises, or remained mute. Since the cause of hysteria was thought to be the womb's retention of superfluities (such as blood and 'sperma') normally shed by sexual intercourse and regular menstruation, such involuntary silence was associated with unmanageable female sexuality, and could be accompanied by all the symptoms of desire (such as quick, uneven pulse and swooning (9r). Furthermore, the most overt demonisation of female sexuality, the witch, while commonly believed to be 'of a slippery tongue, and full of words' (Roberts 43), was also associated with silence. 'In such a deformed silence, witches whisper / Their charms' (3.3.58–9), observes Delio in Webster's *The Duchess of Malfi*. Reginald Scot, in arguing that the confessions of women tried for witchcraft were extorted by torture, asks:

how can she in the middest of such horrible tortures and torments, promise unto hir selfe constancie; or forbeare to confesse anie thing? Or what availeth it hir, to persevere in the deniall of such matters, as are laid to her charge unjustlie; when on the one side there is never anie end of hir torments; on the other side, if she continue in hir assertion, *they saie she hath charmes for taciturnitie or silence*? (21; emphasis added)

The witch was the dark sister of the mutely inspired prophetess. Anna Trapnel knew that her silence would convict her of witchcraft: 'The report was, that I would discover myself to be a witch when I came before the justices, by having never a word to answer for myself; for it used to be so among the witches' (cited Hobby 35). Female visionaries such as Trapnel, who proliferated during the Interregnum and were often arraigned as witches, were 'invariably described, paradoxically, as dumb' (Mack 32). Arise Evans's 1653 account of Elinor Channel's visions, for example, foregrounds her mystical silence: 'when she is dumb, all her senses are taken up, and then the matter which troubles her mind, is dictated and made plain to her by the spirit of God' (cited Mack 32).[29] Such divinely inspired silences – especially among Quakers – were in the eyes of the authorities inseparable from politically dangerous silences. That both were frequently associated with witches, hysterics and prophetesses certainly had profound implications for traditional notions of feminine silence as chaste and obedient.

Feminine silence, then, is in Brathwait's phrase 'a moving Rhetoricke', a signifier which slides unmanageably from chastity to desire, obedience to defiance. While there is no doubt that there were women in early modern England who were simply silenced – either by a scold's bridle or by an internalised fear of authority – we should be wary of replicating that silence by ignoring the multiple and mobile possibilities inscribed in feminine reticence. When women keep their silence they occupy a space defined by contrary male impulses of fear and desire. Enjoined to remain mute as a sign of chastity and obedience to allay male fears, the early modern woman may at the same time provoke those fears by becoming either unfathomable or openly resistant. On the one hand the shifting multiplicity of referents for women's silences meant that people, especially men, could interpret them for their own ends: Iago seizes on Bianca's silence in the final act of *Othello* as proof of her guilt (5.1.106-12), whilst Paulina relies on the

newborn Perdita's silence to signify her 'pure innocence' before Leontes (*Winter's Tale* 2.2.44); Pheroras in Elizabeth Cary's *Mariam* claims that 'silence is a sign of discontent' (2.1.42), whilst De Flores in *The Changeling* assures the woman he is about to rape that 'silence is one of pleasure's best receipts' (3.4.167). Silence leaves women, perhaps more than men, open to manipulation. As Harvey writes of the silent hysteric, 'Her "voice" and special propensity for language is transformed into a kind of somatic dumb-show, making her particularly dependent upon the men who must translate her bodily signs into language' (66). On the other hand women's speech is firmly circumscribed by early modern convention: vehemence becomes shrewishness, prolixity sexual wantonness. Desdemona's verbal barrage on Cassio's behalf confirms Othello's suspicions of her promiscuity; Bianca's silence confirms her guilt. There seems to be no way out for women: speaking, they are shrews or whores; silent, they are blanks to be inscribed by others.

Much recent feminist criticism has simply registered this impasse: for Kate McLuskie, too often 'feminist criticism ... is restricted to exposing its own exclusion from the text' (97); for Belsey, early modern women are denied a 'single, unified, fixed position from which to speak' and thus cannot be autonomous subjects (*Subject* 160). Yet Goldberg points out that 'It is not necessarily a sign of power to have a voice, not necessarily a sign of subjection to lose it' ('Shakespearean' 130). Whilst it has become a battle cry for many feminists that women must 'break out of the snare of silence' (Cixous, 'Laugh' 251) because 'silence is the mark of hysteria. The great hysterics have lost speech ... They are decapitated, their tongues are cut off and what talks isn't heard because it's the body that talks, and man does-n't hear the body' (Cixous, 'Castration' 49), other feminists think differ-ently. 'The silence in women is such that anything that falls into it has an enormous reverberation', writes Marguerite Duras; 'Whereas in men, this silence no longer exists' (175). Early modern conduct books expose the cracks and fissures in the man-made fortress of women's silence. In the drama silence that is both prohibition and subversion can open up new space for women because, on the stage — to borrow from Hélène Cixous — 'it's the body that talks'. Yet equally useful for women is the fact that, given its multiple signifiers, the language of the silent body is often beyond simple translation.

Notes

1 Katharine Maus touches on this double standard when discussing male appro-
priation of the female womb as a metaphor for inwardness: 'The very unreadabil-
ity that seems so attractive in one's (male) self seems sinister in others; one man's
privacy is another woman's unreliability' (192–3). Linda Woodbridge also notes
a double standard in the early modern gendering of speech acts: 'Male characters
in Renaissance literature scold fairly frequently, but characteristic diction excuses
male scolding (which is dignified by titles like "exhortation" and "oratory") and
condemns female scolding' (208).

2 Wayne Rebhorn notes the frequency of this image in descriptions of the *rhetor* and
finds: 'Equally suggestive of the sexual nature of the orator's eloquence are the fre-
quent images of it as flowing liquid that fills up the auditor' (*Emperor* 155). He
thus connects rhetoric with ravishment. More significantly for this discussion,
Rebhorn notes that the imagery of flowing liquid associated with male speech is
in fact ambiguously gendered: 'the flowing forth of the rhetor can be read not just
as an image of insemination but as one of birth, so that the water imagery, which
earlier seemed to "save" rhetoric as a masculine activity, actually allows for a read-
ing that makes it, if not exclusively feminine, at least sexually indeterminate'
(*Emperor* 174).

3 Masculine rhetoric was haunted by the spectre of effeminacy. Patricia Parker
points to 'the anxieties of effeminacy which attended any man whose province was
the art of words' ('On the Tongue' 445–6), and Rebhorn discusses at length 'the
notion of rhetoric as an enticing, wanton, deceptive woman' (*Emperor* 140). Linda
Woodbridge exhaustively catalogues misogynist references to female garrulity in
early modern drama (*Women* 207–11).

4 An important context here is the heated contemporary conflict over competing
definitions of masculinity as rhetorical and Orphic or as military and Herculean
(Wells 25–8). This early modern quarrel over the meaning of manhood relied on
fundamental distinctions between 'rhetorical and physical forms of persuasion'
(Wells 27). Whilst Peacham and other humanists appropriated military metaphors
to masculinize rhetoric, they were more likely than the chivalric ethos with its
'unequivocally masculine' honour code to accommodate traditionally 'feminine'
values (Wells 15).

5 The Pythagorean table of opposites is cited by Aristotle in the *Metaphysics* (I.v.6):
'Others of this same school hold that there are ten principles, which they enunci-
ate in a series of corresponding pairs: (i) Limit and the Unlimited; (ii) Odd and
Even; (iii) Unity and Plurality; (iv) Right and Left; (v) Male and Female; (vi) Rest
and Motion; (vii) Straight and Crooked; (viii) Light and Darkness; (ix) Good and
Evil; (x) Square and Oblong.' Patricia Parker comments: 'Binary opposition –
including the opposition of male and female – is, as this table from the sixth

century B.C. makes clear, by no means the invention of some recent structuralism, and its reiteration within Aristotle's text gave to such theories of sexual difference an extraordinarily tenacious influence' (*Literary* 181).

6 Androgyny, defined in the *OED* as the 'union of sexes in one individual', is the result of a process described by Patricia Parker as 'gender crossing' ('On the Tongue') and by Dubrow as 'gender elision' (289) – the borrowing by one gender of characteristics associated with the other. There have been many treatments of androgyny in recent scholarship, many of them focused on the transvestite theatre or on the real-life crossdressing controversy (see, for example, Howard). They have ranged from discussions of early modern notions that 'all bodies contain both male and female elements' based on their homologous structures (Greenblatt 'Fiction' 77) to discussions of the ambiguity of the androgyne, perceived as on the one hand 'an image of transcendence' and on the other 'an image of monstrous deformity' (Rackin, 'Androgyny' 29). Whilst scholars have generally agreed that early modern gender boundaries were markedly shifting and unstable (Howard 425), they have frequently disagreed about the implications of androgyny – some emphasising its liberating potential (Dubrow) and some arguing that it led to anxiety and compensatory rigidity (Levine).

7 The residual ideology surviving alongside Christian humanism can be identified largely with a native medieval tradition: M. C. Bradbrook points out that the shrew's role is 'the oldest and indeed the only native comic role for women' (134), and Katharine Rogers claims that 'the favourite attack on women in the middle ages was for insubordination – disobedience, scolding, verbal or physical resistance, struggling for the mastery – no doubt because patriarchy was still so strong in Church teaching and social practice' (93). It is clear that this residual ideology was still thriving in early modern popular culture. Many historians have documented an 'increase [in early modern England] in instances of crime defined as exclusively female: "scolding", "witchcraft", and "whoring"' (Boose 244). This gendering of discursive evil was nowhere more evident than in the cultural practice of bridling female scolds Boose describes. It is worth noting, however, that two of the instances of bridling she cites as evidence for the practice are in fact male: Tamburlaine's threat to bridle Orcanes and the three Egyptian kings who defy him; and the bridling of Swetnam by women in *Swetnam the Woman-hater Arraigned by Women* (1620) (Boose 259). One might add to these the torture meted out to the lecherous Duke in *The Revenger's Tragedy* (1607), when Vindice instructs his brother: 'with thy dagger / Nail down his tongue' (3.5.192-3). Such instances should attenuate claims that all experiences of enforced silence were female.

8 Patricia Parker concedes *Lingua*'s 'resistance at one level to the gender stereotyping closest to mind – the tradition of garrulity as a disease associated with women', yet she maintains its 'reinscription of a version of this gendering in regard to language and the art of words' ('On the Tongue' 446). Whilst Erasmus does

claim that 'Women are more inclined to the affliction of talkativeness than men', he goes on to group garrulous women with servants, young and old men, and barbers, all of whom are guilty of 'idleness' ('Lingua' 377). His occasional reliance on the gender stereotype of female garrulousness to critique male behaviour should not obscure the fact that *Lingua* is, as Parker points out, 'a conduct book for the male rather than the female tongue' (449).

9 The description of woman as the 'weaker vessel' originated in William Tyndale's 1526 translation of the New Testament (1 Peter 3.7) and recurs in *An Homily of the State of Matrimony* (1562), a text which was read at every marriage service and thus heard by almost every early modern woman (Aughterson 23). In *A Mouzell for Melastomus* (1617) Rachel Speght uses the notion of woman as a 'weaker vessel' to excuse Eve's transgression: 'Sathan first assailed the woman, because where the hedge is lowest, most easie it is to get over, and she being the weaker vessell was with more facility to be seduced' (14).

10 Phyllis Rackin points to historical difference in the construction of masculinity: 'Valuing sexual passion, the popular wisdom of contemporary culture associates it with the more valued gender, assuming that men feel it more often and more strongly. Despising lust as a mark of weakness and degradation, Renaissance thought gendered it feminine ... and regarded excessive lust in men as a mark of effeminacy' ('Historical' 47).

11 Anthony Fletcher claims that 'George Webb's *The Araignment of an Unruly Tongue* ... was not explicitly an attack on women but there is little doubt that ... he had women principally in mind' (15). Fletcher's claim provides evidence not of Webbe's misogynist agenda but rather of the danger of approaching all early modern texts with *a priori* assumptions about their content.

12 My argument differs from that of Ann Rosalind Jones, who concurs with Ruth Kelso's theory that 'male intellectuals leaving the monasteries to become tutors, advisors, and ambassadors to noble families, rising clans, and new political bureaucracies compensated for their engagement in the emergent secular world by immuring women more firmly in the household, a conceptual sphere in which residual virtues such as piety, chastity, silence, and withdrawal from the world were rewritten as specifically feminine qualities' (Jones 11).

13 Patricia Parker points to a reference to Erasmus's '*golden booke ... concerning the vices and the vertues of the tongue*' in *The Necessarie, Fit and Convenient Education of a Young Gentlewoman* (1598), and claims this as evidence for her argument that *Lingua* was 'read with particular reference to women' (461; 452) and thus understood to be primarily gendered feminine, even with reference to men. I claim, by contrast, that the writing of feminine conduct within the larger context of male humanist discourse reconfigured it. If Parker focuses on 'the inhabiting of male discourse with this unruly "female" trait [of garrulousness]' (452), I wish to emphasise the inhabiting of female 'silence, chastity and obedience' (452) with the humanist discourse of self-contained wisdom.

14 Jones also notes that 'Brathwaite concludes with a fiercely elaborate metaphor, rewriting a Homeric formula (men's teeth as fences against angry speech) by invoking women's teeth as a constraint on their natural garrulity' (25). She assumes, however, that the Homer is simply pressed into service for misogynist purposes, and does not remark on what I see as a conflation of gendered prescriptions for silence.

15 According to Robert Cleaver, 'all in the family are not to be governed alike. There is one rule to govern the wife by, another for children, another for servants' (cited Amussen 38).

16 The *tail/tale* pun lurks beneath the sexually obsessive Ferdinand's speech to the Duchess in Webster's *Duchess of Malfi*: 'What cannot a neat knave with a smooth tale / Make a woman believe?' (1.1.339–40). And in the same scene Ferdinand implicitly links the tongue with the penis: 'And women like that part which, like the lamprey, / Hath ne'er a bone in't' (1.1.336–7).

17 Benson unaccountably sees this as a sign of More's progressive attitude to women's education.

18 After completing this book, I became aware of two other works which hint at some of my concerns here. In her essay 'Lessons of the "Schoole of wisedome"' Gwynne Kennedy cites Gouge and Whately, and notes that 'Renaissance marriage texts express some anxiety about a wife's silence, for it can be read as a potentially subversive act of resistance' (116). In *Self-speaking* Richard Hillman also notes 'the destabilizing menace of female silence' and cites several instances of 'such menace lurking beneath the standard assumption of silence's desirability' (241).

19 Of course even this generally permitted form of women's speech could be forbidden in some texts. In *An Apologie for Women* (1609) William Heale writes testily: 'I could never approve those too too holy wome[n]-gospellers, who weare their testament at their apron-strings, and wil weekely catechize their husbands, citing places, clearing difficulties, & preaching holy sermons too, if the spirit of their devotion move them. For sure I am, antiquity held silence to be a woma[n]s chiefest eloque[n]ce, & thought it their part to heare more the[n] to speake, to learne rather then to teach' (35–6).

20 In a letter to her husband (undated, but probably written some time between 1604 and 1607) Maria Thynne writes: 'My best Thomken I know thow wilt say (receiving 2 letters in a daye from me) that I have tryed the vertue of Aspen leaves under my tounge, which makes me prattle so much; but consyder that all is busines, for of my owne naturall dispossission I assure thee ther ys not a more silent woman living than my selfe' (Trill *et al*. 79). For Thynne her silence is a figurative rather than a literal virtue which she reconciles quite easily with chattiness in the letters.

21 This view of *Astrophel and Stella* has been frequently expressed: Maureen Quilligan, for example, points out that 'it is the author's total control over Stella as a (silent) character in his plot which enacts his masculine, social mastery' ('Sidney' 185).

22 Catherine Belsey notes that John Philip's early *Play of Patient Grissell* (1558–61) shows simply 'the good example of her pacience towards her husband', whilst the much later version of the story, *The Ancient, True, and Admirable History of Patient Grisel* (1619) displays '"How Maides, by Her Example, In Their Good Behaviour, May Marrie Rich Husbands"' (*Subject* 167).

23 Remarking on the same trope, Mary Ellen Lamb cites a passage from Sidney's *New Arcadia* describing the modest Parthenia on her wedding day: 'Her lips though they were kept close with modest silence, yet with a pretty kind of natural swelling they seemed to invite the guests that looked on them' (109). She comments: 'Paradoxically, silence, which prevents the supposedly overwhelming sexuality of women's speech from endangering their reputations, is presented as itself a means for attracting sexual attention' (90). However, Lamb views silence as sexualised primarily because of its potential as speech: 'Speech and silence, sensual and chaste: the boundaries between these opposites have become so tenuous that they come to imply each other' (91). A similar passing remark is made by Margaret Ferguson, in her discussion of the figure of Graphina in *The Tragedie of Mariam*: 'The strange little scene queries the logic of the "chaste, silent and obedient" topos by suggesting first that womanly "silence" may function just as erotically as speech in a nonmarital relation (the conduct books never consider this possibility)' ('Running On' 47).

24 In his essay 'Shakespeare's Nothing' David Willbern explores the semantic richness of 'nothing' in Shakespeare, and notes its association it with both womb and genitals. He finds a 'hidden genital significance' lurking even beneath Cordelia's 'nothing' (246), and calls her 'the queen of silence' (247). Citing an erotic poem in a manuscript collection, Ian Moulton remarks that it 'explicitly rejects the notion, fashionable in many circles in more recent periods, that it [the vagina] is an absence, a lack – mere emptiness: "well what it is I cannot guess / but well I wott some thinge it is"' (51).

25 David Bevington proposes that 'Hotspur is perhaps being ironic in averring that silence is a woman's weakness' (*Henry IV* 220n.). Yet 'fault' is surely an unusual and overdetermined choice of words here.

26 Fletcher cites J. Ray's *Collection of English Proverbs* (1670): 'commonly shrews are good housewives' (4).

27 I am indebted here to an unpublished paper by Louis A. De Catur, who writes of early modern popular fiction: 'The scolds are described in harsh, "unfeminine" terms and are physically and psychologically offensive to their husbands, mostly because their scolding is public, not private. The men experience the embarrassment of being married to a woman whom they cannot control. The cuckolding wives are frequently the opposite of the scolds in that they appear to be acquiescent to their husbands' wishes, but secretly betray the males in ways that strike at the core of their maleness' ('Scolds and Griseldas in Popular Fiction: Two Fishwives' Variants of the Patient Griselda Story', paper presented to the Shakespeare Association of America conference, Chicago, Illinois, March 1995).

28 It is worth pointing out that this formulation does not originate with Dod and Cleaver's work; Henry Smith's *Preparative to Mariage* (1591) makes almost identical assertions: 'The third signe is her speach, or rather her silence; for the orname[n]t of a woman is silence … The eye and the speach are the mindes Glasses; *for out of the abundance of the heart* (saith Christ) *the mouth speaketh*: as though by the speach we might know what aboundeth in the heart' (38–9). Of course early modern conduct books borrowed liberally from their predecessors.

29 In a useful discussion of Elinor Channel's silences Hilary Hinds notes, 'questions of power, silence and utterance are not straightforward here; there are no simple binary oppositions between power and its absence, speech and silence. Silence is productive of Channel's discourse, her dumbness "empowering" her to speak as its lack had constrained her' (74).

3 Silence and drama

Because it is dynamic and interactive, the early modern drama is a particularly fertile site for an exploration of silence. On the stage we see silence in action, embodied by the actor and framed reactively by his onstage and off-stage audiences. Actors on stage were frequently silent: according to R.M.'s *Micrologia*, a player 'may stand one while for a king, another while for a beggar, *many times as a mute or cipher*' (cited Bruce Smith 278–9; emphasis added). Whilst the background silences of some clearly set off the rhetorical delivery of others, in a theatre characterised by rapid delivery and dense verbal texture, in which 'Speech was almost non-stop', pauses and silences could also be highly obtrusive (Gurr 161) and range from a skipped beat in a half-line of verse to a lengthy dumb-show. Smith points out that 'As a mimesis of real-life speech situations, theater ... resembles conversation' (269), and just as silence in conversation might serve as either a necessary counterpoint or a potential threat to speech,[1] so silence in the theatre could go virtually unnoticed or evoke powerful anxiety.

Moments of silence in the theatre may also provide unique opportunities for audiences and actors to share the same auditory space; at such moments the stage mirrors the silent audience back to itself.[2] If, as Smith argues, medieval plays which impose silence on audiences as a sign of submission (271–4) gradually give way to early modern experiments in 'decenter[ing] the aural field' by allowing multiple speakers to compete for auditory attention (276), then silences in early modern performances may well have offered a further, radical decentring, especially when they were subject to variant readings on the stage. If a medieval audience was accustomed to accepting its own silence (like that of the subjects of God or King) as acquiescence to the play's auditory – and political – dominion (Smith 273–4), then an early modern audience saw its own muteness represented more often than not in the silent, subversive energies of a Cordelia or a Bolingbroke. And, if the medieval prototype for silent resistance was

invariably the doctrinally secure figure of Christ himself (as in the York *Crucifixion*),[3] the early modern stage offered an array of secular figures whose silences were open to a variety of conflicting – and often partial or inadequate – interpretations.

If early modern culture moved away from an investment in speech to a validation of silent inaccessible spaces, this ideological shift paradoxically found its perfect expression in the public theatres so popular at this time. For in the theatre verbal utterance is always potentially in tension with silence – or with what Keir Elam calls 'kinesic components of performance – movements, gestures, facial expressions, postures, etc.' (69).[4] In Elam's view 'The performance text … is characterized by its semiotic thickness or density, by its heterogeneity and by the spatial and temporal discontinuity of its levels. It is, at the same time, a highly *ambiguous* text, being at every point semantically "over-determined"' (46). The silent dimensions of performance – the actor's body moving in and through space separate from, even if accompanied by, speech – contribute largely to this semantic thickness and ambiguity. The theatre is always a 'semiotic' and bodily experience – for actors and audience alike – and as such it invariably challenges the symbolic order of language. And, whilst conventionalised stage gestures derived from oratory (such as those catalogued in Bulwer's manual for the deaf, *Chirologia* (1644)) may function discursively as substitutes for speech and thus reduce the ambiguity of the language of gesture, these were 'openly condemned as old-fashioned' by 1600, giving way to a 'relatively new art of individual characterisation' (Gurr 99; 98). The gradual disappearance of conventionalised gesture coincided with the turn to inscrutable inwardness, and silent stage action – designed to convey 'the nature of the person personated' (Heywood, cited Gurr 98) rather than generic emotion – was very likely far more difficult to simplify and decode than it had been in the past. In early modern England, Maus observes, 'theater [was] an art of incompletion: a form of display that flaunts the limits of display' (210). The actor who retreated into silence could render himself inaccessible and inscrutable.

The sign systems of the theatre, while determined to some extent by conventional codes, are none the less firmly embedded in the larger signifying practices of culture (Elam 52). In Paster's words 'the actor's body, embodying fictional characters and moving through the narrative *duree* of mimetic action, can function as a somatic locus of collective social

identification, interrogation, reinscription, or change' ('Unspeakable' 64). The first two chapters argued that the value and qualities of silence for both men and women were disputed, changing and open to interpretation in early modern England; this chapter will explore their shifting inscription on the body of the actor. As the inherited and ancient notion of silence as a form of eloquence was clearly still active, though largely only for men, it contended with growing alternative constructions of silence as private, inscrutable, resistant to interpretation, and even bestial and dangerous. Shakespeare's *Richard II* and Kyd's *The Spanish Tragedy* illustrate the growing range of possibilities. At the same time silence which began to suggest an antirhetorical, private space threatened traditional gender distinctions codified in Aristotle's *Politics* (masculine eloquence versus feminine silence) and frequently reiterated in early modern conduct books. The resulting potential for androgyny prompted anxiety about and interrogation of gendered norms of behaviour, and both tendencies are manifest in a range of early modern plays from *King Lear* to *Coriolanus*.

Because cultural shifts and changes are neither tidy nor chronological, and thus 'a multitude of justifiable positions [are] available within a cultural moment' (Matchinske 13), a single play may contain a wide range of constructions of silence, and gender these in complex and overlapping ways. The following illustrations are intended to be suggestive rather than exhaustive; because institutional practices have established Shakespeare as the 'gold standard' for critics, they are largely, though not exclusively, drawn from his plays. On the one hand, as Elizabeth Hanson points out, this 'ongoing, reflexive Shakespeare-centrism is unjustifiable in a criticism that purports to explicate the culture of early modern England rather than just its highest aesthetic achievements' (77). On the other, as Karen Newman argues, 'the new historicist, cultural materialist or feminist turn to Shakespeare allows the contemporary critic working in the early modern period to be read' ('Cultural Capital's' 100). While the following discussion draws also on plays by Kyd, Marston, Webster and Middleton, its extended treatment of Shakespearean drama aims not merely to provide illustrations from the most familiar and accessible sources but also – and more importantly – to defamiliarise the familiar by re-examining its multiple texts and contexts in the light of the 'moving Rhetoricke' of silence.

Staging impotent/eloquent silence

Shakespeare's early tragedy, *Richard II*, is set in a medieval world of cere-
monial forms already archaic and obsolete in the late sixteenth century.
Fittingly, this old-fashioned play illustrates the two *rhetorical* construc-
tions of silence (as impotence and as eloquence) outlined in Chapter 1 so
well that it can almost be allegorised as the defeat of Ciceronian oratorical
eloquence by the more Machiavellian Attic style. It is significant that, in one
of his first speeches in Shakespeare's *Richard II*, Henry Bolingbroke
alludes to the story of Zeno biting out his own tongue, for the Stoic style
will later distinguish him from his adversary. To the King's suggestion that
he retreat from the challenge he has presented to Mowbray, Bolingbroke
replies indignantly:

> Ere my tongue
> Shall wound my honour with such feeble wrong,
> Or sound so base a parle, my teeth shall tear
> The slavish motive of recanting fear,
> And spit it bleeding in his high disgrace,
> Where shame doth harbour, even in Mowbray's face.
>
> (1.1.190–95)

In this highly rhetorical speech Bolingbroke appropriates the Stoic silence
trope to formulate his defiance. It is a fitting beginning to a play in which
the new order enshrined in Bolingbroke is distinguished by its contempt
for the 'tongue' that is so vital to the old one. While Mowbray contemplates
his banishment as a 'speechless death, / Which robs [his] tongue from
breathing native breath' (1.3.166–7), and John of Gaunt trusts in 'the
tongues of dying men' to 'Enforce attention like deep harmony' (2.1.5–6),
Bolingbroke becomes the 'silent King' (4.1.280) whose power is directly
related to his speechlessness.

As a synecdoche for will and power, the tongue is obsessively present
in the discourse of Richard and his followers. The 'word' (1.3.208) is the
source of Richard's power, as Bolingbroke points out – 'such is the breath
of kings' (1.3.208). When Gaunt dies Richard is told that 'His tongue is
now a stringless instrument' (2.1.150). The Queen can conceive of silence
only as oppression: 'O, I am pressed to death through want of speaking!'

(3.4.73), she exclaims after eavesdropping on the gardeners. Richard himself imagines 'a lurking adder, / Whose double tongue may with a mortal touch / Throw death upon' his enemies (3.2.20–2), an appropriate vision of revenge for a man who is as invested in rhetoric as in the divinity of kingship. Yet, as Gaunt points out, Richard himself is susceptible to flattery's 'Lascivious metres to whose venom sound / The open ear of youth doth always listen' (2.1.19–20). The tongue – speech itself – is as infected as the power it figures.

The alternative source of power in *Richard II* is, of course, silence. Initially the rebels find in their silence only enforced oppression and powerlessness: 'My heart is great, but it must break with silence / Ere't be disburdened with a liberal tongue' (2.1.229–30), cries Ross to his discontented compatriots. Ironically it is Aumerle, loyal to Richard, who first articulates the subversive potential of silence. Returning from delivering Bolingbroke to his banishment, Aumerle responds thus to Richard's query 'What said our cousin when you parted with him?':

> 'Farewell.' And for my heart disdained that my tongue
> Should so profane the word, that taught me craft
> To counterfeit oppression of such grief
> That words seemed buried in my sorrow's grave.
> (1.4.11–14)

As Richard's follower, Aumerle appropriately justifies his silence by exalting the sacred alliance between tongue and word. At the same time, however, he points to its subversive potential as 'craft' (or, as Wright would say, 'prudence and policie'). Silence is potentially subversive because of its multivalency – what Bolingbroke is encouraged to take for grief, Aumerle redefines as contempt. Bolingbroke himself exploits the instability of silence: initially his silence apes proper submission to the monarch (3.3.188–99), but quickly becomes a readable and stable sign of his ascendancy over the voluble Richard.

Like Ross, Bolingbroke at first draws loosely on the Senecan tag *'Curae leves loquntur, ingentes stupent'* to construct his silence as the impotence of grief. 'O, to what purpose doth thou hoard thy words[?]' (1.3.241), asks Gaunt of his taciturn son. 'I have too few to take my leave of you,' he tells his father, 'When the tongue's office should be prodigal /

To breathe the abundant dolour of the heart' (1.3.244–6). The silence that is here constructed as a deficiency of language (according to the Ciceronian paradigm) becomes later a source of eloquence, however, when Bolingbroke suggests that his army march silently before Richard, 'without the noise of threat'ning drum' (3.3.50). As Rebhorn points out, 'A show that *persuades* without any need for words at all, it is far more powerful than the non-existent legion of troops that Richard earlier insisted the king's *name* alone could call forth to fight on his side … the silent display of physical force often constitutes a far more potent rhetoric' (*Emperor* 57). After his long speech at the beginning of the deposition scene (3.3.30–60), Bolingbroke speaks only rarely, and then chiefly in single-line questions or commands; Richard insistently narrates his own fall in a bid for power that is above all rhetorical, yet he is doomed with his 'own tongue' to 'deny [his] sacred state' (4.1.199). Bolingbroke, on the other hand, remains a silent stage presence who understands the 'excellent dumb discourse' of visual images, and conforms to advice offered by Guazzo: 'It is muche in my opinion to keepe a certaine majestie in the jesture, which speaketh as it were by using silence, and constraineth as it were by way of commaundement the hearers, to have it in admiration and reverence' (130). 'Fetch hither Richard,' he commands, 'that in common view / He may surrender. So we shall proceed / Without suspicion' (4.1.146–8). His anti-Ciceronian style illustrates perfectly the accommodation of silence (both literal and figurative) to a non-verbal form of rhetorical power. In this respect Richard's reticent successor uncannily anticipated Elizabeth's; Jonathan Goldberg points out that King James, during his coronation procession, 'never said a word. Power lay in the withholding of utterance, the staging of the self as a spectacle unfathomable because inaccessible' (*James I* 134).

The relation between the silence / eloquence trope and power is illuminated from a different point of view in *A Midsummer Night's Dream*. There Theseus gives a beneficent account of an anonymous subject's unexpected silence:

> Where I have come, great clerks have purposed
> To greet me with premeditated welcomes,
> Where I have seen them shiver and look pale,
> Make periods in the midst of sentences,

> Throttle their practised accent in their fears,
> And in conclusion dumbly have broke off,
> Not paying me a welcome. Trust me, sweet,
> Out of this silence yet I picked a welcome,
> And in the modesty of fearful duty
> I read as much as from the rattling tongue
> Of saucy and audacious eloquence.
>
> (5.1.93–103)

Theseus's charitable construction of his subject's silence as 'the modesty of fearful duty' (echoing the injunctions of conduct books to wives) suggests the stability of signs in a secure social hierarchy; the monarch, God's deputy, can 'read' the transparent fearful and obedient inwardness of his subjects, to which silence bears eloquent witness. Similarly, Thomas Wright remarks that 'superiours may learn to conjecture the affections of their subjectes mindes, by a silent speech pronounced in their very countenances' (29). As in Plutarch's *De garrulitate*, Theseus assumes that the subject's silence is not a refusal of speech – that 'most pleasant and human of social ties' (Plutarch 411) – but a more authentic alternative to it. The subject's silence, appropriate to his subordinate position, is also a welcome alternative to the 'saucy and audacious eloquence' of the upwardly mobile and rhetorically adept Elizabethan courtier. In both *Richard II* and *A Midsummer Night's Dream*, the monarch has the power both to interpret and to manipulate silences to reinforce his own authority.

Theseus's benevolent construction of silence, however, is a hopelessly anachronistic moment of nostalgia in the late sixteenth century which reveals more about the monarch than about his subjects. With Theseus's idealised tongue-tied subject compare the citizens in *Richard III*, who maintain a 'wilful silence' (3.7.28) when Buckingham suggests Richard as their future king. 'They spake not a word,' remarks Buckingham, 'But, like dumb statues or breathing stones / Stared on each other and looked deadly pale' (3.7.24–6). Richard, aware – like Coriolanus – that he requires the 'voices' of the people in his quest for power, denounces them as 'tongueless blocks' (42). Far from reading the silence of the citizens as consent or submission, Richard recognises its resistant power – power resistant both to manipulation and, potentially, to interpretation. At the beginning of Jonson's masque *The Gypsies Metamorphos'd* (1621), the Porter, delivering

the Prologue for the Burleigh performance, addresses James directly and notes the obtrusive silence of his favourite Buckingham:

> The *Master* is yor Creature, as the *Place*,
> And everie good about him is yor *Grace*,
> Whome, though he stand by silent, thincke not rude,
> But as a man turnd all to gratitude,
> For what he nev'r can hope how to restore,
> Since while he meditates one, you poure on more,
> Vouchsafe to thincke he onelie is opprest
> With theire aboundance, not that in his brest
> His powers are stupid growne.
>
> ('At the Kings Entrance' 15–23)

While the Porter adroitly shapes King James's interpretation of Buckingham's silence as 'gratitude' and decorous submission, his acknowledgement that silence can equally signify stupidity, lack of refinement or menace ('rude' carried all meanings then (OED 1, 3, 4) is telling.[5] The shifting multivalency of the silence of subordinates can be politically dangerous; power lies in managing, defining and appropriating that silence.

John Marston's *Parasitaster, or The Fawn* (1606) is a play which gently satirises the early modern veneration of rhetoric as well as its attempts to appropriate silence. The foolish Gonzago, Duke of Urbin, is (according to the Dramatis Personae) *'a weak lord of a self-admiring wisdom'* ('Interlocutors' 2) who affects the study of formal rhetoric and frequently trots out terms from Wilson's or Puttenham's rhetorical handbooks. His constant companion is Granuffo, *'a silent lord'* (7), who never contradicts him, and provides him with a needed blank space on which to inscribe his discourse. Thus speech and silence in this play are dramatically represented as indivisible and codependent; speech, moreover, continually co-opts silence to confirm its own value. In a single long speech in the first act, for example, Gonzago appeals to Granuffo no fewer than three times (1.2.149, 154, 187), in the final instance to point to his own use of 'a [rhetorical] figure' (188). '[T]his Granuffo is a right wise good lord, a man of excellent discourse, and never speaks', declares Gonzago, 'his signs to me, and men of profound reach, instruct abundantly' (3.294–7). Gonzago's clever daughter Dulcimel mocks the deluded self-assurance of her 'wise,

aged, learned, intelligent father, that can interpret eyes, understand the language of birds, interpret the grumbling of dogs and the conference of cats, that can *read even silence*' (3.252–5; emphasis added). An index of Gonzago's foolishness is his claim to manage and interpret silence. Marston's play thus satirises the 'Ciceronian elocution' (3.279) that would contain silence itself as a form of oratory. It is hardly surprising, at the end of the play, that Granuffo is exposed as a sot, and Gonzago learns that 'Thus silence and grave looks, with hums and haws, / Makes many worshipped, when if tried th'are daws'(5.386–7). As Marston's play makes clear, the spectre haunting the silence as eloquence model is the silence as impotence one; the eagle may be a daw in disguise. Whilst Marston's coda reverts to the silence as impotence paradigm, his play actually exposes not only rhetoric's investment in defining and managing silence but also the intrinsic *potential* resistance of silence itself to being managed.

Staging inscrutable (masculine) silence

Given the increasingly antirhetorical culture of early modern England, it was perhaps inevitable that the figure of silence should be appropriated by playwrights as a means of reflecting or fuelling cultural scepticism about the limits of rhetorical control. The potential of silence to elude discursive definition and containment is foregrounded in a number of early modern plays, but one of the earliest and most influential examples is Thomas Kyd's *The Spanish Tragedy* (1585–7?). The play has long been discussed by critics as a text in which the 'perils' of rhetoric outweigh the pleasures (Barish 'Spanish'), yet its important contribution to the history of silence has been underestimated. This play – so popular in the Elizabethan theatre – vividly illustrates silence's move out of its secure place in the rhetorical tradition. From constructing silence alternatively as impotence or communicative loquacity (as in *Richard II*), *The Spanish Tragedy* finally moves to a startling new image of silence as unreadable and dangerous self-closure.

The opening of the play is firmly rooted in the Tudor valorisation of rhetoric. The antithesis of Old Hamlet's ominously silent ghost, Andrea begins the play with an 85-line speech in which he vaunts himself on 'pleasing Cerberus with honeyed speech' (1.1.30) and employs the familiar inexpressibility topos in recounting that he 'saw more sights than thousand

tongues can tell' (57) in the Virgilian Underworld. When Hieronimo first enters the play, he stage manages the dumb-shows and obligingly explicates their meaning for the King of Spain (1.4.137–71).[6] Indeed his faith in speech is marked throughout the play: upon discovering a body hanged in his arbour, Hieronimo repeatedly attempts to dispel his 'trembling fear' (2.5.2) by communicating with words. 'Speak, here I am' (4), he cries at first; then, when he recognises the body as his son's, he converses with it: 'O was it thou that calledst me from my bed? / O speak, if any spark of life remain'(2.5.16–17). The speech is a series of apostrophes which signal Hieronimo's secure place in Tudor rhetorical tradition, even under the stress of terrible grief. And, despite the deafening silence of the 'empyreal heights' which give his 'words no way' (3.7.15, 18) – visible to the audience in the form of the slumbering Revenge (3.15.25) – Hieronimo persistently clings to traditional forms of human communication. His vow to 'listen more, but nothing to bewray' (3.2.52) is one of which Plutarch would have approved, since he is still invested in social exchange. And, while he laments 'My grief no heart, my thoughts no tongue can tell' (3.2.67), he determines to 'cry aloud for justice through the court … And either purchase justice by entreats / Or tire them all with my revenging threats' (3.7.70–3). In fact he imagines himself struggling against the impotence of silence to gain the power of speech: 'Why, is not this a strange and seld-seen thing, / That standers-by with toys should strike me mute?' (3.12.3–4), he asks himself while summoning up the courage to approach the King. Even after his speech is dismissed as 'distract' and 'lunatic' (3.12.89), Hieronimo resolves simply to modify his style and try 'milder speeches' (3.13.41). Silence then enters the play in the figure of Bazulto, a *senex* mourning his dead son, and Hieronimo queries: 'But wherefore stands yon silly man so mute, / With mournful eyes and hands to heaven upreared?' (3.13.67–8). Bazulto is Hieronimo's 'semblable' (Barish '*Spanish*' 80), 'the lively image of [his] grief'(3.13.162); his silence is the equivalent of Hieronimo's speech. If Hieronimo urges Bazulto to 'sound the burden of [his] sore heart's grief' (119), and exposes his own misconstruction of the non-verbal dimension by mistaking Bazulto for others, he finally successfully reads and manages the old man's silence as an alternative form of eloquence.

Hieronimo's faith in the civilising power of rhetoric persists until the end of the play. That he chooses to stage a play *'in sundry languages'* (4.4.10

s.d.) signals, while it complicates, his determination to communicate *something* to his audience. Indeed, his explication of his theatrical entertainment is delivered in the 'vulgar tongue' (4.4.75) for clarity, and he pits himself against silence and oblivion in an effort to 'tell his latest tale' (85): 'But night, the coverer of accursed crimes, / With pitchy silence hushed these traitors' harms' (4.4.102–3). Then he ends his long speech with the neat heroic couplet: 'And, gentles, thus I end my play: / Urge no more words: I have no more to say' (151–2). As Gordon Braden points out, 'A victorious union of self-sufficiency and effectiveness shines in that stance' (212); his silence here, after all, is an effective rhetorical close (a kind of exclamation mark), signalling both the sufficiency of language and his place in the community of 'actors gone before' (150) – including, ironically, the villainous Lorenzo whose part he has played. But the play does not end there. Braden comments that 'Strange things immediately begin to happen in the text of the play' (212). Hieronimo's triumphant *coup de théâtre* falters. Instead, he is seized by the authorities, who demand repeatedly that he 'speak' (163) – even though he has just spoken at great length. Some critics have posited a corrupt text; Edwards, for example, has hypothesised that the final moments are in fact 'an alternative ending to the play' (xxxvi). Braden plausibly argues that the strange coda complicates our response to Hieronimo as 'victorious avenger' – when his control falters, we see him suddenly as a 'criminal' (213). In addition the ending of this play reflects a culture obsessed with the silence that lies on the other side of discourse.

The Spanish Tragedy illustrates various dominant cultural paradigms of silence. First, throughout the play, silent stage pictures – the dumb-shows, Bazulto's grief, the body hanging in the arbour – are interpreted discursively, contained by the play's rhetorical project as an alternative form of eloquence. Silence is either managed or denounced as the 'pitchy' co-conspirator of murder. Occasionally there are traces of the silence as impotence trope, first when Hieronimo despairs of being struck 'mute', and, strikingly, when he responds to the King's demand for speech with: 'What lesser liberty can kings afford / Than harmless silence? Then afford it me' (4.4.180–1).

Here he repositions silence in a discourse of power, claiming that his refusal to speak, like Granuffo's in Marston's *The Fawn*, is actually inoffensive and impotent. The remark may allude also to contemporary debate

about the right to silence before the law. At any rate, it functions as an important reminder of dominant cultural forms before the play's final move into powerful, overdetermined silence.

In the play's final moments Hieronimo bites out his tongue, paradoxically violating himself in order to protect the thing which he has 'vowed inviolate' (4.4.188). As critics have noted, his action imitates that of Zeno the Stoic philosopher.[7] Whilst Kyd is clearly seeking a gruesome theatrical effect to close his play, he is also foregrounding a crucial site of cultural interest and anxiety. Hieronimo's final dramatic self-silencing certainly signals – for the first time unequivocally – his retreat from rhetoric and its social values. But he could, like Iago, have simply refused to talk to his captors.[8] His self-mutilation, which in its sheer gratuitous excess literalises the silence trope, points to something more. In one sense his insistence on silence in the face of the King's repeated injunctions to discourse (4.4.163–4) connects him with those recusants and martyrs who refused to speak in defiance of authority, and gestures toward an unmanageable inwardness which 'cannot be exhausted by the action he takes', staging paradoxically an interiority, 'a radical subjectivity never to be told' (Braden 214). In another sense, however, Hieronimo's repudiation of his distinctive human capacity for speech links him with the terrifying, chaotic, bestial, *inhuman* disorder so feared by early modern writers – a link that is reinforced by his subsequent bizarre and un-Stoical murder of Castile, who defended him earlier (3.14.58–70). In fact Kyd's play hovers anxiously between two visions of silence: one finds death, madness and the beast – the 'monstrous' (4.4.192, 202) – on the other side of speech;[9] the other, formulated under the pressures of rhetorical coercion, imagines silence as the construction of an achieved, aggressive Stoic selfhood. Hieronimo's silence partakes of the ambivalence surrounding rhetoric in the early modern period described by Rebhorn (*Emperor* 197–258): like Bakhtin's classical and grotesque bodies,[10] it is both self-contained, closed, secret *and* open, multiple, uncontrollable, unfathomable.[11] The conflation of these two constructions of silence, one unsettling the other, mark Hieronimo as 'inscrutable', unreadable and unmanageable – a site of cultural anxiety about the stability of the subject. And Hieronimo is of course a 'subject' in a double sense. 'To be a subject', as Belsey puts it, 'is to have access to signifying practice, to identify with the "I" of utterance and the

"I" who speaks', but 'the subject is [also] a subjected being' (*Subject* 5).
Hieronimo's silence signifies both subjectivity and subjection; it is at once
a sign of impotency, of subversive triumph and of bestial excess. In keeping
with Kyd's overall project in *The Spanish Tragedy* of marking the limits of
human knowledge and control, Hieronimo's silence defies our attempts at
decoding or restricting its meanings.

Staging inscrutable (feminine) silence

Women as such did not exist on the early modern public stage; they were
normally impersonated by boys. 'Pray God your voice, like a piece of
uncurrent gold, be not cracked within the ring' (*Hamlet* 2.2.410–11), says
Hamlet to the boy player of the troupe; the boy's unbroken voice was
apparently essential to a convincing imitation of femininity. In the induc-
tion to *The Taming of the Shrew* the Lord instructs his page on playing a
woman by recommending a 'soft low tongue' to reinforce his verbal self-
description as Sly's 'humble wife' (Induction 1.110–12). As in the con-
duct books, decorous feminine behavior was conveyed not through silence
but through speech. Similarly, woman's silence in the drama, like her
speech, was largely a male construction, written, represented and inter-
preted by men, and often confidently read as somatic speech. So Ulysses
contemptuously constructs Cressida's silence as a rhetoric of wanton invi-
tation 'To every ticklish reader' (4.6.62): 'There's language in her eye, her
cheek, her lip; / Nay, her foot speaks' (4.6.56–7). Interpreted as speech,
feminine silence could be reinserted into patriarchal ideology; in *The
Taming of the Shrew*, Petruchio strategises before meeting Katherine: 'Say
she be mute and will not speak a word, / Then I'll commend her volubil-
ity, / And say she uttereth piercing eloquence' (2.1.172–4). Woman's
silence on the stage could be firmly managed in the interests of masculine
rhetorical control.

 However, as we have seen, early modern male authors living in an
antirhetorical culture also frequently endorsed the virtue of silence as an
'inscrutable' space, a desirable refuge from the dangers of speaking and
being legible. And, just as this space of inscrutable silence was often associ-
ated with women and represented iconographically as feminine, it could and
did take feminine form in the drama. In these plays feminine silence becomes

a useful instrument for marking the limits of masculine discursive control and knowledge: Kyd's Hieronimo gives way to Shakespeare's Lavinia and Cordelia. Yet because of the pervasiveness of early modern misogyny, the silent woman is a more problematic figure than the silent man; if he risks becoming a monster or a beast, she threatens to turn into a witch or a whore. Even as they expand the potential for female agency, powerfully silent women can exceed their dramatic functions to become emblems of unruly chaos. As Maus puts it, women's 'bodies, unreadable from the male point of view, figure a kind of anarchy' (193). Potentially androgynous, silence became a crucial site where gender markers could be reinforced, interrogated or elided on the early modern stage.

Titus Andronicus

No play in early modern drama foregrounds feminine silence more than *Titus Andronicus*, and no play exposes so vividly the competing cultural constructions surrounding it. Before Lavinia is raped, she prudishly shrinks from uttering that which 'womanhood denies [her] tongue to tell' (2.3.174). Even to utter the word 'rape' is to participate in it; modesty and silence are coextensive. However, at the moment she is dragged offstage to be violated, she discovers that woman's silence has another meaning. 'Confusion fall –' she cries, and is abruptly silenced by Chiron's 'Nay then, I'll stop your mouth' (2.3.184). The editor of the 1948 Cambridge edition politely gives the stage direction '*he gags her*' (32), but the phrase occurs too often in Renaissance plays for one to be in much doubt of its meaning.[12] In *Troilus and Cressida* (3.2.123), for example, Troilus understands Cressida's request to stop her mouth as a plea for a kiss, and in *The Duchess of Malfi* (3.2.20) Antonio stops his wife's mouth with a kiss, as in *Much Ado About Nothing* (5.4.96). Lavinia hence discovers that her womanly reticence can become involuntary silence. We may note that the sign of retreat from rape – the closed mouth – becomes the sign of rape itself; the trope of feminine silence is radically destabilised. When Lavinia reappears in the following scene, tongueless and '*ravished*' (2.4.1 s.d.), her silence utterly disrupts the established relation between signifier and signified; here, feminine silence is monstrously *un*chaste. Robbed of the offensive 'glibbery member', Lavinia's body inscribes male ideals of female decorum so literally that they are savagely exposed and inverted. In a feminised version of

Hieronimo's final moment, Lavinia's body is both sealed up in silence and open, bleeding, sexually violated, 'grotesque'.[13]

The unstable paradoxes of Lavinia's silence are illuminated by contrast with attempts in the play world to manage and restrict its meanings. When Lavinia first appears on the stage, '*her hands cut off and her tongue cut out, and ravished*' (2.4.1 s.d.), for example, Marcus attempts to define and limit her in a notoriously ornate and lengthy speech which has attracted much critical commentary (Hibbard 47–51; Waith 86–7). Reading Lavinia's silent gestures, Marcus declares:

> Ah, now thou turn'st away thy face for shame,
> And notwithstanding all this loss of blood,
> As from a conduit with three issuing spouts,
> Yet do thy cheeks look red as Titan's face
> Blushing to be encountered with a cloud.
>
> (2.4.28–32)

His interpretation of Lavinia's silence is more problematic than it first appears. Of Sonia Ritter in Deborah Warner's 1987 production, Douglas Green notes: 'Though her actions matched Marcus' words, one could never be quite sure whether Lavinia's turning away "for shame" (in which sense of the word?) ratified Marcus' lighting upon the apt Ovidian analogy or sought to avoid this painful contact altogether or indicated rejection.' Whilst he sees this as 'a powerful instance of the ways in which women's playing parts originally meant for boys have historically altered readings of the text' (324n.), there is no reason to attribute the ambiguity to performance conditions – the gesture itself is inherently ambiguous in the text. Though Marcus tells us that Lavinia blushes, and that this blush is a sign of 'shame', Shakespeare uses the word elsewhere in different senses: in *The Comedy of Errors* it is used as a synonym for disgrace ('Free from these slanders and this open shame' (4.4.62)); in *A Midsummer Night's Dream* it is a synonym for modesty ('Have you no modesty, no maiden shame, / No touch of bashfulness?' (3.2.286–7)). 'The shameful blush', David Bevington tells us, 'may represent one of two opposite responses: dismay and confusion at an undeserved accusation, or admission of guilt' (*Action* 96). Which meaning applies here? The *OED* glosses 'for shame' as (13a) 'from a sense of shame, because one feels shame; also, for fear of shame, in

order to avoid shame'. The difference, however slight, is important: is Lavinia acknowledging a feeling of disgrace by turning her face, or is she protecting herself from Marcus's invasive gaze? Is she dissociating herself from or implicating herself in the act of rape? Indeed the ambiguity is compounded by the curious analogy Marcus finds for her blush: Titan's blush is usually associated not with shame but with anger (as it is, for example, in *Richard II*, where the king arrives to face his deposers, 'As doth the blushing discontented sun / From out the fiery portal of the east / When he perceives the envious clouds are bent / To dim his glory' (3.3.62–5)). Given such a range of referents for Lavinia's silence, as well as the unspeakable horror she figures, the audience (unlike the play's male characters) cannot 'read' her simply, reduce her to a single signified.

Lavinia's 'open' silences multiply as the play proceeds.[14] After Titus's suggestion that 'we bite our tongues, and in dumb shows / Pass the remainder of our hateful days' (3.1.131–2), Lavinia's response is indicated by Lucius: 'at your grief / See how my wretched sister sobs and weeps' (136–7). But the directive to the actor does not remove the ambiguity surrounding the emotional display. Is she weeping at her father's grief or at his terrible self-absorption and masochistic narcissism? Is her reaction a reinforcement of or a corrective to Titus's insular despair? Titus's solipsism should make an audience wary of his claim to 'understand her signs' (143), especially when Marcus continually draws attention to their ambiguity. While Titus seeks to make his daughter into a mirror for his own grief for his condemned sons, for example, Marcus suggests, 'Perchance she weeps because they killed her husband; / Perchance because she knows them innocent' (114–15). As others have pointed out, 'Lavinia is polysemic and disruptive' (Green 325) and ultimately 'unknowable' (Marshall 204). Yet few have noted that Lavinia's inscrutability relies on the early modern 'moving Rhetoricke' of silence: while, as a form of eloquence, her silence invites reading, as an inscrutable, overdetermined space, it resists being read. And while, as a sign of female closure, it should guarantee subjection, as a potential sign of disobedience and unchaste behaviour it confounds all assurances. *Titus Andronicus* not only undermines humanist assumptions about an eloquent rhetoric of silence, it associates silence's unruly openness with women who lie beyond masculine rhetorical control.

The play itself provides a hermeneutics of silence separate from Lavinia. Just before the mutilated daughter appears to 'blind a father's eye' (2.4.53), Titus laments the tribunes' refusal to hear his plea for the life of his sons:

> Therefore I tell my sorrows to the stones,
> Who, though they cannot answer my distress,
> Yet in some sort they are better than the Tribunes
> For that they will not intercept my tale.
> When I do weep they humbly at my feet
> Receive my tears and seem to weep with me,
> And were they but attired in grave weeds
> Rome could afford no tribunes like to these.
> A stone is soft as wax, tribunes more hard than stones.
> A stone is silent and offendeth not,
> And tribunes with their tongues doom men to death.
>
> (3.1.36–46)

Cut in part or whole in most productions (Dessen 55), this speech constructs silence as impotent in contrast to the 'tongues' of tribunes who 'doom men to death' with words. Like the ideal early modern woman, the stones, 'soft as wax', receive Titus's imprint as their silence holds no threat; real power resides in masculine discourse. Of course Titus is wrong: stones are not soft, but hard and unfeeling like the tribunes. And the speech's context further deconstructs Titus's reading: the immediate, visible source of power is not words, but the *silence* of the tribunes as they pass over the stage deaf and resistant to Titus's pleas. The text thus opens up the semiology of silence that Titus tries to close down. Consistent with this project, Lavinia's silence exposes the limits of masculine rhetorical culture, its dramatic excesses visibly undermining the humanist rhetoric of eloquent silence.

King Lear

Once she abandons silence and imitates Marcus's act of writing, Lavinia almost disappears from the play until she returns veiled, to be killed by her father, in the final scene.[15] Far from a triumphant 'testimonial of the limits of nonverbal communication' (Bevington, *Action* 31), Lavinia's phallic inscription of her rapists' identities diminishes her central position as cipher in the play's events. In *King Lear*, however, Lavinia, adored and

abused daughter, is remade into Cordelia, and the imposed silence of the early tragedy becomes the wilful reticence of the later one.

In the final scene of *King Lear* Lear's utopian vision of blissful exile with his daughter confronts the silence of her corpse. Her involuntary silence echoes the earlier one which persistently refused to collude with Lear's fantasies. As both chaste closure in its recognition of the limits of speech and frank openness in its exposure of an anarchic, primitive world which takes shape on the heath, Cordelia's initial silence, like Lavinia's, draws on shifting, unstable constructions of feminine silence in early modern culture. Unlike Lavinia's involuntary, objectified silence, however, Cordelia's wilful silence recalls Hieronimo's in its confrontation with authority's insistence on speech. On the stage, *King Lear* shows us, the cultural paradoxes of silence can create new space for women to resist definition and claim multiple subjectivity.

In the final, terrible moments of *King Lear*, Lear crouches over the lifeless body of Cordelia, straining to catch a breath or a whisper. As those about him speak of apocalypse, Lear focuses on the small physical details that distinguish life from death. His anguish is made more evident by painful efforts to ward it off:

> I might have saved her; now she's gone for ever. –
> Cordelia, Cordelia: stay a little. Ha?
> What is't thou sayst? – Her voice was ever soft,
> Gentle, and low, an excellent thing in woman. –
> I killed the slave that was a-hanging thee.
>
> (*Tragedy* 5.3.244–8)

The pause which lengthens the caesura in the third line is filled up by Cordelia's silence. Ironies abound: the silence to which Lear had refused to listen in Act 1 is now the source of his despair, yet, as in Act 1, he cannot listen to what it tells him – that she is dead. And, at the very moment when the quiet voice that violently launched the tragic action is for ever silenced, it is reduced by Lear to a conventional feminine trait. Of course Lear's sentimentalising of Cordelia, like Bosola's sentimentalising of the Duchess of Malfi as 'sacred innocence' (4.2.355) after her death, provides him with the energy for the burst of machismo that follows, while at the same time illuminating by contrast the woman's complexity – a complexity that is

registered in the power of her silence. Yet Lear's portrait of Cordelia as a model of Renaissance womanhood with a gentle, low voice does draw attention to a central paradox in the play: Cordelia's silence, which sets the tragedy in motion – that silence that fills up the great pauses in the Folio text between reverberating 'nothings' – is both a daring act of subversion and a cliché of feminine reticence.

For an audience, Cordelia's aside, 'Love and be silent' (*Tragedy* 1.1.60), reassuringly circumscribes filial disobedience within a larger context of virtue. And, when Cordelia does speak in Act 1, she presents her silence as support for, rather than a threat to, patriarchal authority. Like Desdemona, who finds her duty 'divided' between husband and father (*Othello* 1.3.180), or like Isabella, who fears Angelo's rape lest her 'son should be unlawfully born' (*Measure for Measure* 3.1.190), Cordelia defends patrilineage, stating clearly, 'Haply when I shall wed / That lord whose hand must take my plight shall carry / Half my love with him, half my care and duty' (*Tragedy* 1.1.98–100). Jardine claims that 'to her father, Cordelia's silence is not a mark of virtue, but a denial of filial affection … The audience must, I think, understand this as a moral mistake on Lear's part' (*Still Harping* 108). Similarly, Elizabeth Harvey notes that 'Cordelia's linguistic restraint … stands for a constellation of particularly feminine virtues' (132–3). Given the conventional nature of Cordelia's silence, backed as it is by verbal assurances, why does Lear perceive her as most monstrous in disobedience? Is his response clearly one of dotage which no members of his audience would have shared?

That Cordelia's initial silence is an act of disobedience which ultimately expresses her filial duty is consistent with other paradoxes in the play – with blindness leading to insight, and madness to clarity (Colie 119). But this particular paradox is rooted in a struggle between the complex and unstable early modern constructions of women's silence outlined in the previous chapter. Cordelia herself takes one view of her refusal to speak in the terms demanded of her by her father, by defending it as the 'want [of] that glib and oily art / To speak and purpose not' (*Tragedy* 1.1.222–3). Like Kent she is determined 'to be plain' (2.2.85); unlike him she must do so through silence. According to the conduct books, as we have seen, her behaviour is exemplary. But Lear responds to Cordelia's silence not only as the rebellion of child against father but as the assault of the subhuman

upon the superfluous needs of men – the 'barbarous Scythian' who feeds
on his own young is the (ironic) parallel he finds for his 'sometime daughter' (1.1.114–17). Later he compares the apparently virtuous, reticent
woman to the 'fitchew' or the 'soiled horse' (*Tragedy* 4.5.117). The silent
woman has become something quite other than chaste, irreproachable
virgin. The culture that produced and watched *King Lear* may thus have
experienced Cordelia's silence as both reassuringly submissive and dangerously subversive – a complex nexus for competing views of women's
silence.

Initially, the resolutely silent Cordelia appears to cross the same
gender lines as Brathwait's English gentlewoman or Du Bosc's 'compleat'
woman by figuring silence, not as outright rejection of social discourse but
as its more authentic alternative – anti-Ciceronian plainness underwritten
by Pythagorean sagacity. Indeed, when Kent assures Lear that 'Thy
youngest daughter does not love thee least, / Nor are those empty-hearted
whose low sound / Reverb no hollowness' (*Tragedy* 1.1.150–2), he is
simply reformulating Plutarch's description of garrulous men as 'emptie
vessels, which give a greater sound than they which are full' (399). This
conceit underlies Cordelia's own claim, in the Folio, that her love is 'More
ponderous' than her tongue (76); the full heart *cannot* be heaved into the
mouth (90), just as the heavy, laden vessel will not readily produce a ringing sound. Cordelia's suggestion that speech cannot adequately convey or
exhaust subjectivity seems the discursive equivalent of Hamlet's theatrical
'I have that within which passeth show' (1.2.85). Yet just as Hamlet insists
that outward signs do not denote him truly even as he dons the 'trappings
and the suits of woe' (86), Cordelia frames her refusal to speak as itself a
speech act, at least in the Folio: 'What shall Cordelia *speak*? Love and be
silent' (*Tragedy* 1.1.60; emphasis added). Her move aligns her with the
anti-Ciceronian Attic directness of Seneca against the Ciceronian ornamental extravagance of her sisters; a debate which, as Russ McDonald
points out, 'is grounded in conceptions of sexual difference and is related
to the figuration of language as feminine and action as masculine in early-modern language theory' (98). In other words the eloquent silence of the
deed or (figuratively) the pithy phrase was gendered male, and associated
with the ascendancy of Baconian plain style.[16] Cordelia's dissent actually
appears to participate in the masculine rhetorical culture it challenges.

While Cordelia's silence may initially be an antirhetorical rhetoric that aligns her with masculine wisdom rather than feminine submission, its complexities do not end there. Like her speech, her silence is rife with paradox. Initially she lays claim to an inaccessible subjectivity and rhetorical discretion normally gendered masculine; later, more subversively, she appropriates the nonverbal agency of masculine deeds. This she does in a casually parenthetical remark as she publicly defends her right to silence:

> I yet beseech your majesty,
> If for I want that glib and oily art
> To speak and purpose not – since what I well intend,
> I'll do't before I speak – that you make known
> It is no vicious blot, murder, or foulness,
> No unchaste action or dishonoured step
> That hath deprived me of your grace and favour,
> But even the want of that for which I am richer –
> A still-soliciting eye, and such a tongue
> That I am glad I have not, though not to have it
> Hath lost me in your liking.
> (*Tragedy* 1.1.221–31)

The end of the speech, with its rejection of the 'unchaste action' implicit in the transgressions of that 'glibbery member', the tongue, and the open, inviting gaze, clearly aligns Cordelia with traditional feminine virtue. Yet her overt appropriation of such conventional tropes seems an attempt to foreclose the threatening possibility briefly alluded to at the speech's opening: 'what I well intend, / I'll do't before I speak.' Here Cordelia contrasts her sisters' divorce of speech from meaning with her own insistence on their interdependence. Yet she goes well beyond a modest claim to mean what she says, unlike her sisters; *her* speech will merely ratify a deed already carried out on her own initiative, without the social approval afforded by discourse. This is quite distinct from the more acceptable ratification of the word by the deed that Kent urges on Goneril and Regan: 'And your large speeches may your deeds approve, / That good effects may spring from words of love' (*Tragedy* 1.1.181–2). Cordelia's radical claim to prelinguistic agency is foreshadowed in the Quarto's version of her first aside: 'What shall Cordelia *do*? Love and be silent' (*History* 1.1.54; emphasis added). And the opening scene surely confirms that Cordelia's silence is not merely a countermove in

rhetorical exchange but an *action* which triggers a series of disastrous consequences. This identification of Cordelia's silence with the deed aligns her on the one hand with the silent goddess Angerona ('the goddess of deeds-not-words' (Orgel 144)), and on the other hand with Coriolanus's martial commitment to action over speech (2.2.68–9) or to Troilus's reputation as a 'true knight' 'Speaking in deeds and deedless in his tongue' (4.6.98–101). Such an insistence on the primacy of the deed may lead to dangerous and unchecked autonomy, however, as in *Macbeth*, where Macbeth recognises that 'The flighty purpose never is o'ertook / Unless the deed go with it' (4.1.161–2). Not only does the depth of Cordelia's subjectivity lie beyond the monarch's control, her claim to agency approaches the independent action of the warrior or the assassin. Though France later attempts to reinterpret Cordelia's silence charitably as a minor fault, 'a tardiness in nature, / Which often leaves the history unspoke / That it intends to do' (*Tragedy* 1.1.233–5), his attempt to replace silent action with intention cannot contain her more subversive claim. And it is precisely Cordelia's claim to silent masculine agency as well as subjectivity that triggers Lear's fears. Those fears are later displaced on to the androgynous Goneril, who emerges the 'better soldier' (4.4.3) than Albany, even as she becomes Edmund's mistress, urging silence as requisite for their adulterous affair (4.2.21–3). Thus Cordelia's claim to 'do't' without speech finds its obscene equivalent in Goneril who, like the lascivious Duchess in *The Revenger's Tragedy*, 'will do with devil' (1.1.4).

Dumb-shows and Hamlet

When Titus first confronts his mutilated daughter Lavinia, he asks her: 'shall we bite our tongues, and in dumb shows / Pass the remainder of our hateful days?' (3.1.131–2). His answer, of course, is no: the dumb-show is Lavinia's alone, and those who 'have … tongues' will use them to 'plot some device of further misery' (133–4), translating language into action. Yet if Titus is wrong to think that the dumb-show of Lavinia's silence exempts her from agency, he may also be wrong about dumb-shows in general. A neglected site of meaning in a play such as *Hamlet*, the dumb-show illuminates the theatrical 'thickness' of feminine silence. Whilst critics of *Hamlet* have found in the silences of Ophelia[17] – and less often of Gertrude[18] – significant counterpoints to the play's masculine discourses, signifying everything

from vacancy to tragic awareness, they have rarely considered a form like the dumb-show which marries theatrical convention to cultural history. Like other powerful non-verbal moments, the 'inexplicable dumb-shows' (*Hamlet* 3.2.10–11) of early modern plays frequently position the feminine in an overdetermined, hence indeterminate, silent space and thus foreground the 'cipher' of feminine silence, which resists interpretation.

In early modern plays the metatheatrical form of the dumb-show could and did serve as a site where women and men alike were exposed as *performers*, dissemblers, hypocrites. In the case of women this merely capitalised on already powerful cultural tropes. Act 2 of Heywood's *The Golden Age* (1610), for example, opens with the presenter, Homer, introducing the dumb-show as a means of revealing a 'show' of deception – which he pointedly genders feminine:

> What cannot women's wits? they wonders can,
> When they intend to blind the eyes of man.
> Oh! lend me what old Homer wants, your eyes,
> To see th'event of what these Queens devise.
>
> (20)

In response to the Delphic Oracle's prophecy that his son will usurp the throne and destroy him, King Saturn has commanded that his newborn be put to death. In the dumb-show Vesta, Saturn's mother, along with a nurse/midwife, dispatches the child into another's care, then displays to Saturn '*with counterfeit passion*' the bleeding heart of an animal. Their dissembling is discovered at the end of the dumb-show when '*the King departs one way in great sorrow; the Ladies the other way in great joy*' (20). Another dumb-show at the beginning of the third act shows Calisto, ravished by Jupiter, refusing to undress (and probably counterfeiting modesty) for fear of revealing her pregnant belly. Atlanta, however, soon '*finds her great belly, and shows it to Diana*' (36). In these dumb-shows featuring dissembling women the theatrical medium is the message; the theatrical 'show' is the performance of a dissembler, as well as a means of showing that show, exposing it as a performance. Underwriting performances like these is the misogynist construction of woman as 'Foul pith contain'd in the fairest rind' (*Mariam* 4.189), 'a glow-worme which is bright in the hedge and black in the hand' (Swetnam 12).

Such a construction relies on a stable and privileged masculine ability to 'see through' feminine dissimulation, and make clear distinctions between inside and outside. However, such distinctions were difficult to maintain in practice; as the conduct books suggest, and Homer himself acknowledges, women 'wonders can, / When they intend to blind the eyes of man'. Other dumb-shows suggest that 'performance' can be a matter of style or substance – and for the viewer it may be impossible to determine which is intended. In *Hamlet*'s dumb-show, for example, the poisoner is clearly dissembling when he and other mutes '*seem to condole with*' the bereaved Player Queen. Yet the Player Queen, who '*makes show of protestation*' to the King, '*makes passionate action*' upon his death, and '*seems loath and unwilling*' upon the poisoner's attempted seduction (3.2.122 s.d. 3, 9, 12), is a site at which cultural and theatrical discourses converge and collide. Are these the 'shows' of a dissembling woman, or simply the stylised gestures of an actor? How can we know? Ophelia registers this uncertainty in her reaction: 'Will a tell us what this show meant?' (3.2.129). And, though Hamlet replies confidently (and obscenely), 'Be not you ashamed to show, he'll not shame to tell you what it means' (3.2.130–1), his self-assurance is undercut not only by the perfunctory Prologue who explains nothing but also by the indeterminacy of the dumb-show itself.

The problem of decoding the dumb-show begins with its written stage directions. Unlike masques, dumb-shows often use verbs of seeming and showing to suggest at some points heightened, stylised gesture, at others mimed dissimulation and hypocrisy.[19] In performance the dumb-show's exaggerated acting styles derived from emblematic and ceremonial modes may or may not intimate feigning in the more naturalistic play world. In a dumb-show in Webster's *The White Devil*, for example, after Flamineo writhes Camillo's neck about with the aid of the others on the stage, he '*seems to see if it be broke, and lays him folded double* as 'twere *under the horse*, makes shows *to call for help*' (2.2.37 s.d. 7–8; emphases added). If the first verb ('*seems to see if it be broke*') is almost certainly metatheatrical (suggesting merely exaggerated movement, since Flamineo has no need to feign before accomplices), the second ('*makes shows to call for help*') probably indicates distress *dissembled* (for the benefit of those who answer his calls?). In the dumb-show in Middleton and Rowley's *The Changeling*

Vermandero makes '*action of wonderment*' at the disappearance of Alonzo; he then points to Alsemero as a new husband for Beatrice-Joanna, '*the gentlemen* seeming *to applaud the choice*' (4.1.1 s.d.). Here the verbs are more obviously mere theatrical directives. But where does stylised performance in such instances become simultaneously the posture of deceit? And how might the artifice of the dumb-show, by showing *all* the play's characters in a carefully choreographed ballet of contrived movements, problematise early modern gendering of feigning as feminine? Clearly, metatheatrical forms such as the dumb-show have especially complex implications for the representation of women and silence. Three dumb-shows, all of which feature women appearing to resist a villainous seducer before accepting him, offer some intriguing possibilities. Each of these dumb-shows – in Shakespeare's *Hamlet* (1601), Marston's *Antonio's Revenge* (1600) and Middleton's *Hengist, King of Kent* (1618) – hampers the audience's judgement by placing feminine theatricality in a metatheatrical context, thus making them indistinguishable.

The three dumb-shows exhibit some striking similarities. In two of the three the villain openly commits or commissions murder; in the third (*Antonio's Revenge*) the villain is already a well-established murderer. In each case the villain is aided by others in his attempt to win the woman. In two of the three plays (*Hamlet* and *Hengist*) the villain is also a hypocrite: the poisoner '*seems to condole with*' the Queen, and Vortiger '*seems to express much sorrow*' for the murder he in fact committed. But what unites the three plays above all is their common depiction of a woman showing resistance or reluctance to accept the love of the villain before finally doing so. Taken out of context, each dumb-show appears to be a visual, emblematic representation of the common early modern theme of dissimulated female modesty giving way to the imperatives of female desire (for gifts, for power or for passion). Indeed all three plays contain plenty of misogynist commentary on this theme. In *Hengist* Horsus in an aside undercuts Hengist's illusions about his daughter Roxena's devoted pursuit of their army by cynically (and accurately) attributing it to female appetite; '"tis her Cuning, / The love of her owne lust, wch makes a woman / Gallop downe hill as feareless as a drunkard, / Theirs noe true Loadstone ith world but that' (2.3.189–92). 'Thy sex is weak' (3.5.8), Andrugio's ghost tells Maria simply in *Antonio's Revenge* after demanding, 'What raging heat reigns in

thy strumpet blood?' (2). And Hamlet frames the dumb-show by remarking to Ophelia, 'look you how cheerfully my mother looks, and my father died within's two hours' (3.2.114–15). All three dumb-shows seem to use the theatricality of the dumb-show to expose feminine dissembling; however *apparently* 'Constraind' or unwilling, the silent 'Consent' (*Hengist* dumb-show ii.20) given by each woman to her seducer marks her as, in Joseph's Swetnam's words, 'easily wooed and soone won, got with an apple and lost with the paring' (26–7). As the anonymous author of *The Schoolhouse of Women* (1541?) puts it: 'Few or none, for the most part, / Gently entreated, deny you can / Within her tables to enter her man' (Henderson and McManus 139). In the same vein, in *The Revenger's Tragedy* Vindice presents the adorned skull as 'a country lady, a little / Bashful at first as most of them are, but after / The first kiss my lord the worst is past with them' (3.5.132–4).

Context, however, is all, and these dumb-shows serve entirely different ends in their respective plays. In *Hengist*, for example, although Castiza is at some points placed in parallel relation to the villainous Roxana (both are wooed by Vortiger, and forced to swear oaths of chastity before him; 4.2.135–269), the parallel is clearly designed to emphasise a contrast. Castiza remains true to her name, chaste – 'neither by Consent / Or act of violence staind' (5.2.261–2). Far from indicting her, the dumb-show is designed to exonerate her. This it does partly by the presenter's framing commentary, which emphasises both the coercion of Castiza's male relatives and her own virtuous obedience:

> Then Crowne they him, and force ye mayd
> That vowd a virgin life to wedd,
> Such a strength greate power extendes
> It Conquers fathers, kinn, and friendes;
> And since fate's pleasd to Change her Life
> She prooves as holy in a wife.
>
> (Chor.3.11–16)

Yet it is not only careful rhetorical management that mitigates this potentially damaging visual display. As in many other dumb-shows, theatricality is so overdetermined here that it becomes unreadable. The same stage directions in the manuscript version imply on the one hand simply the

stylised gestures of pantomime ('*Vortiger seemeing to solissitt them*' [dumb-show 2.2]; '*ye two* Brothers *who much astonished seeme to fly*' [dumb-show 2.21]) and on the other the posture of deceit ('*he seemes to express much sorrow*' [dumb-show 2.11–12]).[20] Actions become difficult to interpret – as, for example, the murderers who '*seeme to be over Come wth pittye*' (dumb-show 2.7). Are the actors required to mime real pity or to feign pity? How can the audience tell the difference? Likewise, when Castiza '*seems to be brought in unwillingly*' (dumb-show 2.17), is she unwilling or feigning unwillingness? In this case the metatheatrical context mitigates or neutralises the otherwise strong overtones of female weakness and dissimulation.

Like Castiza, Maria in *Antonio's Revenge* enters the dumb-show a virtuous woman and leaves it joined to a murderous villain. In Dieter Mehl's view this signals Marston's incompetence: 'Piero's attempt to convince Maria of his love and to persuade her to accept him [is] obviously a dramatic situation calling for dialogue and persuasive rhetoric. As a pantomimic scene it loses all dramatic effectiveness and conviction' (128). Yet this, surely, is precisely the point. Though Maria is certainly not a Castiza, Marston needs to downplay her feminine weakness in order to remake her later as a credible revenger. He does this by distancing her fall from the audience by means of the dumb-show. Had Marston chosen to play the scene out dramatically, he would have ended up with something like Vindice's temptation of his mother Gratiana in *The Revenger's Tragedy*. A woman who can say, as Gratiana does, 'Men know, that know us, / We are so weak their words can overthrow us' (2.1.105–6) can hardly expect to play the major role in the final bloody revenge that Maria does. Thus both Marston and Middleton use the dumb-show to remove from their women an agency which would otherwise convict them.

This brings us, of course, to *Hamlet*. Its dumb-show is structured far more carefully than either of the other two to reveal a pattern of repeated 'shows' by the Player Queen. This pattern is especially clear in the Folio text: upon entering with the King, the Queen '*makes shows of protestation*' to him; upon discovering his death, she '*makes passionate action*'; upon being wooed by the poisoner, she '*seems loath and unwilling*'. Do these repeated shows indicate the theatricality of the Queen – as she feigns love for her husband, grief for his death and reluctance in betraying him?

Rosenberg thinks so: 'Sincere as her silent protestations of love may seem, something hollow in her makes the King doubtful, makes him lie down in some unease, makes her leave almost as if she is aware of the imminence of the poisoner' (*Masks* 577). Yet the stage directions, which call for highly stylised, conventionalised theatrical gesture in each case, make it impossible to distinguish what is simply mimed from what is dissembled. Exaggerated gesture need not indicate insincerity or hypocrisy; in *The Winter's Tale* deep feeling is highly theatrical: 'There was casting up of eyes, holding up of hands, with countenance of such distraction' (5.2.42–3). If the protestations of love at the outset are stylised representations of genuine love, is the Queen's unwillingness at the end a real resistance akin to Castiza's in *Hengist* – a resistance which shifts the focus of blame on to her villainous seducer? The other dumb-shows prove that the spectacle of a woman yielding to her seducer need not convict her.

It is clear that these questions raised by the dumb-show are simply unanswerable. Patricia Parker finds the dumb-show in *Hamlet* closely linked metaphorically to 'grotesque' female sexuality, 'the proverbial inability of women in particular to keep from disclosing what should be hid' ('*Othello*' 127). What makes this show really threatening, however, is not its revelation but its dissimulation of secrets – its unmanageable indeterminacy. And, as Jacqueline Rose points out, in both *Hamlet* itself and *Hamlet* criticism, 'what is in fact felt as inscrutable, unmanageable or even horrible … is nothing other than femininity itself' (38).

The success of Hamlet's plan in producing 'The Murder of Gonzago' relies on the authenticity and intelligibility of theatrical representation, even though Hamlet himself continually inveighs against the deceptiveness of theatre, of those 'actions that a man might play' (1.2.84), and explicitly rejects dumb-shows as 'inexplicable' (3.2.10). In fact this dumb-show justifies Hamlet's fears about unmanageable spectacle, turning his theatrical impulse back on itself to reveal theatre as, in Maus's words, 'an art of incompletion: a form of display that flaunts the limits of display' (210). The dumb-show should alert us at an early stage to subsequent flawed attempts at mimesis, when, for example, Hamlet's narcissistic desire substitutes nephew for brother in the murder scene (3.2.247), making Claudius's response overdetermined and unreadable. In a larger sense, of course, there is mimesis, though not the kind Hamlet wants or expects: the

unintelligibility of theatre mirrors the shifting uncertainties of Hamlet's world, which are in turn reflected in unmanageable feminine silence.

Staging androgynous silence

King Lear illustrates the agency potentially available to women within the figure of silence which, instead of keeping both genders in their places, frequently allowed them to trade and borrow one another's qualities freely. Yet this move towards androgyny did not come without considerable resistance. Even as women adopted traditionally masculine attributes in their deployment of silence, the 'inscrutable' silence which was often recommended for early modern men bore a strong and sometimes unsettling resemblance to self-enclosed, impenetrable and potentially 'passive' female silence. Predictably, a number of early modern texts reveal anxiety about this cross-gendering of silence. In Jonson's *Volpone*, for example, the bedridden Volpone reacts to Lady Politic's 'flood of words' by invoking Euripides or Sophocles (190n.) to stem her 'torrent' (3.4.64), crying: 'The poet, / As old in time, as Plato, and as knowing, / Says that your highest female grace is silence (3.4.76–8)'. Of course Volpone dignifies feminine silence only in order to shut his voluble companion up. A few lines later, however, he desperately declares that he will 'Profess obstinate silence' (86) as his 'safest' refuge. On the surface the double standard for silence noted at the beginning of Chapter 2 seems intact: man's silence is an expression of will, yet the silence to which he seeks to reduce woman can apparently mean only desired submission. John Taylor endorses Volpone's approach to Lady Would-Be in *A Juniper Lecture* (1639). In his advice to men plagued by scolding wives, Taylor writes:

> There is nothing more vexing to a scold, than when she perceives the party she scolds at not to be vex'd: for they cannot be angred worse than not to answer them … for an Answer is encouragement; and indeede it is too much Honour for a man either to descend so low as to take notice of what they say, or to stoope lower to afford them any Reply, but to shame them with their mortall enemy, Silence. (Henderson and McManus 201)

In Taylor's text the taciturn man is a 'strong, silent type'; the woman reduced to silence is by implication simply erased. While Volpone clearly

appeals to just such a gendered double standard, the fluid and complex power relations in the play as well as the immediate dramatic context undermine his concerted attempts to fix and gender silence. Volpone's double standard is a defensive gesture to distinguish his own powerlessness (as he lies in bed feigning disease) from the traditionally feminine position: *his* silence, he insists, is obstinacy, not the feminine subordination it so closely resembles. In Jonson's later play *The New Inn* (1629) the lovesick Lovel 'stand[s] mute' (5.6.117) before Frances, expecting that 'she might read it [desire] / Best in my silence' (115–16), but he is roundly condemned by the Host (Frances's father in disguise): 'Could you blame her, sir. / When you were silent and not said a word?' (113–41). Jonson's neo-Stoic masculine ideal of 'the plain and passive fortitude / To suffer, and be silent' (*Sejanus* 4.294–5) is in both cases a mask for male impotency.

Anxiety about silence as an emasculating, feminised space emerges more explicitly in Shakespeare's *Macbeth* and *Coriolanus*. In *Macbeth* Macduff learns of the murders of his wife and children and visibly retreats into unspeakable inwardness. His companion Malcolm objects to his silence: 'What, man, ne'er pull your hat upon your brows. / Give sorrow words. The grief that does not speak / Whispers the o'erfraught heart and bids it break' (4.3.209–11). While the advice he offers is purely conventional, based as it is on Seneca's *Hippolytus*, the ensuing conflict over Macduff's silence is far from gender-neutral. The only speech acts Macduff can perform are interrogative and exclamatory, fragmented verbal ejaculations which merely intensify his hidden pain: 'My children too?' (212); 'My wife killed too?' (214); 'All my pretty ones? / Did you say all? … All?' (217–18). His disordered language does not conform to Malcolm's idea of the 'words' he should utter to dispel grief and silence: 'Dispute it like a man' (221), Malcolm reproaches him. The Arden edition glosses 'dispute' as 'struggle against' (135), yet here it also retains its primary meaning of 'debate, discuss, argue' (*OED* v.3). Malcolm urges Macduff to reject not grief but silence and linguistic chaos, which he implicitly genders feminine in urging Macduff to return to coherent male speech. Macduff's response, however, reinscribes the feminine as masculine: 'I must also feel it as a man' (223), he tells Malcolm. Yet this glimpse of androgyny is rapidly obscured as Malcolm urges Macduff to use his grief as 'the whetstone' of his sword (230), and Macduff responds – significantly – with a misogynist reassessment of his

own behaviour. 'O, I could play the woman with mine eyes / And braggart with my tongue' (232-3), he tells Malcolm, reconstituting femininity as artifice, equivalent to the mere show of the garrulous braggart. In doing so Macduff realigns himself with silent, eloquent masculine *deeds* and banishes the spectre of silent feminine inwardness. 'This tune goes manly' (237), Malcolm tells him approvingly.[21]

This scene rewrites a similar moment in *The Rape of Lucrece*, when Collatine reacts to Lucrece's suicide after her rape:

> The deep vexation of his inward soul
> Hath served a dumb arrest upon his tongue,
> Who, mad that sorrow should his use control,
> Or keep him from heart-easing words so long,
> Begins to talk; but through his lips do throng
> Weak words, so thick come in his poor heart's aid
> That no man could distinguish what he said.
>
> (1779-85)

While this again seems initially no more than a reprise of the Senecan commonplace of inarticulate grief, Collatine's moment of silence followed by incoherence has uncomfortable implications for a man who is, after all, the cuckolded husband of a woman whose rape appears to give her full access to speech.[22] He returns to full masculine strength first by celebrating his claim to possession of the woman against another man (like Hamlet in his contest with Laertes), and then by turning to an act of bloody revenge (like Macduff). In these plays silence marks an unruly interior feminine space which is quickly suppressed in favour of eloquent male action.

Whether the space of silence was rejected as emasculating or recuperated for masculine virtue depended on text and context, however. In *Hamlet*, for example, a speech which follows Hamlet's quasi-parodic shouting match with Laertes at Ophelia's graveside reads: 'Anon, as patient as the female dove / When that her golden couplets are disclosed, / His silence will sit drooping' (5.1.271-3). The speech is assigned to different speakers in variant texts of the play – to Claudius in Q1 (in a different form)[23] and in F, and to Gertrude in Q2[24] – and the gender of the speaker has a significant bearing on the impact of the speech. If Claudius delivers the lines (and directs them to Laertes, as in Q1), they may signal his attempt

to deflect the 'danger' he fears earlier will be hatched by Hamlet's brooding melancholy (3.1.163–6) by sneeringly predicting his lapse into impotent, feminised ('drooping') silence after (feminine) rhetorical excess. If Gertrude delivers the lines, however, she may be heralding her son's shift from his 'fit' of uncontrolled verbal hyperbole into patient, contemplative silence, assigning it a more positive value. In the latter reading the speaker uses the childbirth metaphor to associate the production of poetic form ('golden couplets') with the act of giving birth; the silence that follows is a silence of consummation that is gendered feminine. This small textual moment strikingly illustrates the potential ambiguity of silence when adopted by men.

Coriolanus

In Shakespeare's *Coriolanus* the values attached to silence cross and recross gender lines in striking and complex ways. Initially the double standard for silence seems firmly in place: Coriolanus hails his wife Virgilia as his 'gracious silence' (2.1.161), yet represents his own silence as a very ungracious critique of language as opposed to action, declaring to Brutus: 'oft / When blows have made me stay I fled from words' (2.2.67–8). While such an admission might imply effeminate cowardice, it is proffered here as aggressive self-sufficiency. Yet the reticence that is acceptable and decorous in Coriolanus's wife is perceived as inappropriate in him: as a form of resistance to social exchange, it makes him unfit for public office. 'It then remains / That you do speak to the people' (2.2.131–2), says Menenius, reminding Coriolanus that military action must be supplemented by words in the masculine Roman world of politics. Silence as a sign of classical male stoicism is highly problematic in *realpolitik*. Volumnia attempts to accommodate his silence to a dominant rhetorical model when she advocates silence as eloquence, telling her son 'Action is eloquence, and the eyes of th'ignorant / More learned than the ears' (3.2.76–7). At the same time, however, she problematises the gendering of this silence by acting it out herself as feigned humble submission, which Coriolanus associates with the harlot and the beggar (3.2.112, 117). In the final act Coriolanus recuperates silence as a sign of stoic masculinity, presenting himself as a *man* who is 'author of himself' (5.3.36), 'Not of a woman's tenderness' (130) in marked contrast to the group of *women* including Virgilia, whose *subordinate* silence is broken only

by the greeting 'My lord and husband' (5.3.37). Volumnia deplores the autonomy proclaimed by his silence; for her it is tantamount to adultery: 'This fellow had a Volscian to his mother. / His wife is in Corioles, and this child / Like him by chance' (5.3.179–81), she tells the audience. For her his resistant silence repudiates the very foundations of masculine identity as head of his household and citizen of Rome.[25] Thus, while Coriolanus's famous capitulation to his mother's appeal – immortalised in the stage direction, '*holds her by the hand, silent*' (5.3.183 s.d.) – is associated by Aufidius with the impotence and male effeminacy of a 'boy of tears' (5.6.103),[26] it has already been constructed by his mother as an acknowledgement of *patriarchal* as well as filial responsibility. At this moment, as critics have observed, Volumnia clearly remains the overbearing matriarch who threatens her son and Coriolanus is still the 'overstrained child' (*Observer* 16 April 1967, rev. of 1967 Royal Shakespeare Company production) who simply gives in. But critics who see only 'a child holding his mother's hand' (Adelman, 'Anger's' 119) underestimate the depth and resonance of that remarkable silence. R. B. Parker points out that the moment is 'fraught with contradictory meaning: weak surrender, new humility, grief (as with Macduff), strength of family affection, and a deeper, more mysterious affirmation' (*Tragedy* 102). Silence in *Coriolanus* is inescapably gendered through most of the play: masculine silence is associated with action, resistance and eloquence, while feminine silence is tied to submission. Coriolanus's silence when holding his mother's hand, however – as a simultaneously masculine and unmasculine space – becomes a contested site which finally blurs the distinctions it raises between different forms of silence.

If *Coriolanus* evokes the gendered double standard for silence only to interrogate it, the same has not generally been true of the play's critics. Although the moment of silence assigned to Coriolanus by the stage direction belongs also to Volumnia, even those critics prepared to accept change and complexity in Coriolanus deny them to his mother. Whilst his silence at the end of her plea is seen as 'a breaking-through into a new territory of value and of moral experience' (Brockbank 59), her silence is invariably seen as an inability 'to voice the sympathy, approval, or affection the moment naturally invites' (Kahn 171). Yet if Coriolanus's moment draws on the androgyny of early modern silence, Volumnia's silence too may be more complex than at first appears. As R. B. Parker points out, 'this play

… has many such "overdetermined" gaps and silences – moments, that is, for which no explanation is given, not because there is none, but rather because too many, contradictory explanations and emotional subtexts are possible' ('Tale' 137).

Volumnia's silence in this climactic scene gathers its complex resonance first from the play's non-verbal structural repetitions and variations. In the earlier supplication scene (3.2) – which has no counterpart in Shakespeare's source – Volumnia enters alone and is joined by senators and nobles; the case she presents is political rather than personal. In the later scene Volumnia is one member of a collective of 'all living women' (5.3.98) – a collective dominated by the gentle wife who 'comes foremost' (5.3.22).[27] Coriolanus's startling lyrical transformation of the chatty busybody Valeria into a semi-icon, 'chaste as the icicle / That's candied by the frost from purest snow / And hangs on Dian's temple' (5.3.65–7), evokes dramatic antecedents like the pleading of the virgins before Tamburlaine (*I Tamburlaine* 5.1), and distances the mother–son encounter. No longer a political strategist, Volumnia stands in opposition to the real political presence of Aufidius and his soldiers. And, in a play in which outward appearance is seen to reflect inner essence – in which, Brockbank points out, 'all qualities of the spirit have a physical manifestation' (46) – the women's change of 'raiment' (5.3.95) for this scene is full of meaning. Volumnia's pleading rags look back to two earlier moments – to the gown of humility worn by Coriolanus when he sues for votes (2.3), and to the '*mean apparel*' he dons when he turns to Aufidius and the Volscians (4.4.1 s.d.). The double analogue suggests Volumnia's ambiguity throughout the supplication scene – her tattered garments may be at odds with her inner arrogance, as in Coriolanus's appeal for votes, or they may recall Coriolanus's reversion to the enemy, when his mean attire was 'a potent visual suggestion that something in the man himself, not just in his circumstances, ha[d] changed' (Van Dyke 143). The latter echo may suggest that here Volumnia, like her son in Antium, bares herself to the enemy and finds herself in a situation for which her nature had never been prepared, requiring a compromise of absolute values.[28] The rags worn by mother and son in the last two acts can suggest a connection between their individual moments of crisis, when both make a choice to abandon pride and self-sufficiency and seek clemency in the bosom of the enemy – a choice of which both must later become victims.

This somatic language infuses Volumina's discourse. As she begins to speak, Coriolanus anticipates and rejects the 'colder reasons' (5.3.86) he heard earlier; what he gets is a verbal plea anchored in physical sensation. For, though the text of Volumnia's speech stays remarkably close to Plutarch's original, it is filled out by phrases which convey the physiological strain on the women, who 'weep and shake with fear and sorrow' (5.3.101) at the bodily violence of Coriolanus, 'tearing / His country's bowels out' (5.3.103-4). Moreover Volumnia's motives for her intervention remain complex and obscure. Does she still sincerely believe that peace is an alternative? It seems important that Coriolanus is finally convinced, not by the blatant emotional blackmail of the first part of Volumnia's speech, in which she outlines her dilemma and threatens suicide, but by the peace plan she sets out in the second part. Yet even a fully cognisant Volumnia must leave us with a tangle of equally unresolved questions. Is she saving her own skin at her son's expense? Is she still the coldly patriotic virago of the first act, sacrificing Coriolanus for the sake of Rome? Or is her patriotic sacrifice made in conscious, agonised awareness of its costs for herself and her son? If so, it is a far cry from the one she gleefully imagines in Act I. Is it a sacrifice made not for Rome but for the young wife and child with her on the stage? Or is she committed to saving Coriolanus from his own inhumanity, even at the cost of his life? These indeterminate and multiple possibilities culminate in the lengthy moment of silence Volumnia shares with her son; while defying simple description or representation, it is a moment of potential complexity and transformation for both characters. The conflicting early modern discourses of silence – as power or as impotence, as innocence or as guilt, as acquiescence or as grief – contribute to make Volumnia's silence just as complex as her son's.

Volumnia's silence at the end of the supplication scene is followed by another, when she passes wordlessly over the stage in the company of Virgilia and Valeria as a Roman senator hails her as 'our patroness, the life of Rome' (5.5.1). Critics tend to take the senator's word for it; they usually see her as 'the one triumphant figure that survives the play, the savior of Rome' (Berry, 'Sexual' 315) and insist that she is not 'given a moment of reflection or of recognition that [she has] caused Martius' death ... Coriolanus' new acknowledgement of the power of tenderness and family

bonds does not change the grim world of the play; it does not even change Volumnia' (Pearson 180).[29] As Janet Adelman puts it:

> When Volumnia triumphs over his rigid maleness, there is a hint of restitution in the Roman celebration of her as 'our patroness, the life of Rome' (5.5.1). But like nearly everything else at the end of this play, the promise of restitution is deeply ironic: for Volumnia herself has shown no touch of nature as she willingly sacrifices her son; and the cries of 'welcome, ladies, welcome!' (5.5.6) suggest an acknowledgment of female values at the moment in which the appearance of these values not in Volumnia but in her son can only mean his death. ('Anger's' 121 n.7)

Silence, it seems, appears to be not only entirely legible but also resistant to any transformative or subjective potential; critics read Volumnia as acquiescent to the interpretations of those around her. But what about a Volumnia who shows not only a 'touch of nature' in the final scenes but an agonised awareness of the costs of her actions? Might the silence of Volumnia's final scene draw on the oft-reiterated Senecan topos of unutterable grief (*Hippolytus* 607) as well as on the public display of the early modern triumphal procession? Might it also hint at a subjectivity not fully accessible or readable to an audience? It seems reductive to read Volumnia as a primeval mother-goddess whose promise of loving union includes inevitable death for her son (Sprengnether 106).

Whilst modern performances clearly do not recuperate Shakespeare's actual practice (Worthen 14), they can open up a range of neglected interpretive possibilities. If some directors show us Volumnia's fierce delight at her son's capitulation (often – as in the 1978 and 1990 Royal Shakespeare Company productions – departing from the text to present young Martius as her next exalted victim), others have conceived of her quite differently. Following a venerable modern stage tradition (which includes at least five major productions since 1954),[30] Irene Worth rendered Volumnia's silence in the 1984 National Theatre production as mute devastation. Francis King records what he called 'her finest moment': 'Small, twitching smiles acknowledge the plaudits, but the eyes express a terrible desolation, since she already realises that he must die' (*Sunday Telegraph* 23 December 1984). This much-praised interpretation, integral to what was hailed as 'the best Shakespeare production to emerge from the National in its 21

years' (Billington, *Guardian* 17 December 1984), presented a 'deeply thoughtful' Coriolanus who, in the supplication scene, 'grows up as we watch, and becomes human, and so has to be killed' (Barber, *Daily Telegraph* 17 December 1984). In this production Volumnia's complex silence seemed to measure her son's emotional achievement.

A closer look at the brief scene as it is printed in the Folio lends support to this staging. In the previous scene a relieved and exultant Menenius joins with the tribunes in anticipating Volumnia's triumphant return; the joyful noises of the crowd are heard offstage. In the procession itself, however, there is no entry recorded for Menenius, the tribunes or the boisterous mob; since most of the company is probably needed to fill out the crowd in the next scene, the women are accompanied only by two senators and 'other lords'.[31] One of the senators urges:

> Call all your tribes together, praise the gods,
> And make triumphant fires. Strew flowers before them.
> Unshout the noise that banished Martius,
> Repeal him with the welcome of his mother.
> Cry, 'Welcome, ladies, welcome!'
>
> (5.5.2–6)

But no noisy crowd carries out the senator's commands and guides our response; as its surrogate, the audience can only sit in uneasy silence. The quiet of the procession contrasts with other noisy processions in the play (notably with Coriolanus's in the following scene 5.6.48) and with Plutarch's account of the 'honorable curtesies the whole Senate, and people dyd bestowe on their ladyes' (Brockbank 364). The effect is potentially both ominous and deflationary. The 1981 Stratford, Ontario production, directed by Brian Bedford, captured the mood of this oddly untriumphant 'triumph' by using a frieze of citizens on the upper stage. As Ralph Berry tells it:

> Bedford showed a cortege. Led by a grim, unsmiling Volumnia, the black-clad procession of the three women and young Martius moved rapidly across the stage. There were no words, no sounds of applause, only the electronic bells in Gabriel Charpentier's disturbing and moving soundscape. On the upper stage, a rectangle of harsh light picked out the citizens as in a film frame, the people soundlessly crying their applause for Rome's savior. The effect was ominous, tragic, heart-stopping. ('Stratford' 202)

If the scene is staged less as a triumph than a dirge, a mournful Volumnia further reinforces the tension between word and image. Still wearing the dishevelled garb of the supplication scene, she casts – as a reviewer of the 1954 Old Vic production put it – 'a mauve shadow on the optimism' (Brink, *Truth* 5 March 1954) of the senator's words, and stands in opposition to other members of her class. A terse silence shared by Volumnia and the theatre audience knits them together in common resistance to any simple view of the supplication scene, confirming its complexity. And if the scene is played as a rejection of public acclaim, it brings the wheel full circle; the mother's silence recalls her son's: 'No more of this, it does offend my heart' (2.1.154). In *Coriolanus* the androgyny of early modern silence works to complicate oversimple notions of silently submissive men or of women silently acquiescent to the constructions of others. By mapping silence as a complex interior space and then extending it to Volumnia as well as Coriolanus, Shakespeare exploits its androgynous potential. In doing so he also fashions a fully tragic female protagonist – in Michael Goldman's words 'a woman who could be Lear' (193).

As early modern English men became increasingly aware of the potential duplicity and danger of speech in an age of turmoil, they sought and validated silence as a space which, when detached from the masculine silence / eloquence trope, was traditionally defined as feminine. Thus feminine silence began to do ideological work for early modern males by signalling the turn away from rhetorical culture. This ideological shift had multiple effects: even as it stimulated considerable anxiety about emasculation, it also led to feminine silence itself assuming a prominent place in the public forum of the drama. Of course, in a public theatre written and acted only by males,[32] gender was always a matter of representation rather than embodiment. Silent women such as Lavinia and Cordelia who stand at the centre of their respective tragedies are prominent not as female subjects but as embodiments of masculine scepticism about the limits of masculine rhetoric and hermeneutics. Maus argues that 'The woman's body … incarnates in risky but compelling ways some of the particular privileges and paradoxes of Renaissance subjectivity' (191); investing these figures with silent subjectivity was risky because it evoked other, ambivalent associations with feminine silence – as lasciviousness, as disobedience – and these provoked further anxiety which had to be managed. Yet it is significant that, at this

point in history, it served male interests to represent and stage silent female subjectivity, despite its dangers, for this move could serve to enlarge the options open to real early modern women. The following chapter will explore some of the ways in which these women appropriated and reshaped the 'moving Rhetoricke' of silence for their own purposes.

Notes

1 We may recall here on the one hand Guazzo's silent listener, who strives 'to keepe the mouth more shut and the eares more open' (120) to improve conversation, and on the other Erasmus's adage that 'Silence breaketh many friendships' (*Proverbes* fol. xxxir).

2 Early modern audiences were sometimes silent, sometimes not. Drayton describes a theatre filled with 'Showts and Claps at ev'ry little pawse, / When the proud Round on ev'ry side hath rung' (cited Gurr 209), though in Middleton's *The Roaring Girl* one character describes a cutpurse working the crowd, 'whilst with obsequious eares, / Thronged heapes do listen' (1.2.25–6).

3 Christ delivers two prayers during the course of the play (49–60, 253–64); their effectiveness depends on his prolonged silences as the soldiers nail him to the cross.

4 Elam warns against 'the danger of viewing the performance as a "language" directly analogous to speech and thus a suitable object for analytic models taken straight from linguistics' (35), though this is none the less the aim of his book.

5 Dale Randall argues that Jonson wrote the masque 'as a mode of satirical admonishment' (12) to discredit Buckingham by representing him as a thieving gypsy and rapacious upstart; if so, the Prologue may well have been intended ironically, to point to the potential unruliness of Buckingham's apparently deferential silence. I am grateful to Andrea Stevens for drawing my attention to this masque in her M.A. thesis, '"A Disguise Sufficient": Representations of Racial Otherness in *The Masque of Blackness* and *The Gyspies Metamorphosed*' (M.A. Dalhousie, 1998).

6 That Hieronimo is first identified with the silence of the 'inexplicable' (*Hamlet* 3.2.10) dumb-shows is significant, for they illuminate its potential resistance to careful management: while Hieronimo's entertainment is apparently intended to flatter both his own King and the Ambassador of Portugal (as common enemies to England), the Ambassador reads it as a chastisement to Spain (168–71), and English theatre audiences would undoubtedly have understood it as an allegory of triumph for England over both Spain and Portugal.

7 Lyly's *Euphues and his England* has an account of the famous story which reads as follows: 'Zeno bicause he would not be enforced to reveale anything against his will by torments, bit off his tongue and spit it in the face of the tyrant' (146).

8 Daniel Stempel offers a reading of Iago's final silence as a manifestation of Jesuitical Machiavellianism, in its 'assertion of the freedom of the self-determined will' (262) – a notion that would, of course, have been abhorrent to English Protestants. He argues that 'If he [Iago] is no longer free to act, he is at least free not to act, to remain silent and unmoved by accusations and threats'. Stempel's argument about Iago's resolute will manifest in silence illuminates Hieronimo's position by contrast, for, if Iago advocates 'the Jesuit emphasis on the self-deter-mination of the will' (258), Hieronimo represents the opposite: a man whose will is in fact in the service of a force beyond himself.

9 Whilst Watson views Hieronimo's self-silencing as his attempt to erase and con-tain death and mourning (62), he also points out that 'The invasion of reality into Hieronimo's fiction attacks our mythology of denial' (72). While Hieronimo clearly seeks self-definition and control in biting out his tongue, the theatre audi-ence may find in his theatrical gesture a return of the very chaos and annihilation that he attempts to foreclose.

10 Bakhtin's well-known formulation comes from *Rabelais and his World*, and is explicated by Rebhorn as follows: 'the first [classical body] is completed, limited, and self-contained and can be read as an expression of the "official," upper-class culture of the Renaissance; the second [grotesque body] is unfinished, trans-gresses its own boundaries, constantly interacts with the world around it, and is tied to folk and popular culture and to rituals of inversion such as carnival' (*Emperor* 198–9). I appropriate Bakhtin loosely here to articulate an essential par-adox in cultural constructions of silence; unlike Bakhtin's classical body, however, neo-Stoic silence frequently was not a ratification of official culture but a protest against that culture.

11 One text which foregrounds these divergent constructions of silence especially well is Affinati's *Dumbe Divine Speaker* (1605). On the one hand the author refers to 'unnecessarie and ill shapen silence' (8) which is frequently instigated by the devil, 'making a man dumbe, and bereaving him of the use of speeche' (120). On the other hand the author recommends silence as 'the onely best coverture for this vessel [of our heart] … the guarde of the conscience, a bridle from insolence, the beautie of innocence, and a signe of sapience' (27).

12 Deborah Warner's prompt script for her 1987 production reads 'C[hiron] pulls her head back and savagely kisses L[avinia] – spits out piece of her tongue'. (Previous directors miss or ignore the sexual implication.)

13 The term is M. M. Bakhtin's, from *Rabelais and his World*, but is applied by Peter Stallybrass specifically to the female body, which is '*naturally* "grotesque"' (255).

14 Philip McGuire invents the term 'open silence' for a silence which is 'textually indeterminate' (xix) – when, in other words, the text itself offers no guidance as to how the silence should be interpreted on stage. In his view a silence which is 'open' in the text must always be closed in performance: 'Isabella may in silence agree to or refuse to marry the Duke or she may refuse to make such a decision,

but she cannot do all three simultaneously' (143). Whilst I agree that such a moment calls for a decision on the part of actor or director, I cannot accept that indeterminate silence cannot be represented on the stage. Anthony Dawson points out that 'silences are ... a sign of the indeterminacy of the text as a whole, of its refusal to yield univocal meanings' (320). Like performance itself, stage silence complicates and undermines attempts to fix and determine its meaning. McGuire's point that an actor cannot do everything at once should not lead us to oversimplify what an actor can do, or to represent as a failure what is really a strength. Isabella may agree to marry the Duke gladly, reluctantly or resentfully, for example (to widen McGuire's range of options), but an audience may never be able to read her motives for or feelings about doing so with certainty.

15 Lamb remarks that 'as she holds a basin between her stumps to catch the spurting blood, Lavinia is acting the role of dutiful daughter as well as of revenger', and 'Lavinia has become a figure of pathos rather than of rage' (219). Whilst I agree with Lamb's reading of Lavinia's diminished role at the end of the play, I argue that Lavinia's silence earlier in the play elicits and exceeds the men's attempts to define and contain it.

16 On the ascendancy of the 'Attic' style in the late sixteenth and early seventeenth centuries see Croll. On the gendering of the Attic and Asiatic styles see McDonald.

17 Rovine, for example, contends that '[Ophelia's] silence not only indicates her inability to direct her own destiny, but also her tragic acceptance of her position' (46), whilst Sandra K. Fischer remarks: 'The silences of the hero [Hamlet]'s female counterpart add a telling layer of commentary to the dialectic of speakable/unspeakable determined by the textual politics of Renaissance society' (3). In Fischer's view Ophelia's 'sole rhetorical remedy is elliptical, a hermeneutics based on silence, absence, and ambiguity' (7). As the title of Fischer's essay suggests, however, her aim is to 'hear' Ophelia and translate her silence into discourse. Anthony Dawson acknowledges that 'One way of reading Ophelia's madness may be to see it as a silence that enables Hamlet's speech', but argues instead for 'Ophelia's madness as central, not peripheral, as a mark of the text's appetite, what it desires: freedom *from* interpretation or mastery' ('Making' 433). Dawson's brief suggestion anticipates some of my argument here.

18 Lisa Jardine points out that Gertrude is 'Virtually silent on her own behalf (Gertrude speaks fewer lines than any other major character in the play)' (*Reading* 149). G. B. Shand also remarks that 'the role is relatively silent, leading many observers to characterise the Queen as unthinking, unintelligent, unresponsive, unaware' (104). Shand goes on to argue that Gertrude actually remains carefully within prescribed feminine decorum equating silence with chastity, and he cites the following lines from the closet scene as evidence for the fact that 'she understands the theory behind her silence': / 'Be thou assur'd, if words be made of breath, / And breath of life, I have no life to breathe / What thou hast said to me' ([3.4.]197–9). Whilst Shand's primary concern is with the art of the actor playing Gertrude, he

anticipates some of my concerns with his comment, 'Interpretation of her silence as emptiness, then, is not in line with Renaissance attitudes' (105).

19 Dessen and Thomson note that verbs of 'seem, seeming' are 'used most often for events in *dumb shows* and other pantomimed actions' but also occur 'as an equivalent to *counterfeit, feign, pretend*' (*Dictionary* 190).

20 McJannet comments that 'The evidence of other dumb-show directions suggest that "seeming" was the preferred term to describe the miming required of the actors', although she also observes that 'Vortiger's sorrow is in fact pretense, and refers to the character's, not the actor's, "seeming"' (162).

21 Here I differ from Coppelia Kahn, who argues that 'courage and pity fused, [Macduff] marches against Macbeth, his opposite in every sense, who kills pity in the name of courage' (189–90), and find myself in agreement with Janet Adelman's view that 'Dramatically and psychologically, [Macduff] takes on full masculine power only as he loses his family and becomes energised by the loss, converting his grief into the more "manly" tune of vengeance' (*Suffocating* 144).

22 Jonathan Bate finds in Lucrece's loquaciousness 'an eloquence that may well appear indecorous in the mouth of the violated' and claims that 'Shakespeare did, I think, recognise that there is potentially something tasteless about giving so much rhetorical copiousness to a persona who is supposed to have been raped' (*Shakespeare* 81). Bate's tacit assumption linking voice and sexuality, however questionable in a contemporary critic, none the less illuminates a tradition in which the text participates.

23 The Q1 lines read: '*King.* Forbeare *Leartes*, now is hee mad, as is the sea, / Anone as milde and gentle as a Dove: / Therfore a while give his wilde humour scope' (I2r).

24 Hibbard in his Oxford edition attributes the speech to Claudius on the grounds of its similarity to Claudius's metaphor at 3.1.165–8: 'There's something in his soul / O'er which his melancholy sits on brood; / And I do doubt the hatch and the disclose / Will be some danger.' Shand, however, prefers Q2's attribution to Gertrude, commenting that 'the specificity of "female dove" and "golden couplets," and its beautifully organic relation with patience and silence, suggests a shift from a formulaic and ham-handed misappropriation of birth imagery, expressed by a suspicious male, to the same imagery expressed by a nurturing personality' (106n.). See also Leverenz's remark that '"the female dove" in him prepares for a final silence ... Inwardly he has already left the world of fathers, roles, and mixed messages' (305).

25 The kind of 'Stoicall disposition of husbands to their wives' Coriolanus displays is likewise deplored by William Gouge, who recommends 'courteous behaviour, gesture and speech' for husbands, and denounces 'the disposition of such husbands as have no heat, or heart of affection in them: but Stoic-like delight no more in their own wives than in any other women' (362).

26 I associate boys with women by recalling not only theatrical practice but also Rosalind's remark in *As You Like It* that 'boys and women are for the most part cattle of this colour' (3.2.371).

27 The physical detail is from Plutarch, but Virgilia's prominence at the beginning of the scene is insisted on by Shakespeare: in Plutarch he kisses his mother first; in Shakespeare he first exchanges a long and passionate kiss with his wife (5.3.44–5).

28 A reviewer of the 1965 American Shakespeare Festival production remarked that 'When she attempts to persuade her son that he must compromise, this Volumnia argues with a blazing temper but lets it be seen at once whence came his pride. When she leads the women to plead for mercy, she is a humble, piteous figure' (Taubman, *New York Times* 21 June 1965).

29 Critical consensus on Volumnia is reflected in Harold Bloom's statement that 'Volumnia hardly bears discussion, once we have seen that she would be at home wearing armor in *The Iliad*' (4). Yet discussion there has been, particularly among feminist and psychoanalytic critics, who usually find in her the chief cause of both Coriolanus's masculine aggression and his eventual death at the hands of the Volscians. Because his mother failed to nurture him as a mother should, Coriolanus channelled his need for nourishment into phallic aggression. Because, again, it is Volumnia who makes the case for 'great nature' in the supplication scene, this fleeting hope of redeeming, 'female', values is contaminated at the source.

30 I include in what follows evidence for four productions' interpretations of Volumnia's silence as devastation – the 1954 Old Vic, the 1972 Royal Shakespeare Company, the 1981 Stratford, Ontario and the 1984 National Theatre. In a letter R. B. Parker tells me that in the 1961 Stratford, Ontario production 'the scene was presented as a torchlit procession under cover of darkness, with black-garbed women hurrying home stony-faced among huge flickering shadows'. Richard David describes Volumnia crumbling during the procession in the 1972 RSC production, 'her ravaged face showing no glimmer of joy, hardly of life' (146).

31 R. B. Parker first suggested this to me in a private correspondence; he subsequently elaborated his observation in his essay 'A Tale of Three Cities: Staging in *Coriolanus*', 121–2. I am grateful for his generosity in sharing his work with me.

32 Elizabeth Cary's *Tragedy of Mariam* was (by necessity and probably by choice) a 'closet drama', written in the Senecan style and never designed for public performance; the masques in which aristocratic women were frequently silent actors (and less often silent collaborators, as Queen Anne may have shared in the conception as well as the execution of Jonson's *Masque of Blackness*) were performed primarily at court.

4 Silence and women's writing

Silence, scripture and subversion

The contradictions inscribed in early modern constructions of feminine silence and discussed at length in Chapter 2 may owe something to humanist discourse and something else to the notorious paradoxes of Puritan marriage ideology (Mary Beth Rose 126–31). They may also owe something to the behaviour of real Renaissance women, who showed repeatedly the gap between the theory and the practice of silence. Some women, for example, clearly showed displeasure by withholding communication: Lady Anne Clifford, for example, records the following entry in her diary for May 1617: 'I wrote not to my lord because he wrote not to me since he went away' (55). For other women the silence urged upon them may have offered a safe refuge from which to observe and judge the masculine world. Lady Grace Mildmay, while recording her governess's advice 'that I should ever carry with me a modest eye, a chaste ear, a silent tongue, and a considerate heart', is not inhibited by this decorum from passing judgement on 'a gentleman of great account sitting at my father's table, who spent all the dinnertime in arguments & much talk, wandering in his discourses' (Martin 217; 216). Silence in fact offers both women the opportunity to observe 'how he gloried in his own wit and to hear himself speak, and how his words were many but little true substance of matter' (216). Far from obedient self-erasure, this silence is clearly conceived as morally superior to empty speech in a standard humanist trope. Some women thus used silence to their own ends, producing what Jones terms a 'negotiated' response to contemporary ideology (4). Doubtless there were also women who spoke their minds or were simply silenced. Whether the repeated exhortations of conventional tracts suggest how often they were ignored by Renaissance women (Jones 12) or how comfortable and acceptable these doctrines had become (Davies 78) is still a subject of some debate. Yet it is

certain that all early modern women were affected in some way by the oft-quoted biblical injunction for their silence:

> Let your wives keep silence in the congregations. For it is not permitted unto them to speak: but let them be under obedience, as saith the law. If they will learn any thing, let them ask their husbands at home. For it is a shame for women to speak in the congregation.
> [marginal gloss: The woman must be in subjection to her husband.]
> (1 Corinthians 14.34–5, trans. William Tyndale (1534))

If male playwrights tapped feminine silence as a rich source of cultural anxiety and aesthetic ambiguity, early modern women themselves may well have had a vested interest in broadening and complicating the possibilities for agency within the Pauline prohibition against their speech. That this prohibition was strongly felt is indisputable: it is largely responsible for the long literal silence in the history of women's authorship, broken for much of the sixteenth century only by the genres of religious translation and meditation. Catherine Parr's *Lamentacion or Complaynt of a Sinner* (1547) clearly reveals the internalisation of this patriarchal ideology: 'The true followers of Christes doctryne, hath alwayes a respecte, and an eye to theyr vocacion', she writes. 'If they be women maryed, they lerne of Saynt Paule, to be obedient to theyr husbandes, and to keepe silence in the congregacion, & to lerne of theyr housbandes at home' (Travitsky 40). Parr clearly reveals the impact of Paul's teaching on women's lives (and perhaps inadvertently explains her ability to publish an original composition only after Henry's death). At the same time, however, she carefully limits his injunction to silence to a particular setting (the congregation), thus partially mitigating its impact and authorising her own appearance in print.[1] This is directly opposed to the practice of many later male preachers such as William Whately, who writes in *A Bride-bush* (1619): 'The Apostle commands the woman to be in silence, or in quietnesse, wherein hee enjoynes not alone a publike, but a generall silence to hold in the house and other private meetings: for why should that place of Scripture be needlessly restrained, which is fitly capable of a larger interpretation[?]' (200). The paradox of Parr's written recommendation of silence for women may rely on the fact that, unlike public speaking, writing was a liminal mode: though mass

production meant that it could potentially reach a wide audience, it was produced and frequently consumed in a private, silent space.[2]

Like Parr, whom she may have served as a waiting woman and protected under torture (Askew xxvii), Anne Askew, the famous Protestant martyr, works to revise and circumscribe the Pauline dictum. In her autobiographical account of her examinations at the hands of religious authorities, first published by John Bale (1546) and later included in Foxe's widely read *Acts and Monuments* (1563), Askew records this dialogue with her examiners:

> Then the Byshoppes chaunceller rebuked me, and sayd, that I was moche to blame for utterynge the scriptures. For S. Paule (he sayd) forbode women to speake or to talke of the worde of God. I answered hym, that I knewe Paules meanynge so well as he, whych is, i Corinthiorum xiiii. that a woman ought not to speake in the congregacyon by the waye of teachynge. And then I asked hym, how manye women he had seane, go into the pulpett and preache. He sayde, he never sawe non. Then I sayd, he ought to fynde no faute in poore women, except they had offended the lawe. (29–30)

Askew defends herself against the heaviest weapon in the patriarchal arsenal by localising and literalising it, thus thwarting its broader, more abstract application. Her thorough knowledge of scripture thus becomes a means of anchoring biblical prohibitions in their original contexts; in this she anticipates Margaret Fell's more radical insistence on historicising Paul's injunction in *Women's Speaking Justified* (1666). Over a century later, Fell was able to explain Paul's injunction as meant only for women in 'malice and strife, and confusion' among the Corinthians, with no relevance to contemporary women: 'And what is all this to Womens Speaking?' she asks, 'That have the Everlasting Gospel to preach, and upon whom the Promise of the Lord is fulfilled' (10–11). Unlike Fell, however, Askew's prime concern is not to justify her own act of speaking and defy Pauline teaching; rather her emphasis shifts away from herself to a collective of 'poor women', all presumably (like herself) falsely accused of crimes they never committed (public speaking).[3] Elaine Beilin finds in this 'an example of Askew's controlled irony, for she has already shown herself to be anything but a poor unfortunate' ('Self-portrait' 85); 'she responds not with the acquiescence that might be expected of a woman, someone assumed to be

both silent and unread, but in the role of a Reformer … The language of the prosecutor has been entirely appropriated by the defendant' ('Dialogue' 318). But this reading illuminates the dangers of identifying Askew with masculine modes she herself resists; from here it is a small step to Bale's subsequent reading of Askew as an exemplary woman privileged to speak: 'Manye godlye women both in the olde law and the newe, were lerned in the scriptures, and made utteraunce of them to the glorye of God' (Askew 30). Such exemplarity, as Ferguson notes in her discussion of Elizabeth Cary, results in 'the double-bind situation so often discussed by modern feminists: achievement is bought at the price of dissociation from what the culture considers to be one's nature' ('Running' 44). Askew herself, however, eschews irony and exemplarity to identify her own plight with that of her gender. Like those 'poor women', she seeks not to 'preach' but to avoid betraying 'the law' (in her case, the law of the reformed Church). Although Beilin claims that 'nothing in her earlier life suggests that she subscribed to the obedience and silence recommended for her sex' ('Self-portrait' 79), Askew's own account does not indicate that she sought to undermine Paul's teaching; indeed, her reverence for scripture makes this a most unlikely possibility. Instead, she offers early modern men and women a living testimonial to the complex possibilities inherent in women's silence, as she draws on competing paradigms: of classical Stoicism (embodied in Plutarch's Laena), of Christian martyrdom, incarnate in Christ himself (to whom she is frequently compared by Bale) and, of course, of virtuous womanhood.[4]

It is clear that Askew's examiners find her refusal to speak more disturbing than her speech, even as they construct her transgression as a speech act. It is significant, for example, that the bishop's chancellor's accusation of Askew for 'utterynge the scriptures' follows directly not upon one of her scriptural interpretations but upon her silent reaction to one of the questions put to her: 'they asked it of me, wherunto I made them no answere, but smyled' (27). This is consistent with her resistance throughout: as she recounts in her reply to Christopher Dare's needling demand, 'how I toke those sentences? I answered, that I wolde not throwe pearles amonge swyne, for acornes were good ynough' (21). Later a priest comes to quiz her about the sacrament; she refuses again to speak: 'I desyred hym agayne, to holde me excused concernynge that matter. Non other answere

wolde I make hym, because I perceyved hym a papyst' (24). As the exami-
nations proceed, the interrogators become increasingly frustrated by her
silence and intent on making her speak: 'Also he requyred my cosyne
Bryttayne, that he shulde ernestlye persuade me to utter, even the verye
bottom of my harte' (40); 'He requyred me also in anye wyse, boldelye to
utter the secretes of my harte' (40); 'he went into his gallerye with mastre
Spylman, and wylled him in anye wyse, that he shuld exhort me, to utter all
that I thought' (42); 'Then my lorde of London persuaded my cosyne
Bryttayne, as he had done oft before, which was, that I shuld utter the
bottom of my harte in anye wyse' (44). Even Bale gets the point here: 'Styll
foloweth thys ghostlye enemye, hys former temptacyon,' he complains, 'and
calleth upon mortall utteraunce, or utteraunce full of deathe, that he myght
crye with Cayphas, Luc. 22. what nede we further testymonye? Her owne
mouthe hath accused her' (45).

Askew's silences are remarked on by the examiners, as she points out:
'Then he asked me, whye I had so fewe wordes?' Her reply is worth careful
attention: 'And I answered. God hath geven me the gyfte of knowlege, but not
of utteraunce. And Salomon sayth, that a woman of fewe wordes, is a gyfte of
God, Prover. 19' (51). At this point Askew overtly conflates the silence
enjoined upon women by one of the most misogynist texts of the
Apocrypha[5] with the silence of divine 'knowledge' and, implicitly of course,
of resistance. Whilst Bale's gloss identifies Askew's silence with Christ's
before Caiaphas (51), Askew herself is again careful to align herself with her
gender. Beilin's reading of this passage demands that Askew again be con-
structed as exemplary, and as vocal, the embodiment of 'assertiveness and
loquacity' ('Self-portrait' 79): 'her words are few only in the sense that she
does not speak the ones he wishes to hear' ('Self-portrait' 87). Yet Askew's
narrative is marked by its reticence and refusal; that she clearly wished par-
adoxically to record publicly her silences does not change them into acts of
discursive disclosure. Beilin goes on to claim that 'Askew ironically cites a
text often used to support the dogma for woman's obedience and silence'
('Self-portrait' 87); in a later version of her essay, however, Beilin cites the
same passage to show that 'the rhythm of her own sentences often passes
imperceptibly into the cadences of Scripture' (*Redeeming* 47). It is difficult
to see how Askew's tone can register both reverence and irony. Helen
Hackett points out that women writers may have employed irony as 'a

legitimate though circumscribed means of female expression' because they are 'at once saying and not saying, using its double-edged sword in cutting fashion without breaching the social code of feminine decorum' (55). Yet Askew's language is potent and double-edged, not because she wishes to undermine the patriarchal scripture she cites with irony (as Beilin's improbable reading implies), but because (like the later conduct books) she is drawing on the richly complex history of silence, which allows for some convergence between residual notions of feminine silence and traditionally powerful masculine modes. At the same time, however, Askew's text eschews the transvestism thrust upon her by Bale, who compares her to John the Baptist and Christ (54); Askew repeatedly insists on her femininity. Beilin argues the opposite: she finds Bale 'Continually remarking on her inherent womanly weakness and daintiness', while Askew herself is 'learned, argumentative, courageous' (*Redeeming* 31). Yet, while Askew is clearly courageous, she consistently presents herself as a woman among women rather than as exceptional. Her personal ordeal mirrors the oppression of all 'poor women' and her inner strength and resourcefulness, insistently gendered feminine, thus offer a potentially inspirational model. Carole Levin argues that Askew's example was a difficult one for upper-class women to follow,[6] but this ignores the strongly gendered message of her text. When Bale's commentary was excised from Foxe's immensely popular *Acts and Monuments*, one may imagine that Askew's unaccommodated narrative had the potential to inspire not only Protestant fervour but also women's revaluation of the traditional conflation of silence and obedience continually imposed upon them.

Askew's silences stand in marked contrast to Bale's lengthy coda to the *First Examination*, which rails against those who fail to speak.[7] 'If I shuld holde my peace and not speake in thys age, the veryte so blasphemed, my conscyence wolde both accuse me and condempne me of the unconsyderaunce of my lorde God ... What Christen hart can abyde it, to se the creature yea not of God but of man, to be worshypped in the stede of God, and *say nothynge* therin?' (69–70; emphasis added). Indeed, Bale's impassioned defence of the 'vehement ... rebukes' (69) of the Reformers seems almost an indirect attack on Askew's silences. Without Bale's sustained glosses, speech, especially in the *Latter Examination*, is invariably masculine and evil: using Bale's term for the reformers to describe her enemies,

Askew reports, 'Then had I dyverse rebukes of the counsell, bycause I wolde not expresse my mynde in all thynges as they wolde have me' (94). Later 'came mastre Pagett to me with manye gloryouse wordes, and desyred me to speake my mynde to him' (99); 'mastre Ryche and the Byshopp of London with all their power and flatterynge wordes went aboute to persuade me from God. But I ded not exteme their glosynge pretenses' (119). '[L]ete them never overcome me with vayne wordes', she cries just before her death (146). Beilin points out that Askew turns her accusers' own strategies against them: she allows them to incriminate themselves 'merely by letting them speak' ('Dialogue' 315). Throughout, Askew's silence is a sign of her mental and physical integrity, her 'whole skynne' (45), which cannot be penetrated or exposed to reveal inner wounds. What is merely metaphorical in the first examination becomes literal in the second, when she is put on the rack, where she 'laye styll, and ded not crye' (127). While Askew clearly gathered her extraordinary strength chiefly from her religious conviction, she also drew on traditional notions of feminine silence infused with inherited models of heroic martyrdom. Though Beilin claims that Askew 'presented herself independently of current definitions' (*Redeeming* 30), it is clear that she fashioned herself from cultural materials available to her, including the model of the good, silent woman. This is not to say that Askew remained silent; certainly she frequently engaged in lively dialogue with her interrogators, who 'were not ... unanswered, for all that' (94). Yet throughout the *Examinations* she consistently exploits the trope of feminine silence to represent herself. Sixty-five years later, Aemilia Lanyer's *Salve Deus Rex Judeorum* (1611) draws on the same material to feminise the silent Christ, as he confronts the loquacious tyranny of his male oppressors.

Although, at the end of *Salve Deus*, Lanyer includes mention of some early Christian martyrs such as St Stephen, St Laurence and St Andrew (ll. 1745–800), she does not allude to more recent martyrs such as Askew. Her acquaintance with Foxe may, however, be responsible for the vivid image of Stephen, who 'beeing filled with the holy Ghost, / Up unto Heav'n he look'd with stedfast eies, / Where God appeared with his heavenly hoste / In glory to this Saint before he dies' (ll. 1761–4). Yet it is largely in her characterisation of the martyred Christ that her text bears comparison with Askew's. Throughout the poem Christ is insistently

feminised: the sensuous physical description borrowed from the Song of Solomon (ll. 1305–20), which properly refers in the Bible to the Church, Christ's spouse, is here applied to Christ himself; his principal virtue, 'Patience' (l. 604), is a metonymic term for woman (l. 793); and his 'Humility' (l. 473) and 'Obedience' (l. 529) are traditional feminine virtues. In the narrative itself, however, what is continually foregrounded is Christ's silence, in direct opposition to the evil tongues of his enemies. 'False Witnesses' possess 'trothless tongues' (ll. 639–40), and wrest Christ's speech from its true signification: 'They tell his Words, though farre from his intent, / And what his Speeches were, not what he meant' (ll. 655–6). Yet though his audience gives him 'attentive eare / To heare the answere, which he will not make' (ll. 665–6), he 'answers not' (l. 669); since 'by his speech, they might advantage take: / He held his peace, yet knew they said not true' (ll. 692–3). Later Lanyer apostrophises Pilate: 'Yet neither thy sterne browe, nor his great place, / Can draw an answer from the Holy One' (ll. 881–2). Of course, here Lanyer is following the Bible closely: 'Then said Pilate unto him, hearest thou not how many things they witness against thee? And he answered him to never a word; insomuch that the governor marvelled greatly' (Matthew 27.13–14). Yet Lanyer's general emphasis on 'Deceitfull tongues' (l. 112) also owes much to 'Those rare sweet songs which *Israels* King did frame' ('The Authors Dreame' l. 117), the Psalms, well known to Lanyer in Mary Sidney's translation: 'Lord ridd my soule from treasonous eloquence / Of filthy forgers craftily fraudulent: / And from the tongue where lodg'd resideth / Poison'd abuse, ruine of beleevers' (Psalm 120.245). In relating the evils of the (male) tongue and Christ's contrasting silence during his Passion, Lanyer is thoroughly orthodox; by feminising Christ himself, however, Lanyer hints at the heroic potential of such traditionally passive feminine virtues. In her enumeration of Christ's attributes Lanyer confounds distinctions between active and passive, masculine and feminine virtues, praising his 'valour' along with his 'chast behavior', and 'continence', his 'zeale' along with his 'meekenesse' ('To the Ladie Katherine' ll. 91–4). Christ's silence in Lanyer's poem is a sign both of his obedience to God (l. 529) and of his resistance to earthly, masculine power (l. 669); thus the feminisation of Christ implicitly offers this conflation as a model for early modern women, to whom Lanyer's poem is explicitly addressed.

Silence and (in)discretion

> It is therefore useless to trap women into giving an exact definition of what they mean ... They are already elsewhere than in this discursive machinery where you claim to take them by surprise. They have turned back within themselves, which does not mean the same thing as 'within yourself.' They do not experience the same interiority that you do and which perhaps you mistakenly presume they share. 'Within themselves' means *in the privacy of this silent, multiple, diffuse tact.* (Irigaray, 'This Sex' 103)

> By being silent, thou shalt both know other mens imperfections, and conceale thine owne. (Grymeston H3v)

> Let thy love hang on thy hearts bottome, not on thy tongues brimme. (Grymeston H3r)

Elizabeth Grymeston's collection of adages written for her son Bernye sounds like a feminine, maternal equivalent to the advice offered by Polonius to his son Laertes in *Hamlet*: 'Give thy thoughts no tongue, / Nor any unproportioned thought his act' (1.3.59–60); 'Give every man thine ear, but few thy voice. / Take each man's censure, but reserve thy judgement' (68–9). As a Catholic, Grymeston may well have meant her injunctions to silence as practical advice on living as a recusant; in any case her reiteration of such commonplaces illuminates her acquaintance with the notion of silence as a strategic virtue. But Grymeston goes further than Polonius in emphasising the dangers of giving every man one's ear; for her, even the silent act of listening is hazardous. In her Preface she offers her son a gendered metaphor:

> As a false Lover that thicke snares hath laied,
> T'intrap the honour of a faire yoong maid,
> When she (though little) listning eare affoords
> To his sweet, courting, deepe affected words,
> Feeles some asswaging of his freezing flame,
> And soothes himself with hope to gain his game.
>
> <div align="right">(B1v)</div>

If the perfidious 'Lover' is, like the devil, a 'rare linguist' (*The White Devil* 3.5.105), the young maid's silence offers no effective protection against his

'flattring gloze', his discursive intrusions, as long as she 'listning eare affoords'. Here Grymeston's advice to her son resembles less Polonius's advice to Laertes than Laertes' advice to Ophelia: 'weigh what loss your honour may sustain / If with too credent ear you list his songs, / Or lose your heart, or your chaste treasure open / To his unmastered importunity' (1.3.29–32). Silence for women in both accounts is a dangerous and potentially unruly space; in Grymeston's text it is virtuous in men and women only when it signals closure, or 'discretion', an emerging term which begins in this period to connote not merely 'judgement' or 'prudence' but also 'separateness', a meaning latent in its Latin root (David Hillman 74–5). Grymeston foregrounds the multivalency of silence, as it may strategically invite others' confidences, facilitate outward self-control, conceal desire, or offer dangerous openness to seduction. Indeed, as we have seen, perhaps the most threatening aspect of this slippery signifier is its resistance to any single interpretation.

Lady Mary Wroth's epic romance *The Countess of Montgomery's Urania*, along with its appended sonnet cycle, *Pamphilia to Amphilanthus* (1621), offers a more complex and sustained exploration of the relationship of silence to gender and discretion than any other early modern woman's text. Yet, whilst critics are divided on Wroth's own relation to 'the chastity-silence equation' (Jones 2), they are unanimous in accepting the equation itself. To support her claim that 'Wroth does not rebel against restrictive ideologies' (132), Tina Krontiris declares that 'Pamphilia is … "spotless" in her conduct, reticent, silent, secretive, and self-controlled' (134). Similarly, Gary Waller writes:

> Pamphilia describes herself as desiring isolation and silence – desiring, that is, precisely what the dominant ideology prescribes for women: to have her organs of self-assertion, her mouth (for speech), her genitals (for sexual self-assertion), and the door or gate of her room, house or garden closed or locked … she accepts her assignment of silence, isolation, and frigidity. (*Sidney Family* 206)

On the other hand, Naomi J. Miller argues that 'Wroth undermines the strictures of female silence and passivity so much emphasised in Renaissance directives for women' ('Rewriting' 123), and Nona Fienberg claims, 'In writing about cultural conditions which would impose female

silence, Wroth both risks punishment and challenges those conditions' (178). Less often the debate about Wroth contests the meaning of her silences: whilst Gary Waller claims that 'Pamphilia projects Amphilanthus as presence, herself only as an absence – as lack, incompleteness, and finally, as silence, waiting to be completed' ('Struggling' 249), Naomi Miller retorts that 'the silence of Pamphilia's muse ... is a silence not of lack but of completion' ('Rewriting' 304–5). Generally, however, whether critics see Wroth in an acquiescent or rebellious relation to her culture, they concur in assuming that feminine silence in that culture is fixed and stable. This assumption produces a Wroth who is either ahistorically capable of transcending her culture, or inevitably oppressed by it. If, as Quilligan reminds us, it is important that 'a sense of "self" is itself socially constructed and cannot therefore exist prior to its social construction' ('Constant' 321), it is equally important to understand the potential instability and fluidity of constructions from which the self is made.

The *Urania* begins with a clearly gendered binarism according to which speech is a masculine, silence a feminine virtue. The open rejection of silence in the opening lines of Perissus's sonnet (discovered by Urania), for example, immediately characterises the speaker as male before the gendered pronouns of the second stanza make it certain:

> Here all alone in silence might I mourne:
>> But how can silence be where sorrowes flow?
>> Sighs with complaints have poorer paines out-worne;
>> But broken hearts can only true griefe show.
>>> (Wroth, *Urania* 2.36–9)

Unlike Urania herself, who in her sonnet solipsistically unites with the 'Eccho' of her solitary 'grieving note' (1.39–2.7) as a form of solace,[8] Perissus eschews silence to communicate actively his grief to his beloved: 'Drops of my dearest bloud shall let Love know / Such teares for her I shed, yet still do burne' (3.1–2). That silence is incompatible with masculine virtue is especially clear in a later episode, when Steriamus, in love with the heroine Pamphilia, attempts to 'discourse' (68.28) of love, only to lapse into a hopeless silence when she actively discourages him. Pamphilia's lady-in-waiting comments disparagingly on Steriamus's silent demeanour: '"Madam," said she, "did you ever see so silent a Prince as this is? Surely if

he were to winne his Kingdome by words, as it must be done by swords, the Countrey might remaine a long time without the lawfull King'" (69.1–3). A true Petrarchan lover, Steriamus claims that his silence is that of a 'dead man' (69.8); later, again silenced by Pamphilia (70.3), he retreats to a cave to die until he meets Amphilanthus, who urges him not to forget himself for 'the rest of the world hath need of such Princes' (70.35). Masculine silence is the antithesis of valour; 'words' are equated with 'swords' as silence is equated with death and impotence. Similarly, Rosindy, in love with Meriana, is cast into speechless despair upon her rejection of his love: 'Words had I none, nor other action, but going straight to my chamber, throwing my selfe on the bed, and there lay I sencelesse, speechlesse, and motion-lesse for some houres' (109.18–20). In fact Meriana rejects him only because he has disguised himself as a servant in order to gain access to her, and has unaccountably failed to reveal himself. Rosindy explains to her the reason for his silence about his real identity: 'feare kept me silent, love made me feare' (110.15–16); unimpressed, Meriana in turn demands that he go off and accomplish 'noble deeds' to prove himself worthy of her love (110.19–22). Again silence in men suggests a kind of castration which must be compensated for by the exercise of the sword. In yet another parallel episode Parselius woos Dalinea first with his 'discourse' which takes 'her eares prisoners' (125.29–30), and successfully arouses her passion; their amorous conference is curtailed, however, by his 'bashfulnesse [which] with-held him', though 'shee would sigh, and in her soule wish that he would once speake' (126.3–4). Finally, after Dalinea compares him unfavourably to a more voluble bird, Parselius cries: 'Feare ... makes men speechlesse, and admiration hinders the declaring their affections' (126.27–8). The moral is that for men 'bashfulnesse is neither profitable nor commendable' (126.31–2); indeed Philarchos is later described as 'the true image, or rather masculine vertue it selfe ... excellent in eloquence, true in profession, and making his actions still the same with his word' (204.19–24).[9] By contrast Dalinea's 'woman modestie [that] kept her silent' (126.4–5) is nowhere suggested as an equally culpable impediment to the union with Parselius. Indeed, the 'proud Nereana' (194.33) is openly chastised by Steriamus for pursuing him: 'He told her, 'Twere more credit he was sure for her, to be more sparingly, and silently modest, then with so much boldnesse to proclaime affection to any stranger' (192.25–7). Philarchos comments: 'A

woman and being madde, had liberty to say any thing' (199.34–5). Similarly, because Antissia's 'strength of judgement was inferior' to that of Amphilanthus or Pamphilia, 'she could least keepe silence, but began discourse' (320.11–12). Such traditional notions of feminine modesty are consistent with those found in Philip Sidney's *Arcadia*, where the 'fair Parthenia' is praised for 'her speech being as rare as precious, her silence without sullenness, her modesty without affectation' (28). At first glance the traditional double standard appears to be equally firmly in place in Wroth's romance: men should speak, and women be silent.

However, just as the *Urania* is plagued by the suspicion that 'mens words are onely breath, their oathes winde, and vowes water' (228.10), their 'eloquent speech, turnd, and imployd to no other use, then flattery, and deceitfull glozings' (201.31–2), its construction of feminine silence is far from simple. Upon closer examination, Dalinea's silence is highly unstable: a sign of 'woman modestie' it may be, but it is equally charged with erotic desire. Like Desdemona, whose transgressive act of listening 'with a greedy ear / Devour[s] up' Othello's discourse (*Othello* 1.3.148–9), Dalinea 'yeelded in her heart to love his person' (125.29) after 'infinitely delighting in those stories' (125.19). Both recall Grymeston's dangerously receptive, silent feminine listener. The episode is one of the most erotic in the entire romance: 'He would with his eyes tell her his heart, with kissing her delicate hand, with a more then usuall affection, let her feele his soule was hers: She found it, and understood what hee would have her understand, nay, shee would answer his lookes with as amorous ones of her part, as straightly, and lovingly would she hold his hand' (125.40–126.2). The silence enjoined by 'woman modestie' does not, apparently, preclude the silence of amorous embraces. Earlier in the romance the narrator describes the decorous silence of Limena, beloved by Perissus but 'kept like a Diamond in a rotten box' (8.35) by her tyrannically jealous husband Philargus. Seated at supper with her father, husband, and lover, Limena holds her peace:

> Neither of these [her husband nor father] brought my Mistris from a grave, and almost sad countenance, which made me somewhat feare, knowing her understanding, and experience, able and sufficient to judge, or advise in any matter we could discourse of: but modestie in her caus'd it, onely loving knowledge, to be able to discerne mens understandings by their arguments,

but no way to shew it by her owne speech. This (and withall feare of discovering some passions, which she, though excelling in wit and judgement; yet could not governe, at least, guiltines forc'd her to thinke so) was the reason she held her gravitie.

(7.30–8)

The passage repays closer examination, especially since it has figured prominently in critical discussions of Wroth's constructions of femininity. Josephine Roberts remarks that 'Limena's silence in company may reflect the cultural expectations of the period' (Wroth, *Urania* 716 n. 7.35), and directs her readers to Suzanne Hull's *Chaste, Silent and Obedient*; both Tina Krontiris and Helen Hackett cite the above passage, significantly omitting the final sentence, Krontiris to show that 'conventional rules regarding feminine conduct, speech, and dress are deployed, especially in cases where the woman's respectability is in need of defence' (133), Hackett to support her claim that 'Wroth conforms with seventeenth–century prescriptions of silence as a feminine virtue' (52). But the passage is a good deal more complex than these critics suggest. First, Perissus hints that her silence is unusual, since she has customarily shown herself able to 'advise in any matter we could discourse of'; indeed it makes him 'feare'. Perhaps to assuage his fear, he then offers to read her silence, but his reading opens up its complex and subversive possibilities. While construing it conventionally as 'modestie', he also says that it indicates her 'knowledge, to be able to discerne mens understandings'. Hardly a sign of submission or obedience here, Limena's silence actually aligns her with the silent wisdom of Pythagoras and Plutarch; following Grymeston's advice, she passes judgement on the men without revealing her own imperfections. The final sentence, however, unsettles even this formulation, when her silence is revealed to be 'feare of discovering some passions'; her veneer of feminine decorum merely disguises the ungovernable emotions (desire, anger?) that seethe below the surface.[10] 'Modestie' and 'guiltines' are thus both encoded in her silence, rendering it deeply subversive. If Limena exercises a form of admirably Stoic self-control, which, as Mary Ellen Lamb points out, 'from its inception depended upon an intense emotion over which the sage could exert rational control' (134), this self-control is vexed and tenuous. Rather than suppressing or disciplining her intense emotion, Limena's silence maps out an unruly interior feminine space.

Limena's silence anticipates that of the heroine, Pamphilia, who is characterised early in the romance as 'the most silent and discreetly retir'd of any Princesse' (*Urania* 61.30). The narrative gives Pamphilia plenty of opportunities to exhibit her silence, since she cannot openly reveal her love for Amphilanthus, in keeping with 'all the codes for courtly female conduct, especially secrecy, passivity, and self-control' (lxii). In an early episode, for example, Pamphilia opts to walk unattended,

> having vowed, that onely one should enjoy all love and faith from her; and in her constancie (this not being knowne, her passions so wisely govern'd, as she was not mistrusted to love so violently) made her of many to be esteemed proud, while it was that flame, which made her burne in the humblest subjection of *Loves* meanest subjects; yet was her choice like her selfe, the best. (64.14–19)

The passage is similar to the description of Limena, even in its use of parentheses to qualify and unsettle the sentence; like Limena, Pamphilia is Stoical, wisely governing her passions, and at the same time passionate and unruly, loving 'so violently'. One may recall here Webster's Duchess of Malfi, whom Bosola describes during her imprisonment:

> She's sad, as one long used to't: and she seems
> Rather to welcome the end of misery
> Than shun it: a behavior so noble,
> As gives a majesty to adversity:
> You may discern the shape of loveliness
> More perfect in her tears, than in her smiles;
> She will muse four hours together: and her silence,
> Methinks, expresseth more than if she spake.
>
> (4.1.3–10)

The Duchess's brother and tormentor, Ferdinand, reads this idealised portrait of a female Stoic as 'melancholy … fortifi'd / With a strange disdain' (11–12), just as observers in Pamphilia's court consider her proud. Those who appear to be transcending worldly attachments are thus reconstructed as still committed to them.[11] In both cases the notion of woman as silent Stoic is complicated and unsettled by the notion of woman as subliminally erotic: Bosola remarks that 'this restraint / (Like English mastives, that grow

fierce with tying) / Makes her too passionately apprehend / Those pleasures she's kept from' (12–15).[12] What is important in both cases is that Stoic self-control and erotic abandon coexist – are, indeed, mutually necessary. If Bosola's description draws on misogynist notions of women's lust, it none the less foregrounds the Duchess's all-important sensuality. By disciplining her passions to avoid self-disclosure, thus achieving a measure of Stoic self-control, Pamphilia (like Limena) can both publicly contain and privately release her desire. Such a strategy conforms to advice offered by Brathwait in his *English Gentlewoman*: 'so soone as you shall perceive your selves moved, restraine your passion; but if you cannot appease nor compose your inward Commotion, at least restraine your tongue, and injoyne it silence' (37). Silence here is not a bridle but a veil. In another episode in the *Urania* the Angler Woman declares that 'more innocency lyes under a fayre Canope, then in a close chest, which lock't, the inward part may be what it will' (295.8–10). Bridling the tongue may even encourage inward unruliness. Both Webster and Wroth draw on emergent early modern constructions of unstable and unfathomable feminine silence to create heroines who are both decorously conventional and at the same time deeply subversive.

It is significant that subversive silence is associated also with women's authorship. In one episode Leandrus gazes at Pamphilia from his window; she is alone, silent and motionless in the garden below. 'But while this quiet outwardly appear'd,' remarks the narrator, 'her inward thoughts more busie were, and wrought, while this Song came into her mind' (212.10–11). This paradox of outward decorum and inward freedom is similar to the one which arouses Richard Hyrde's suspicion of traditional female activities: 'in all handy werkes that men saye be more mete for a woman the body may be busy in one place and the mynde walkyng in another while they syt sowing and spinnyng with their fyngers may caste and compasse many pevysshe fantasyes in theyr myndes' (A4). While Hyrde's larger purpose is to defend women's reading as a superior form of internalised self-restraint, Pamphilia's authorship emerges from just such a split between a quiet body and an active mind – silence here offers a kind of dynamic stasis similar to her eroticised self-control. Pamphilia may frequently be 'without speech, and as (if one would say) fix'd like the heaven', but 'the world of her thoughts had motion in her griefe' (190.25–6). By contrast, Amphilanthus's poetic compositions are an extension of his speech and military valour:

having enough, as hee thought, given liberty to his speech, he put the rest of his thought into excellent verse, making such excelling ones, as none could any more imitate or match them, then equall his valour: so exquisite was he in all true vertues, and skill in Poetry, a quallitie among the best much prized and esteemed, Princes brought up in that, next to the use of Armes. (136.9–14)

When Leandrus approaches Pamphilia in her creative trance, he interrupts the silent 'businesse' of 'her passions' (213.2) 'with words'. As her writing is integrally linked to her secret desire, so both are associated with silence. Unlike Urania, Pamphilia rejects even Echo as a companion, for fear of turning 'blabb' (318.5), yet this does not inhibit her from writing or from loving.

The paradox of Pamphilia's silence in the *Urania* is captured in the ambiguity of the term 'discretion'. As noted, Pamphilia is described as 'the most silent and discreetly retir'd of any Princesse' (61.30). In a key episode Leandrus, in love with Pamphilia, debates the meaning of the word with her. Putting forward his own suit, Leandrus argues that 'love with discretion is the truest love' (213.16–17), but it is soon apparent that by discretion he means prudent, exclusionary class interest, or, as David Hillman puts it, 'an undefined – indeed, an undefinable – standard of linguistic and cultural competence [which] coordinates social and mental structures, and in so doing ratifies the collective practices of a group in the face of subjective potentialities' (75). Pamphilia openly disagrees with him, asserting the privilege of those subjective potentialities: 'therefore my Lord Leandrus, by your favour, I must say, I thinke you erre in this, and in the truth of love, which is a supreme power, commanding the eyes, and the heart: what glory were it to him to have a cold part of wisdome to rule with him?' (213.29–32). Yet at the end of her speech she attempts to have it both ways, claiming that love's 'judgement [is] such, as hee makes discretion shine through all his acts; but how? as a servant to his greater power; as if your heart should command your tongue, to deliver what it thinkes, but discreetly to doe it so, as offence may not proceede from it: here is discretion, and yet the tongue is but the hearts messenger' (214.1–5).[13] Offering a 'startling perspective upon the amorality of love' (Lamb 174), Pamphilia's twisted syntax reflects her difficulty not only in reconciling passion and discretion but also in presenting as tact what many would have seen as deception in a love not expressed but managed 'discreetly'.[14] She does so finally by deconstructing binaries: in her invented hierarchy the indiscretion of love, enshrined in the heart, not only

commands but incorporates discretion, located in the tongue. Silence, or discretion, is both selective prudence and authentic self-expression. Love is discreet because it is silent, avoiding the 'offence' given by the tongue; at the same time love is indiscreet because it is silent, ungovernable, eschewing that 'cold part of wisdome'. One might well say of Pamphilia in Wroth's *Urania* what David Hillman says of the mechanicals in Shakespeare's *A Midsummer Night's Dream*: both have their 'own brand of "discretion," a kind of "anti-discretion," [which] refracts the official structures of discourse' (84). Pamphilia's brand of discretion, here clearly distinguished from Leandrus's broader courtly code of 'judgement' (213.23), is also a radical form of anti-discretion, as she pursues her own subjective desire while outwardly observing the reticence collectively valued by her class.[15]

Whilst silence for Pamphilia signals the 'secresie' (94.2) required by both outward decorum and inward indiscretion, elsewhere in the romance it is a far less stable signifier. Sometimes the narrator is unable to read silence: of a Lord and his false Lady, she writes: 'his speech was sparing, either that naturally he had not store of words, or his inward heavinesse at that time made him silent' (104.26–7). Sometimes the difficulty in reading silence is foregrounded in the narrative: the king of Negroponte, for example, misreads the silence of his evil daughter: 'Shee made mee no answer, but with her eyes cast downe, left the roome where I was. I thought confession and repentance had caus'd this countenance: but alas, I was deceived, for it was rage, and scorne procured it' (118.6–9). Similarly his son Dolorindus lapses into a silence of remorse that is taken for guilt: 'This griefe made me as guilty seeme by shame and silence, which then did possesse my distracted senses, as if I had been as false as they made me appeare' (187.34–6). And quite often feminine silence is (predictably) misread as detachment or indifference (91.32–7; 294.5–30). The grounds for misreading are clear, since diverse emotions are equally marked by a retreat into silence: the nymph Alarina is 'dumb' with joy after confessing her love (218.38) yet 'silently lament[s]' her lover's betrayal (220.41); the 'mournfull silence' of Urania and Amphilanthus (230.21) is followed by the delight of Urania's father who 'could not speake, so was he wrapped and overwhelmd with joy' (231.28–9). Powerful emotions (desire, rage, grief, guilt) as well as modest reticence are all signalled by silence – how, then, can these be easily distinguished? Is the indecipherable quality of silence precisely its advantage for

Pamphilia? Significantly, the multivalency of silence is also used as a powerful form of manipulation and deception. Lucenia, for example, uses *aposiopesis* to seduce Amphilanthus: '"Pardon mee my Lord," said shee, "that I have been thus bold with you, which was caused by –" (with that shee blushing held her peace, desiring to be thought bashfull, but more longing to bee intreated for the rest)' (163.19–21). Similarly Bellamira (a transparent fictionalisation of Wroth herself; lxxii) tells a tale of a manservant using silence, like Iago, to arouse her beloved's suspicions: 'He counterfetted loathnes to speake, as if unwelcome newes would follow his words, the more he was troubled, and silent, the more perplexed was my deere' (383.36–8). If Lamb is right that a character such as Antissia becomes 'a container, a disposal site, into which … anxiety over authorship can be placed' (168), these negative instances of duplicitous silence may be dark analogues for Pamphilia's own practice. Like theirs, Pamphilia's silence both invites interpretation (as 'vertue' 91.37) and resists disclosure. 'Hath my speech at any time betray'd mee?' Pamphilia inquires aggressively of her more loquacious rival Antissia (96.3–4). Indeed, when her 'curious … secrecie' (91.28) is threatened with exposure by Antissia, Pamphilia is forced into outright deception with the claim that she does not love Amphilanthus (95). Here one may recall, from Chapter 1, Bacon's claim that 'Dissimulation … followeth many times upon secrecy by a necessity'. Indeed it may be the implicit threat of unmanageable and unreadable silence that leads others (especially men) to urge women to break their silence and speak: as Dalinea and Parselius embrace, for example, he curiously insists on her speech: 'shee neede have said no more, to make him know she lov'd him: Yet he covetous to have the word spoken, taking her in his armes, "Be not so cruell my onely life," said he, "to barre me from the hearing of my blisse"' (127.5–7). Later, in a similar episode, after the nymph Alarina falteringly confesses her love, her beloved constrains her to speak: 'then did he take me in his armes, and strictly did conjure me to say out' (218.39–40). Urania urges the grief-stricken Pamphilia to unburden herself in words: 'let passion since possessing you, breathe it selfe forth; … speak then' (468.25–8). Direct speech as an expression of desire ruptures the silence of feminine modesty, but at the same time violates the protective, unreadable space silence offers, putting the women firmly in others' power.

Silence and discretion are integrally bound up with the notion of 'constancie' that is so central to Wroth's romance as a whole. Because of its

strong contemporary associations with Senecanism and neo-Stoicism,[16] constancy in *Urania* is frequently read by critics as a subjugation of passion and retreat into silence which heroises residual feminine virtue.[17] Lamb comments that 'Stoicism's emphasis upon passive endurance over heroic action and its privileging of inner composure as a positive virtue provided a powerful model for heroism that was accessible to women' (127). Yet this notion of constancy as a static, self-abnegating and passive virtue has led some critics to see Pamphilia as a masochist unable to escape the restrictions of her culture: 'Her constancy, the virtue with which she is most praised (and thereby by what she is imprisoned), may be opening her to further victimisation' (Waller, *Sidney Family* 211). Lamb herself suggests that, in the *Urania*, passion and anger lead to speech and writing, while 'By its very nature, absolute constancy produces only silence' (166).[18] In the *Urania*, however, anger, desire and constancy are not distinct phases which displace one another (as Lamb suggests); rather, they are simultaneous and interpenetrating. Marta Straznicky points out that 'It is important to notice that stoic philosophy does not speak of eradicating human desire, but that its primary aim is to reorient desire from material to spiritual goods … paradoxically, once the wise man has rid himself of desires whose gratification is beyond his control, his desires are instantly fulfilled' (115–16). While constancy is for Pamphilia certainly a vow of fidelity, 'that onely one should enjoy all love and faith', this vow clearly enjoins both self-restraint ('her passions so wisely govern'd') and continual self-generated erotic fantasy ('she was not mistrusted to love so violently' 64.14–19). Moreover, like the Stoic sage, Pamphilia in Wroth's narrative divorces her expressions of desire from their outward object, making them internal rather than external. Quilligan observes that Pamphilia's unilateral vow of constancy constitutes 'an act of willful self-definition' since 'In order to locate an active desire in her female self, she needs *it* – her own will – to be autonomous' ('Constant' 323). Just as Pamphilia's blush can signal 'both … modesty, and anger' (194.16), so her silence can suggest both containment and desire. It is hardly surprising that Sir Aston Cokayne described the *Urania* as 'repleat / With elegancies, but too full of heat' (Wroth, *Poems* 36).

Although Mary Wroth's sonnet sequence *Pamphilia to Amphilanthus* may predate the *Urania*,[19] it reveals a similarly paradoxical treatment of silence. This treatment is clearly evident in sonnet P45, a poem in which

Wroth appears to reflect on her own authorship. The poem, like many others in the sequence, articulates the grief that stems from absence and indifference on the part of the beloved. The narrator first offers a Stoic response to her plight: 'silently I beare my greatest loss / Who's us'd to sorrow, griefe will nott destroy' (*Poems* P45.3–4). Silence signals discreet containment, allowing the narrator to cultivate moderate 'sorrow' rather than the more extreme 'griefe' and thus desensitise herself to loss and its concomitant passion. The second stanza extends this elevation of Stoic silence as the poet rejects her own 'fram'd words' as 'the dross / Of purer thoughts' (6–7). The comparative is ambiguous: if thoughts are clearly purer than words, they also appear to be purer than the contaminant of excessive emotion. But, as is typical of Petrarchan sonnet form, the sestet surprises by undermining the previous Stoicism: 'For wher most feeling is, words are more scant' (10), declares the narrator in a paraphrase of Seneca's *Hippolytus*. Silence is suddenly destabilised: a self-sufficient space of refuge and restraint is actually a site of unreadable, inarticulate emotional excess. Similarly, in sonnet P52, the poet / narrator begs her interlocutor to cease 'multituds of questions' (2), that 'toungue torture' (8), and seeks to centre herself in a silent, inward space. Yet that space is both closed and permeable: 'only lett mee quarrell with my brest / Which still letts in new stormes my soule to rent' (3–4). Then, begging for release from speech, the narrator makes the startling claim that she is 'possesst, / And mad folks senceles ar of wisdomes right' (10–11). Identifying herself not with the voluble witch but with the mute hysteric, since she constructs herself as silent in opposition to her interlocutor, Wroth here recalls cases like the one documented in 1602, when Elizabeth Jackson was convicted for bewitching fourteen-year-old Mary Glover and rendering her speechless (Harvey 65–6).[20] In early modern England chronic speechlessness in women could be attributed to hysteria ('the suffocation of the mother'),[21] or to possession. Either way women were seen as subject to forces beyond their control, whether inside or outside their bodies. While Wroth's narrator claims possession by 'the hellish speritt absence' (12), she is also conscious that the claim is a strategy to 'fright / That Divell speach' (9–10); thus, her possession is also an exorcism, her passivity really an assertion of agency. The poem finally doubles back on itself to reveal a complex vision: her desire for silence is neither a voguish Stoical retreat from the indiscretions of speech nor a mute yielding to the suffocation of the desiring

errant womb (to those 'poore sences' 13), though it invokes both these pos-
sibilities. Rather, as in the *Urania*, silence offers the opportunity for the nar-
rator to focus, undistracted and unchallenged, on the 'stormes' of her own
desire which none the less receive forceful impressions from within and
without. Jeff Masten maintains that the sonnets 'articulate a woman's res-
olute constancy, self-sovereignty, and unwillingness to circulate among men;
they gesture toward a subject under self-control' (69). Unwilling to circulate
among men she most certainly is, yet such a refusal need not inscribe her as
chaste or tightly controlled; in fact Pamphilia's self-containment marks her
erotic openness to her own desire. Masten further finds that 'the subjectiv-
ity mapped "in" Pamphilia is not only private but privative; the text figures
it in terms of emptiness, lack, loss, and absence' (81); he suggests, in effect,
that *there is nothing there*. The final quatrain and couplet of sonnet P41 sug-
gest otherwise, however:

> Yett is itt sayd that sure love can nott bee
> Wher soe small showe of passion is descrid,
> When thy chiefe paine is that I must itt hide
> From all save only one who showld itt see.
> For know more passion in my hart doth move
> Then in a million that make show of love.
>
> (9–14)

Pamphilia's silent concealment of her desire marks its presence.

 Indeed, Wroth's project can be understood as a subversive application
of Du Bosc's justification of feminine silence in *The Compleat Woman* cited
earlier: 'those who speake so much with others, do never as it were *speake
with themselves*, that *they see not their thought*' (19, emphasis added).
Sonnet P26 uses precisely these terms to construct the narrator's subjec-
tivity. Rejecting the 'sweet discourse' (3) and pastimes of the court as so
many 'poore vanities' (8), the narrator asserts: 'I my thoughts doe farr above
thes prise' (4). Yet, though this rhetoric of interiority articulates itself in
quasi-religious terms ('O God, say I, can thes fond pleasures move?' 13), it
is neither ascetic nor conventionally virtuous. The narrator's 'true pleas-
ure' (8) consists not in the rejection of worldly pursuits but in 'thoughts of
love' (14); these thoughts are expressed as analogous to the frivolities to
which they appear to be contrasted:

When others hunt, my thoughts I have in chase;
 If hauke, my minde att wished end doth fly,
 Discourse, I with my spiritt tauke, and cry
 While others, musique choose as greatest grace.

<div align="center">(9–12)</div>

While apparently rejecting them, Wroth's narrator appropriates the amoral pleasures of the court (with which she was well acquainted) to describe her own. In sonnet P71, seeking to forestall her lover's injurious speech, she explains that 'thinking will orecome, / And loose all pleasure, since griefe breedeth none' (7–8): silent thought is the fount of erotic desire. It is useful here to recall Brathwait's marked ambivalence about the silent retreat he recommends for English gentlewomen: 'PRIVACY is the seat of *Contemplation*, though sometimes made the recluse of *Tentation*. From which there is granted no more exemption in the *Cell*, than in the *Court* … Heere the minde becomes our Mate; Silence, our sweetest Conference: where the retired becomes either the best or worst friend to himselfe' (*English Gentlewoman* 44). Pamphilia's withdrawal activates only to undermine prescriptions for female virtue.

Silence in Wroth's sonnets is also a site where female agency is constructed. In sonnet P32 Grief is likened to a pressing to death:

Use still thy force, butt nott from those I love
 Lett mee all paines, and lasting torments prove
 Soe I miss thes, lay all thy waits on mee.

<div align="center">(12–14)</div>

Like a prisoner who chooses to remain silent in court and face pressing to death to salvage his property for his heirs, the narrator *chooses* the silence of grief in exchange for continued love. The witty, self-interested, slyly calculating metaphor moderates the poem's overtones of simple masochism.

Whilst a detailed discussion of Philip Sidney's poetry lies beyond the scope of this study, it is useful to note here his more conventional gendering of speech and silence. Like the male heroes of Wroth's *Urania*, Sidney's Astrophel is bound to think, speak and write in spontaneous effusion. 'Thought waited on delight, and speech did follow thought: / Then grew my tongue and pen records unto thy glory' (Fift Song 2–3), he asserts. When afflicted by the 'unkindnesse' of his beloved, he turns not to silence

but to verbal abuse: 'That speech falles now to blame, which did thy honour raise, / The same key op'n can, which can locke up a treasure' (17–18). In the Eighth Song, during a lovers' meeting, 'when their tongues could not speake, / Love it selfe did silence breake' (25–6); 'Love', of course, is Astrophel, whose subsequent lengthy appeal to Stella lapses only temporarily into fearful silence (45–6) and culminates in a daring extension of speech into silent action, as he 'would have made tongue's language plaine' (66). Throughout the sequence the narrator's subjectivity is mapped discursively: 'Griefe find the words', begins sonnet 94; 'My words I know do well set forth my mind', opens sonnet 44; 'I am not I, pitie the tale of me', ends sonnet 45. Unlike Wroth, in whose poetry love exists in a silent, non-discursive space, Sidney continually proclaims: 'love doth hold my hand, and makes me write' (90.14); 'my heart burnes, I cannot silent be' (81.11). The opening of sonnet 50 is typical:

> STELLA, the fulnesse of my thoughts of thee
> Cannot be staid within my panting breast,
> But they do swell and struggle forth of me,
> Till that in words thy figure be exprest.

Compare with this Wroth's sonnet P34, in which the same image of the labouring woman is employed to suggest, not the release of a birth, but an endlessly self-inflicted cycle of pain:

> How oft in you I have laine heere oprest,
> And have my miseries in woefull cries
> Deliver'd forth, mounting up to the skies
> Yet helples back returnd to wound my brest.
> (5–8)

Of course Sidney's discursivity is directly related to Stella as a present object of desire and potential reader: if his narrator, like Wroth's, is occasionally afflicted with 'dearth of words' (27.3), he can still direct his eloquent thoughts 'unto *Stella*'s grace' (27.14), unlike Pamphilia, for whom Amphilanthus is a veiled absence. Yet Wroth's rejection of rhetorical self-expression is more than an endorsement of 'the discretion required of court ladies' (Jones 148). In fact Pamphilia's rejection of 'the traditional claim of love poets that composing verses relieves their anguish' (Jones 149) signals

a critique of Petrarchism and male value. In sonnet 50 Sidney's narrator sees that the 'weake proportion' (7) of his verse cannot adequately represent Stella, but refrains from erasing it because it 'bare sweet *Stella*'s name' (14). By contrast, in Wroth's sonnet P45, the narrator rejects her verse not because it fails to represent her beloved, but because it fails to show her own 'purer thoughts' (7); she finally lets it stand not because it mirrors the beloved but because it bears no relation to her own 'crost' (14) fortunes; her writing just doesn't matter that much. What may seem authorial self-abasement, however, is feminine self-validation; speaking and writing are modes of self-assertion women simply do not require.

Given her insistent valorisation of non-discursive space, it is hardly surprising that Wroth inverts Sidney's primarily negative construction of silence. In sonnet P43 Pamphilia welcomes a feminised Night as the embodiment of her suffering; in the final lines she adds Silence and Grief to this female community living as 'companions without strife' (14). Naomi Miller observes: 'Wroth embraces the triple companionship of "silence", "grief" and "Night" in personal terms (P43) that stress her awareness of a shared female bond of suffering and decenter the role of the male beloved, relegating him in effect to the margins of this friendship' (*Changing* 300). Wroth's feminised Silence (a regendering of the emblematic male figure) is particularly striking when compared to her uncle's. If Wroth's narrator embraces silence and night, Sidney's narrator is 'Languisht with horrors of the silent night' (89.8); if Wroth constructs Silence as a female companion, for Sidney Silence is a male rival,[22] as in the opening lines of sonnet 96:

> THOUGHT with good cause thou likest so well the night,
>> Since kind or chance gives both one liverie,
>> Both sadly blacke, both blackly darkned be,
> Night bard from Sun, thou from thy owne sunne's light;
> Silence in both displaies his sullen might.

Though Sidney, like Wroth, recognises the affinities between his own condition and that of night, for him the 'mazefull solitarinesse' (9) they share is entirely painful, and Silence is the 'sullen' conqueror of them both. His identification of himself with 'poore Night, in love with *Phoebus*' light, / And endlesly dispairing of his grace' who 'Silent and sad in mourning weedes doth dight' (97.5–8) places him in the passive feminine posture assumed by

many of Petrarch's Renaissance counterparts (Dubrow 55). At the same time, however, Astrophel's male aggression can be directed at a external masculine embodiment of that silence, which allows him to differentiate himself from his own passivity. As Heather Dubrow remarks, by constructing male rivals the Petrarchan poet 'can ... transpose into another arena his battle with his lady' and thus achieve the differentiation that the elision of gender boundaries otherwise frustrates (54). Throughout Sidney's sequence, Astrophel can escape his dark maze, and the tyrannous rule of Silence, chiefly by speaking, by 'nam[ing] her whom I do love' (55.12). By contrast, as in the *Urania*, Pamphilia seeks differentiation not from 'sullen Silence' but from 'that tongue torture', and desires not speech but retreat into a silent space in which desire is both unconsummated and fulfilled:

> My breath nott able is to breathe least part
> > Of that increasing fuell of my smart;
> > Yett love I will till I butt ashes prove.
> > (P55.12–14)

The difficulty of 'breathing' (drawing breath or speaking) does not prevent Pamphilia from loving; Astrophel, by contrast, eschews 'eloquence' but not the 'art' of speaking and writing which keeps his love alive: 'know that I in pure simplicitie, / Breathe out the flames which burne within my heart, / *Love* onely reading unto me this art' (28.9, 12–14).[23] For Pamphilia, Night and Silence precipitate an inwardness contingent on estrangement from the beloved: in an apostrophe to Night in the *Urania*, she cries: 'you truely shewed my selfe unto my selfe, you were mine eyes to make mee see my selfe' (466.17–19). As both subject ('mee') and object ('my selfe') of her own representation, Wroth's Pamphilia has no need to define herself discursively to another.

Pamphilia and Mary Wroth are not one and the same, of course, and the appropriation of silence as a complex and unstable trope in writing by women is not the same as literal silence. Yet it is significant that even as women wrote and spoke out, they frequently made their speech possible by paradoxically invoking their own 'silence' as superior to the rhetorical excess of men. Indeed, for many of the early modern pamphleteers in the *querelle des femmes*,[24] the antirhetorical prejudice typical of the age quickly becomes highly gendered. Jane Anger, for example, begins her *Protection*

for Women (1589) with the following: 'The desire that every man hath to shewe his true veine in writing is unspeakable, and their minds are so caried away with the manner as no care at all is had of the matter: they run so into Rhethorik, as often times they overrun the boundes of their own wits, and goe they knowe not whether' (Bv). Misogyny, indeed, is constructed as a kind of verbal rape: 'Mischiefe he pries into every corner of us, seeing if he can espy a cranny, that getting in his finger into it, he may make it wide enough for his tonge to wag in' (D1v). Often returning to castigate men's 'railing tongues' (Cv), Anger suggests applying to men the rules for feminine behaviour: 'Tibullus setting down a rule for women to follow, might have proportioned this platform for men to rest in. And might have said. Every honest man ought to shun that which detracteth both health and safety from his own person, and strive to bridle his slanderous tongue' (B4r). The antirhetorical thrust of the pamphlet, however, involves Anger in a dilemma: how can she accuse men of railing when she risks incurring the counter-charge of scolding speech? It is a dilemma she never resolves: though she argues, 'our good counsel is deemed nipping injurie, in that it accordes not with their foolish fancies' (B3r), she never escapes the double bind. Almost thirty years later, Constantia Munda's attack (*The Worming of a Mad Dogge*, 1617) on Joseph Swetnam's antifeminist tract appropriates the same antirhetorical trope to launch an invective against men as well as print: 'The itching desire of oppressing the presse with many sottish and illiterate Libels ... when every foule-mouthed male-content may disgorge his *Licambean* poyson in the face of all the world, hath broken out into such a dismall contagion in these our dayes' (1). In a passage that recalls Plutarch as well as Erasmus in its execration of the unruly tongue, Munda goes further, choosing her metaphors to regender the 'leaky vessel':

> These wide open-dores, these unwalled townes, these rudderlesse shippes, these uncoverd vessels, these unbrideled horses doe not consider that the tongue being a very little member should never goe out of that same ivory gate, in which, (not without a great mysterie) divine wisedome and nature together hath enclosed, it signifying that a man should give him selfe eyther to vertuous speech, or prudent silence, and not let tongue and pen runne up and downe like a weaponed madde-man, to strike and wound any without partiality, every one without exception, to make such an universall massacre (for so I may terme it, seeing words make worse wounds then swords). (4–5)

The same rhetoric constructs men both as implicitly feminine and 'grotesque' ('wide open-dores') and as aggressively, compensatorily masculine in their indiscriminate speech; Munda exploits both antirhetorical gendered paradigms (speaker as whore; speaker as warrior) to ground her subsequent claim: 'Though feminine modesty hath confin'd our rarest and ripest wits to silence, wee acknowledge it our greatest ornament' (5). A modern reader might mistake this for irony; on the contrary, consistent with the attack on speech, it establishes silence both as desirable self-restraint by masculine standards and as a specifically feminine virtue. Displaying her awareness of traditional paeans to feminine silence, Munda marginally cites Sophocles' *Ajax*, balancing against it another classical injunction to judicious speech, carefully distinguishing the latter from the gender-specific terms 'babbling' and 'waspishness' (5). These she later applies, in fact, to Swetnam himself, a 'masculine scold' (26) whose 'hornet braines ... sting' (20). Munda is clearly aware of the double bind involved in violating the ideal of female silence: 'nay, you'l put gagges in our mouthes and conjure us all to silence: you will first abuse us, then binde us to the peace; wee must be tongue-tied, lest in starting up to finde fault, wee prove our selves guiltie of those horrible accusations' (14).[25] But she is at the same time committed not to authorising angry speech (for that would be to participate in and fulfil Swetnam's agenda) but to recommending the classical notion (espoused by Plutarch) of wise and eloquent silence: '[Say something worth saying or keep silent]' (trans. Shepherd 141); 'Either speake peace, or hold your peace' (22). It is significant that Munda loads her pamphlet with classical references, because it is humanist discourse, I have argued, which frequently conflates feminine silence with masculine sagacity. Whilst much of Munda's pamphlet is certainly written as invective, she finally, like Wroth, endorses the traditional feminine virtue of silence informed by the 'constancy' of Stoicism. In the concluding verses, addressed to Swetnam, Munda refuses to attempt to silence him: 'Thy death I wish not, but would have thee live / To rayle at vertues acts, and so to give / Good vertues lustre' (34). Whilst Swetnam is encouraged to 'ever bark' and 'write still', women will exhibit their superiority by remaining silent and constant: 'Whilst women sit unmov'd, whose constant mindes / (Arm'd against obloquy) with those weate [*sic*] windes / Cannot be shaken' (34). Munda's celebration of feminine virtue as stoical *virtu* recalls her

earlier recuperation of Swetnam's essentialist notion of femininity. Responding to Swetnam's notion that men love war, women peace, for example, Munda writes: 'What man soever maketh warres, is it not to this ende, that hee might enjoy peace?' (32). What woman seeks to write pamphlets, is it not to this end, that she might exalt her silence? Munda's text, however rhetorically sophisticated and engaging, draws its authority from the humanist valorisation of silence rather than from protofeminist calls to speech.

Elizabeth Cary's play *The Tragedy of Mariam* (1613) has been frequently acclaimed as a text in which 'the heroine claims a wife's right to her own speech – public and private – as well as to the integrity of her own emotional life and her own self-definition' (Lewalski 201). Many of the play's critics, however, have noted that the play is at the very least ambivalent about women's speech, since it is filled with references to what Belsey calls the cultural 'demonisation of eloquence' for women (*Subject* 178). Yet, like the pamphlets of Munda and Sowernam which it predates by about a decade,[26] Cary's play in fact frequently constructs eloquence as pernicious and evil for both men and women, albeit in distinctly gendered discourses. Instead *The Tragedy of Mariam* recalls Askew's narrative of martyrdom by conflating Stoical, Christian and gendered paradigms of silence to authorise its female protagonist. It is silence, not speech, which finally makes Mariam heroic, overdetermined and unassimilable – just like Graphina, her often overlooked minor parallel in the play's narrative.

As has often been noted, the play is deeply concerned with the dangers of female speech. 'Now stirs the tongue that is so quickly mov'd', Salome in the first act accuses Mariam, who has indeed just spoken in 'choler' (1.227–8). Straznicky is surely right in claiming that 'In stoic terms Mariam's self-righteous verbal rebukes demonstrate that her passions are not fully self-contained' (126), although such an indictment might seem unreliable from a woman whose own mouth 'though serpent-like it never hisses, / Yet like a serpent, poisons where it kisses' (2.333–4). Yet later both Sohemus and the Chorus repeat Salome's charge, exposing parallels between the two women. 'Unbridled speech is Mariam's worst disgrace' (3.183), laments the loyal Sohemus after she has disclosed her hatred of Herod to him. Her outspokenness is both unstoical and unwifelike. 'Then she usurps upon another's right, / That seeks to be by public language

grac'd' (3.239–40), moralises the Chorus, constructing marriage as the husband's ownership of his wife's tongue. Herod and Salome both associate Mariam's speech with adultery: Salome reminds her brother that 'her tongue / Doth but allure the auditors to sin, / And is the instrument to do you wrong' (4.430–2), while Herod agrees, 'It may be so: nay, 'tis so: she's unchaste, / Her mouth will ope to ev'ry stranger's ear' (4.433–4). That Mariam's crime is constructed as indiscriminate, loose speech rather than as the bodily closure which more deeply threatens a husband's marital authority (Ferguson, 'Running' 52) is consistent with early modern ideology: if Mariam's transgression is a speech act, it can be conceptualised or 'read', regulated and punished. And as in early modern culture husbands were licensed to control their wives' speech, so in *Mariam* Salome warns the heroine: 'You durst not thus have given your tongue the rein, / If noble Herod still remain'd in life' (1.219–20). Even after her death, Herod seeks to represent Mariam rhetorically, saying to Nuntius:

> Thou dost usurp my right, my tongue was fram'd
> To be the instrument of Mariam's praise:
> Yet speak: she cannot be too often fam'd:
> All tongues suffice not her sweet name to raise.
>
> (5.29–32)

His discursive appropriation of Mariam is merely an extension of his earlier attempt to control her speech.

In Cary's play, however, men's tongues and mouths, the instruments of patriarchy, are equally susceptible to corruption. Indeed, the entire narrative of *Mariam* is implicitly dominated by 'RUMOUR, … *painted full of tongues*' (*2 Henry IV* Induction 1.1 s.d.) which generates the false report of Herod's death; the chorus at the end of Act 2 exposes the errors of speech, referring to 'the weak uncertain ground, / Whereon they built this tale of Herod's end' (2.425–6). If speech is unreliable, it is also dangerous: early in the play Mariam metonymically identifies her husband's tyrannical power with the organ of its expression as she soliloquises: 'Why joy I not the tongue no more shall speak, / That yielded forth my brother's latest doom[?]' (1.39–40). Her mother Alexandra finds an even more disturbing image for Herod as a devouring orifice in her apostrophe to him: 'Did not the murder of my boy suffice, / To stop thy cruel mouth that gaping stood, / But must thou dim the

mild Hircanus' eyes?' (1.92–4). At the end of the play Herod himself recognises, 'My word, though not my sword, made Mariam bleed' (5.189). But Herod is not alone in abusing the tongue. His brother Pheroras, who claims in Act 2, 'I cannot vaunt me in a glorious style, / Nor show my love in far-fetch'd eloquence' (2.75–6), is moved by Salome in Act 3 to betray Constabarus to Herod; an index of his corruption is his vow:

> Believe this tale for told, I'll go from hence
> In Herod's ear the Hebrew to deface:
> And I that never studied eloquence,
> Do mean with eloquence this tale to grace.
>
> (3.77–80)

Later the perfidious Butler who incriminated Mariam by bearing an allegedly poisoned drink to Herod (4.160) repents his action in soliloquy:

> I am condemned, Heav'n gave me not my tongue
> To slander innocents, to lie, deceive:
> To be the hateful instrument to wrong,
> The earth of greatest glory to bereave.
>
> (4.267–70)

Whilst women's speech is frequently associated with sexual transgression, men's speech is largely identified with political crimes. It is in the context of such masculine rhetorical abuses that we can usefully read transgressive feminine speech acts, for both implicitly gesture towards the uncorrupted space offered by silence in the discourses of Stoic philosophy, Christian hagiography and patriarchal ideology. Conveniently Cary offers three characters who at various times are strongly identified with each of these three discourses: Constabarus, Mariam and Graphina respectively. Yet, significantly, the text exposes the points at which these discourses intersect and overlap, thus making any single, transparent reading of silence impossible.

An erratic (because frequently impassioned) embodiment of Stoic philosophy is Constabarus, who, despite (or perhaps because of) his antifeminist views, is Cary's mouthpiece for antirhetorical sentiment. Chastising his wife Salome for her 'private conference' (1.377) with Silleus (thus anticipating the Chorus's admonition of Mariam), Constabarus carefully distinguishes himself from the diseased rhetorical culture around him:

Oft with a silent sorrow have I heard
How ill Judea's mouth doth censure thee:
And did I not thine honour much regard,
Thou shouldst not be exhorted thus for me.
(1.387–90)

Later, in reply to Babas's First Son's attempt to thank him for sheltering himself and his brother, Constabarus protests, Cordelia-like: 'Too much of this, 'tis written in the heart, / And [needs] no amplifying with the tongue' (2.115–16). He finally welcomes death with neo-Stoic fortitude, saying: 'Yet let us resolutely yield our breath, / Death is the only ladder, Heav'n to climb' (4.281–2). Whilst he certainly does his share of talking (see 4.6.287–350), Constabarus is clearly designed as a virtuous, reticent exception to those around him, whose tongues betray and condemn to death.

The second character associated with silence is, of course, Mariam herself. That she understands the value of reticence is clear early in the play, when she counters Salome's barbed taunts with: 'I favour thee when nothing else I say, / With thy black acts I'll not pollute my breath' (1.243–4). But at this point her self-restraint is inadequate, as she immediately adds: 'Else to thy charge I might full justly lay / A shameful life, besides a husband's death' (245–6). Whilst she claims to bear Salome's 'speech with patience' (254), her appeal to a Stoic standard illuminates just how far she falls short; in fact she defends herself against slander by slandering in turn. Cary's opening portrait of her heroine shows us not a woman heroically finding a voice but rather a woman using 'fumish words' (229) to carp at a member of her own sex. Mariam clearly has a great deal to learn about the uses of speech and silence. It is not until she learns that Herod is alive that she suddenly vows to contain her own tongue:

I know I could enchain him with a smile:
And lead him captive with a gentle word,
I scorn my look should ever man beguile,
Or other speech than meaning to afford.
(3.163–6)

However, though she indeed eschews verbal conciliation with Herod, the relation between her 'speech' and her 'meaning' is problematised in the

text in a way that has gone unnoticed by critics. In her dialogue with Sohemus, Mariam desperately begs him to 'Foretell the ruin' of her family (3.127) rather than apprise her of Herod's return; with Herod himself, however, she unexpectedly represents her repudiation of him as motivated by family loyalty (4.3.111–16). Of course accusing Herod of specific crimes allows Mariam to express her 'hate' (3.138, 158) in a sanctioned form, but her verbal accusations remain significantly estranged from her 'meaning', despite her assertion that she 'cannot frame disguise' (4.145). To use a 'public voice' (1.1) may be to compromise one's private meaning; speech acts like Mariam's tend to define, reduce and finally compromise her – and not only in the eyes of her culture. In the following scene, faced with Herod's counter-accusations of poison and adultery, Mariam can use speech only to deny speech: 'They can tell / That say I lov'd him, Mariam says not so' (4.193–4). For the rest of the scene Mariam remains silent as Herod reads her silence. Earlier she sought to make her external appearance a transparent emanation of her inward self, declaring '[I] never taught / My face a look dissenting from my thought' (4.145–6), thus adhering to the strictest conduct book rules for feminine virtue.[27] But Herod reads her misogynistically as theatrically divided between inside and outside: 'Thou shalt not live, fair fiend, to cozen more, / With [heav'nly] semblance, as thou cozen'dst me' (4.213–14). Her silent body, like her 'unbridled speech', is read as a text reliable only in signifying her unreliability. Her silence here in fact opens her to two closed, dichotomous interpretations, erasing her subjective choice: for Herod she is guilty; for the reader (as for Constabarus) she is innocent. Only in the final act of the play does Mariam achieve a silence that eschews such simple contraries, and defies simple interpretation or reduction to Herod's categories.

 At this point the third silent character in Cary's *Mariam* emerges: Graphina. As 'the only character whose name is not found in Josephus's text or in Lodge's translation of it', Graphina, the low-born slave girl whom Pheroras marries against Herod's wishes, and the 'strange little scene' (Ferguson, 'Running' 47) in which she appears repay careful study as evidence of Cary's original addition to the historical material she inherited. The scene begins typically enough for a Senecan closet drama, with a long speech from Pheroras anticipating his marriage. Although his speech is no

longer than many in Cary's play, Pheroras surprisingly violates generic convention by drawing attention to Graphina, who has of course remained silent throughout. 'Why speaks thou not, fair creature?' he enquires. 'Move thy tongue, / For silence is a sign of discontent' (2.41–2). The rest of the scene is taken up with Graphina's curiously elaborate justifications for her silence. Most critics who mention her at all[28] have read Graphina as an embodiment of the early modern ideal of feminine silence. According to Beilin, 'Graphina is modestly silent, speaking only when addressed and then with humility and gratitude for Pheroras's having chosen her … The word "silence" is associated with Graphina five times in less than thirty lines, making her a significant foil to the vociferous Salome and even to Mariam's "unbridled speech"' (*Redeeming* 169). Similarly, Lewalski notes that 'there is Graphina … whose silence and humility seem to embody stereotypical feminine ideals' (196), Naomi Miller claims that 'the one female character who does not speak in conflict with the others is also the epitome of feminine silence and subjection to male authority: namely, Graphina' (*Changing* 52) and Dympna Callaghan believes that she 'represents the play's ostensible ideal of femininity' ('Re-reading' 177). This critical consensus on Graphina has been challenged by Margaret Ferguson and Jonathan Goldberg. Ferguson first remarked on the 'opaque' quality of the character ('Running' 47), and later argued that the name Graphina, which 'deliberately evokes the classical concept of writing as "silent" speech',

> explicitly raises the possibility that 'silence' may be 'a sign of discontent' (2.1.42), an ambiguous or dissimulated sign that hides from the audience the true thoughts of the female writer or the female speaker. By this logic, writing that appears to be obedient, like Graphina's speech, may in fact harbour subversive designs. ('Renaissance' 155)

Similarly, Jonathan Goldberg critiques feminist readings of the play by attacking their assumption 'that female speech / silence in the play always takes place under the aegis of the familiar patriarchal injunctions to silence, obedience, and chastity' (*Desiring* 170). Arguing instead that Graphina can not 'be reduced to a site of passive inscription' (171), Goldberg reads Graphina's speech not as obedient but as actively resistant: 'The lines turn subservience and inadequation into refusal. They don't deliver. They mark the opacity of this writing, its sheer material resistance to subsumption into

subordination and obedience' (175).[29] In fact Graphina's silence is a perfect example of the 'moving Rhetoricke' of feminine silence that is the subject of this book – a rhetoric that also marks the martyrdom of Mariam herself.

Like Othello, who initially admires Desdemona because she 'is fair, feeds well, loves company, / Is free of speech, sings, plays, and dances well' (*Othello* 3.3.188–9), Pheroras places a high value on a woman's speech. He rejects the infant of noble birth to whom he is betrothed because she cannot talk yet (2.17–18), and he celebrates Graphina for her 'wit' (3.15) and for the 'mirth on her tongue' (17). Yet it is clear that her speech is also firmly circumscribed: 'wisdom is the porter of her head, / And bars all wicked words from issuing thence' (3.25–6), asserts Pheroras proudly. Salome's cynical reply, however, identifies chaste closure not with the mouth but with the ear: 'But of a porter, better were you sped, / If she against their entrance made defence' (3. 27–8). Recalling Grymeston's construct of the dangerously receptive listener, Salome implicitly denies speech its customary place as a full measure of subjectivity, as 'the mirror of the mind'. The dangerous speech here is not Graphina's but that of the (implicitly male) other, who discursively (and sexually) penetrates her, filling her with corruption of which her speech bears no trace. Salome thus replaces Pheroras's myth of a talking Eve with the myth of a silently listening Eve. But Graphina's role as a silent listener has in fact already been problematised by Pheroras himself. Demanding that she speak, he reads her silence not as decorous submission (appropriate to both her gender and her class) but as 'a sign of discontent' (2.42), the manifestation of a subjectivity he cannot control or appropriate. Graphina's attempts to reassure him, however, hardly accomplish their avowed aim: instead of closing off its dangerous paradoxes, Graphina (however inadvertently) actually opens up the multivalency of feminine silence to thoroughly subvert residual ideology. Indeed, her first response links her with the later heroines of Mary Wroth, for she claims her silence signifies desire:

> Mistake me not, my lord, too oft have I
> Desir'd this time to come with winged feet,
> To be enrapt with grief when 'tis too nigh.
> You know my wishes ever yours did meet.
>
> (2.45–8)

The sexual urgency that has been shrouded in her silence here bursts forth so volubly that her rapid subsequent disclaimer fails to repair the damage: 'If I be silent, 'tis no more but fear / That I should say too little when I speak' (2.49–50). At first reading, this seems to approach the fearful submission and 'obedience' (71) that is recommended as traditional feminine virtue; at second reading, it makes desire so intense that it is literally unspeakable. And, while Graphina then goes on to construct her silence as 'amazement' (53) at the fact of Pheroras choosing her, the passive wonder this connotes is soon confuted by her suggestion of a fully private interiority reminiscent of Whitney's Pythagorean emblem 'Silentium': 'Then need not all these favours study crave, / To be requited by a simple maid? / And study still, you know, must silence have' (2.65–7).[30] As it shifts and multiplies its referents – ranging from desire, to fear, to contemplation – her silence becomes loose and unstable, an unreadable sign of a subjectivity beyond speech, beyond appropriation. 'Then be my cause for silence justly weighed' (2.68), she pleads – but her quasi-legal language almost represents her as a defendant claiming the right to silence before a tribunal urging her to incriminate herself in speech.[31] After all this it is not surprising that Pheroras asks her not for speech (which may have merely compounded his anxiety about her silence) but for a silent sign that is simple and *readable*: 'That study needs not let Graphina smile', he pleads (2.73). It is not, I think, mere coincidence that Herod later says the same thing to Mariam: 'Yet smile, my dearest Mariam, do but smile, / And I will all unkind conceits exile' (4.143–4).

Indeed it is difficult to imagine why Cary labours to create and foreground such a lengthy (even clumsy) discussion of the imagined threats implicit in Graphina's silence if she does not intend them to serve a larger purpose in the play – that of illuminating her central female protagonist. For even as Graphina's speech, as Ferguson points out, makes her 'safe', the silence which it attempts to justify becomes increasingly unmanageable and overdetermined. Similarly, in *Mariam*'s final act, Nuntio's report of Mariam's death makes possible a final silence more complex and subversive than her passive reticence in Act 4 and more effective than her slippery discourse in Act 3. Told by Nuntio about Alexandra, who 'did upon her daughter loudly rail' (5.36), Herod responds by repeating his tyrannical suppression of female speech:

Why stopp'd you not her mouth? Where had she words
To [darken] that, that Heaven made so bright?
Our sacred tongue no epithet affords
To call her other than the world's delight.

(5.37–40)

Throughout the scene, in fact, Herod fetishises both his own 'sacred tongue' ('the instrument of Mariam's praise' 5.30) and Mariam's speech: 'Tell all, omit no letter' (5.66), he tells Nuntio. 'Each word she said / Shall be the food whereon my heart is fed' (5.71–2). But such fetishism is merely the obverse of Herod's earlier attempts to 'control' (74) his wife's utterance[32] by killing her for her speech (or for the alleged adultery that is for him significantly a speech act). As long as he can construct Mariam discursively, he can manage her: after proposing to 'smother' Alexandra's 'name' (5.48), he asks eagerly, 'What answer did her princely daughter make?' (49). Nuntio's reply foregrounds Mariam's silence: 'She made no answer, but she look'd the while, / As if thereof she scarce did notice take, / Yet smil'd, a dutiful, though scornful, smile' (5.50–2). The smile Pheroras desired of Graphina and Herod sought from Mariam is here finally provided, but it hardly simplifies her silence, in which are inscribed simultaneously indifference, humility and pride. Cary's text significantly complicates her source in Josephus:

> For first of all, she gave her no answere; neither was any waies altered by her reproches, neither would so much as cast her eie upon her; making it appeare, that she discreetly concealed and coverd her mothers imperfections, & was agrieved that she had so openly shewed so great indignitie. (Cary 281)

In Josephus, Mariam's refusal to look at her mother is a sign of her filial duty, and the 'constant beha[v]iour' (281) she exhibits reconciles stoic fortitude with feminine virtue. Cary, however, capitalises on the multivalency of feminine silence she explored earlier in Graphina to constitute her heroine as beyond the appropriations and reductions of male discourse. Herod's narratological desire to move 'forward in th[e] tale' (5.83) is both satisfied and frustrated by Nuntio, who notes that Mariam's death follows 'after she some silent prayer had said' (84). Whilst it is true that Mariam has finally tamed her unbridled tongue (Straznicky 130; Ferguson, 'Running' 56), her silence maps out a subjective space not only rife with paradox but also finally inaccessible to representation.

As this discussion of the deployment of silence tropes by early modern women writers suggests, the culture which problematised and destabilised feminine silence made it possible for women themselves to capitalise on its inherently subversive possibilities. Women clearly adopted similar strategies for authorising their own speech. Elaborating on Catherine Belsey's argument about the patriarchal construction of a radically unstable speaking position for women, Wendy Wall claims 'that the woman's unstable speaking position is not merely a sign of her culturally circumscribed subject position, however, but a carefully formed *representation* of that problematic portrait, a crafted self-portrait through which women rhetorically recast their riven subjectivity' (287). Similarly, Elizabeth Harvey argues that 'there is a difference between being consigned to a marginalised position by the patriarchal order and voluntarily (and self-consciously) occupying that position as a strategy for subverting the dominant discourse' (57). The scepticism, humanism and even misogyny of early modern England all conspired to invest apparently decorous feminine silence with considerable power and danger – a power which many women writers succeeded in recuperating and replicating in their own works.

Notes

1 Janel Mueller comments: 'On the one hand, her brief early references to her relation to Henry VIII and her later Pauline excursus on wifehood mark her gender and position as comfortably feminine. On the other hand, the process of composition also bespeaks a gradually intensifying sense of spiritual authority in the work' (41).

2 Mary Wroth's romance *Urania* contains several examples of writing conceived as a silent activity distinct from speech: 'I could not silent be, nor yet could speake' (222.1), says one distressed nymph whose love has been betrayed when she opts to write a letter. Similarly, Dolorindus regrets composing love poems when they are planted on another woman, incriminating him: '"O mee," cryed I, "have I framed these to spoyle my fortunes which should have procur'd my blisse, by telling what I could not utter? speach tyed by a power of a greater might. Alas that ever I did take a penne in hand to be the Traytor to my joy"' (187.30–3). In both cases writing is a silent and private means of self-expression not to be confused with speaking. Compare Henry Peacham's 1612 emblem (*Silentij diginitas*), which displays the 'Athenian sage' cutting out his tongue, then explaining in writing that 'Of silence never any yet complained' (156). The act of writing confirms rather than compromises his self-silencing.

3 It is possible, of course, that Askew's foregrounding of an oppressed female col-
 lective is an oblique reference to the mainly female entourage surrounding Queen
 Catherine Parr, which included the Duchess of Suffolk, among others. My read-
 ing of Askew here differs not only from Beilin but also from Matchinske, who
 asserts that 'Her resistances … turn to singular truths, to individual certainties'
 (43).

4 Matchinske also notes Askew's adherence to conventional models of female deco-
 rum: 'Askew never speaks unless she is spoken to' (43), 'Askew will resist in obey-
 ing; she will defy only as long as she defers' (44). I concur with Matchinske's
 general argument that Askew's 'legitimacy acquires its privatised shape via *the very
 institutional restrictions and gender hierarchies that are already in place*. The
 resistant interiority that Askew's text proclaims, an interiority that will, in fact,
 become synonymous with later Reformation paradigms for *both men and women*
 finds at least one of its early voices in an institutionally framed definition of accept-
 able, reformist, *female* exegesis' (43). Matchinske places her emphasis, however,
 on Askew's fashioning of a singular, private, secular notion of self; I argue that
 Askew's allegiance to scripture and gender role is neither secular nor singular; the
 complex and established history of silence accommodates both simultaneously.

5 Askew cites Proverbs 19 as her source, yet the passage comes from Ecclesiasticus
 26.14 (*New English Bible*).

6 Levin's essay begins by suggesting that the female examples in Foxe may 'modify'
 his otherwise traditional presentation of Christian virtues for women (197). It also
 hints at the possibility of a receptive female readership: 'Askew indeed was a sin-
 gular example, and one for *women* to think about as well.' But Levin's citation of
 Hogrefe's assessment of Askew as a woman who 'did not follow the courtesy
 books' forecloses this possibility (201).

7 Although Matchinske's book was published after this book was largely complete,
 some of the points she raises in her chapter on Askew complement my argument.
 She also notes the conflict between Bale's narrative and Askew's, and locates it
 partially in Bale's position of authority in a written tradition: 'Askew's accounts
 provide Bale with the medium to grapple with other writers … Askew's texts offer
 Bale a "safe" discursive platform from which to antagonise his opponents without
 risking life or limb – a means of resistance that validates his own status as writer'
 (35–6).

8 Quilligan writes persuasively about the significance of the figure of Echo in
 Urania's opening sonnet ('Constant' 311–12).

9 A comparable moral lesson is clear in Richard Brathwait's epigram *The Wooer* (*A
 Strappado for the Divell*, 1615). In an extended passage Brathwait first praises
 silence in women by commending the virtue of Bellina: 'With what resolved
 silence would her wit, / Oppose her tongue, and seeme to bridle it?' (90). By con-
 trast, silence in her young suitor Admetus is culpable: 'But he a shamefast lad,
 though oft he sought / Her love, yet durst not utter what he thought. / Nor to her

parents could impart his minde, / How he affected was, and how inclinde' (90). Because of Admetus's failure to speak, his rival gains the upper hand and seduces Bellina. His sexual and discursive advances are described in an elaborate series of military metaphors: 'How he assailes, assaults, ascends, inclines, / Invades, invirons, ruines, undermines' (91). Significantly, Bellina's defeat is signalled by her silence: 'He enters parlye, and speakes ore the wall, / But she (as sencelesse) answers not at all' (92).

10 I find myself generally in agreement with Heather Wiedemann, who writes in another context that Lindamira 'is presented here as a two-leveled text; hence, the narrative implies, she must perform to conceal the fact of a potentially unruly female subjectivity' (193). Wiedemann usefully argues that 'This depiction of a theatrical woman thus paradoxically stages identity both as a provisional role and as an inward self that remains concealable' (201).

11 In Henry Peacham's *Minerva Britanna* (1612) silence is both the badge of the wise Stoic who cuts out his own tongue (156) and the sign of '*Melancholly* musing in his fits' who clutches a sealed purse to signify his avarice (116).

12 Is 'this restraint' a reference to the Duchess's enforced imprisonment or her own self-restraint? Though the sentence which follows suggests the former, Bosola's preceding praise of her 'noble' behaviour may carry over to suggest the latter. If so, the Duchess may be commenting on the precariousness of her attempts at self-control when, in the next scene, she says, 'reason / And silence make me stark mad' (4.2.6–7). In Webster's plays, as in Shakespeare's *Othello*, the misogynist cliché that women have vigorous sexual appetites is recuperated to serve the interests of women such as the Duchess, who delight in 'flesh and blood' (1.2.369) and gobble up apricots on stage to fill a pregnant belly (2.1.151).

13 Wroth echoes a phrase used by William Perkins in *A Direction for the Government of the Tongue* (1597) to recommend discretion: 'The Tongue is the messenger of the heart, and therefore as oft as we speake without meditation going before, so oft the messenger runneth without his errand. The Tongue is placed in the middle of the mouth, and it is compassed in with lipes and teeth, as with a double trench, to shew us, how we are to use heede and preconsideration before wee speake' (16).

14 Discretion can be associated with seditious deception: the Angler Woman, for example, is both 'discreet and observing' towards her husband (290.22) and tormented by the 'rebellious passions' of love (291.4).

15 Later in the romance, faced with Amphilanthus's infidelities, Pamphilia's passionate constancy is more openly in tension with the 'discretion' (or moderate flexibility) urged upon her by Urania (459.5), though silence remains a consistent value: 'few wordes serv'd her turne, and yet because shee would not bee thought too covetous, shee gave them store of sighs to counterpoise the want of speech' (459.30–2).

16 Seneca was the author of *De constantia sapientis*, which, as Heather Dubrow points out, was an openly misogynist text (154); Justus Lipsius not only translated Seneca but also wrote the influential *De constantia in publicis malis* (1584).

17 In her introduction to the *Urania* Josephine Roberts summarises critical perspectives on Pamphilia's constancy. She herself argues that 'Pamphilia is free to redefine constancy, from its narrow meaning in seventeenth-century conduct books as fidelity to one's spouse, to fidelity to one's own freely chosen love' (lxi), though constancy here remains 'unswerving devotion' (lix). Maureen Quilligan finds in Pamphilia's constancy an 'act of wilful self-definition' ('Constant' 323), and Jeff Masten describes constancy as 'a virtue constructed as interior to the self, self-authorised and unchanging' (77). Whilst these critics emphasise Pamphilia's agency in reshaping the ideal of constancy, their notion of constancy as rigid self-discipline still make it difficult to dismiss the arguments of Tina Krontiris and Gary Waller, that 'the solution seems masochistic at best, to become a passive, subjugated wife' (*Urania* lx). My own argument differs from these in claiming that Pamphilia's constancy (like her silence) is not static but dynamic, not self-repressive but highly libidinous, though self-contained.

18 Yet Lamb's own metaphor becomes unstable when she elsewhere aligns rage with silence: 'Anger represents the silent precondition for the heroism of the constant woman lover' (164).

19 The sonnet sequence is extant, not only as part of the published *Urania* but also (with some additions, deletions and transpositions) in an undated holograph manuscript held by the Folger Library. Josephine Roberts, editor of the poetry, argues that 'the holograph manuscript of her poems precedes that of the published version' (Wroth, *Poems* 62), based largely on the dating of the watermark; Jeff Masten questions Roberts's assumptions, and puts forward the hypothesis that 'the manuscript may represent Wroth's own collection of several of her (more or less discrete) sonnet sequences, along with some other non-sequential poems' (69).

20 Wendy Wall also notes that 'one subtext for this poem could be the witch hunts that raged in the early seventeenth century', though she reads the narrator's 'possession' as a strategy to enable her speech: 'The poem makes clear that the speaker takes her terms of identification from her outer public, appropriating their phallic "Devill speech" and "tongue torture" as a means of describing her private unblessed state' (334). In my view, however, the poem characteristically rejects verbalisation; Pamphilia has 'confest / Long since' (6–7), and now seeks to 'fright / That Devill speech' (9–10) by constructing herself as mute, 'possesst' by 'Absence' who arrests all her 'poore senses to his cruell might' (10–13).

21 Edward Jorden's treatise on hysteria entitled *A Briefe Discourse of a Disease Called the Suffocation of the Mother* (1603) describes the symptoms of hysteria as '*suffocation* in the throate, croaking of Frogges, hissing of Snakes, crowing of Cockes, barking of Dogges, garring of Crowes, frenzies, convulsions, hickockes, laughing, singing, weeping, crying' (B2). See Chapter 2, p. 69.

22 Heather Dubrow remarks that Petrarchan poetry 'provided English poets not only with a model, however difficult to interpret, for male-female interactions but also

with a paradigm of one important manifestation of diacritical desire, the relationship between men, especially male rivals. For desire in Petrarch is … linked to and even enabled by a diacritical response to other men' (48).

23 Dubrow comments on Sidney's pun on *heart* and *art* in the opening sonnet of *Astrophel and Stella* (103); Astrophel's interiority is inseparable from his rhetoric.

24 Since most pamphleteers (apart from Rachel Speght) adopted pseudonyms, it is impossible to prove that they were in fact women. Even if they were men, however, it is significant that they chose to adopt *female* pseudonyms (such as Jane Anger, Esther Sowernam and Constantia Munda), since they were clearly capitalising on the advantages of holding a feminine subject position in the debate. Maureen Quilligan interestingly notes the similarities between Wroth and the pamphleteers: 'Wroth's ironic reveral of gender relations is … of a piece with the flare-up of the *querelle des femmes* surrounding Joseph Swetnam's publication of a misogynist tract in 1615, a half-decade or so before Wroth published the *Urania*' ('Constant' 324). She points to Wroth's representation of men as fickle and inconstant; I would add that Wroth's scepticism about speech, often gendered male, as well as her central valorisation of feminine silence, also connects her with the pamphleteers.

25 It is interesting to note that Munda's predecessor in responding to Swetnam, Esther Sowernam, justifies female speech by representing silence negatively. In her mock-legal counter-arraignment of Swetnam, Sowernam first claims that he 'stood mute' upon being asked how he wished to be tried 'for Conscience did so confront him that he knew upon tryall there was no way but one' (30). Swetnam's silence indicts him before the law (see Chapter 1, pp. 33–4); Sowernam capitalises on the legal history of silence to explain, echoing Rachel Speght (3): 'if we should let it so passe, our silence might implead us for guiltie; so would his Pamphlet be received with a greater currant and credite then formerly it hath beene' (32). Between them, Munda and Sowernam illustrate the multivalency of feminine silence, which shifts from a sign of guilt and shame to the 'greatest Ornament' in women.

26 Although *The Tragedy of Mariam* was published in 1613, it was probably written some time between Cary's marriage in 1602 and the birth of her first child in 1609 (Cary 5).

27 See, for example, Brathwait's advice in his *English Gentlewoman*, cited earlier: '*Be indeed what you desire to be thought*' (106).

28 Many essays on *The Tragedy of Mariam* fail to mention Graphina at all. Raber, Straznicky and Shannon all ignore her, although Shannon in particular deals specifically with feminine silence: she asserts that 'the constraints attaching to the chastity of women render communication and exchange impossible: to be chaste, a woman must be silent … In the world the drama portrays, speech by women is seen as publicity, and the publicity of a wife is unchastity' (151).

29 Published after this book was substantially completed, Jonathan Goldberg's chapter on 'Graphina's Mark' in his *Desiring Women Writing* is a significant sequel to Ferguson's treatment of Graphina. Goldberg's own reading of Graphina's speech

attends to her insistence on knowing Pheroras's mind (2.1.54) and hence to her production of 'his mind as her preoccupied territory' (173) in a gesture of mutuality. In the end Goldberg finds marked in Graphina Cary's challenge to gendered, hierarchised difference: 'If the play does have utopic and egalitarian desires, as I believe it does, they occupy the terrain that I have marked as Graphina's, a transgression of the economies of gender subordination that moves toward a reoccupation of a terrain marked as male but re-marked so that female–male equality comes to occupy the position of male–male friendship' (181). My own analysis complements Goldberg's, though my argument about the effacement of gender difference in *Mariam* is worked out specifically through a discussion of the play's deployment of the silence trope whereas Goldberg privileges the notions of friendship and partnership.

30 It is tempting to see in this final line a reflection of Cary's own experience, in the eye of the storm as she 'endure[d] the trouble' of being dressed by her servants, 'while she was seriously thinking on some other business' (Cary 194). Of course, this incident took place well into her marriage with Sir Henry, though one might imagine it was fairly typical of a woman who read and studied avidly even as a child. But biographical speculation is not necessary to explain the potentially subversive implications of Graphina's silence.

31 Another possible biographical connection: *The Life* records Elizabeth's presence at a witch trial presided over by her father, a judge. Accused by several people, the woman confessed indiscriminately to all her alleged 'crimes'. The ten-year-old Elizabeth, suspecting that the woman was incoherent with fear, suggested she be accused of bewitching to death a man who was present at the trial, a 'crime' to which the woman eagerly confessed. Such an experience (as well as others possibly narrated by her father) would certainly have impressed on Elizabeth the dangers of 'unbridled speech' in the court, and the significance of the right to silence to avoid self-incrimination (Cary 186–7).

32 Herod's response to Nuntius's report of Mariam's dying words is 'Oh, that I could that sentence now control' (74). The ambiguity is noted by Ferguson, who claims that 'His remark might also … refer to Mariam's utterance: by killing her, he has after all lost the power to control her speech' ('Running' 57). While I am indebted to Ferguson's insight here, I argue that Herod still attempts throughout the scene to control her speech by fetishising it.

Epilogue: Philomel

It has now become commonplace for critics of Shakespeare to declare that 'what characters do not say in words ... is part of Shakespeare's text' (Rosenberg, *Adventures* 21). Harvey Rovine devotes an entire book, *Silence in Shakespeare: Drama, Power and Gender*, to the subject. Nor has the particular kind of instability I have been claiming for silence in early modern England gone unnoticed by critics. As early as 1930 William Empson recognised in a reference to feminine silence in *Measure for Measure* an example of what he termed the seventh type of ambiguity. Of Claudio's tribute to his sister's 'prone and speechless dialect', Empson commented casually: '*Speechlesse* will not give away whether she is shy or sly, and *dialect* has abandoned the effort to distinguish between them' (202). Jonathan Bate remarks of this passage that Empson's 'real innovation is the switch of gear whereby his analysis begins with "either/or" (... either shy or sly), then abandons "the effort to distinguish between them" and implies that it has been "both/and" all along' ('Words' 14). For Empson, of course, this kind of radical paradox is generated by the author: 'the total effect is to show a fundamental division in the writer's mind' (192). I have argued, by contrast, that the *culture* of early modern England is the source of the paradoxes of silence exploited by individual writers, and that these paradoxes considerably complicate the politics of gender in the period. As Heather Dubrow puts it, 'During the English Renaissance ... the discourse of patriarchy was in fact multivocal and cacophonous, including as it did a series of conflicting discourses that compromise the very use of that noun' (47).

One of these conflicting discourses clearly involved silence. Even in the classical tradition inherited by early modern authors, silence was a 'moving Rhetoricke', shifting between the poles of eloquence and impotence, and sometimes signifying the open defiance of the self-mutilating, stoical Zeno and Laena. Whilst these ancient conceptions still remained in

play (and found subsequent equivalents in the determined muteness of recusants on trial), in early modern England, where 'political men were obsessed with secrecy and ever fearful of dissimulation and deceit in their dealings with others' (Zagorin 256) and printed materials were increasingly produced and consumed in private, silence came increasingly to signify an impermeable and autonomous space resistant to discursive expression or interpretation and opposed to masculine rhetoric. Because, historically, silence when detached from eloquence was associated primarily with women, such an ideological shift had significant implications for figurations of gender in the period.

Early modern men and women were equally influenced by and subject to the ideologies of gender circulating around them, and the texts they produced both mirrored and shaped these ideologies. Drawing its illustrations from a wide range of literary genres, this book has sought to situate both male and female authors within the unstable, multivalent culture that was early modern England.[1] Thus Shakespeare's Cordelia and Wroth's Pamphilia emerged from the same set of complex cultural conditions which simultaneously privileged and destabilised feminine silence, despite the differences between Shakespeare as an 'upstart' man of the theatre at the height of his career and Wroth as heir to literary and cultural privilege writing from a position of virtual exile. Yet this book's arrangement of material in separate chapters for male and female authors raises important issues which require further comment. Far from suggesting an ahistorical biological essentialism, the separate treatment of male and female writers tacitly acknowledges their different histories and the different positions they occupy in culture while acknowledging their common investments in the gender system.

First and most obviously, the histories of silence for men and for women moved in different directions, as was suggested at the opening of Chapter 2, and this had important consequences for their deployment of the silence trope. Men moved from understanding silence in traditional terms as a form of eloquence or impotence, a readable rhetoric, to finding in it 'the safe possession of a hidden or unreadable space' (Maus 191). This unreadable space (as in the silences of Macduff or of Coriolanus, for example) had the potential to redefine masculinity as constituted by elements other than action or communication. For women, on the other hand, early

modern tropes of silence invested a sign of traditional feminine submission with self-contained inwardness. Even if this inwardness was mapped initially by men seeking an alternative to poisoned eloquence and finding it in feminine silence, the result was the elision of gender distinctions and the broadening of possibilities for women. For, while in one sense the sagacious silent woman may have served the interests of patriarchy, in another sense her silence as a sign of deference made her paradoxically morally superior to men.

Of course the functions silence performed for women as a multivalent sign of subservience, subjectivity and even superiority easily aroused anxiety about female hypocrisy. Maus points out: 'While it might seem that the calculated cultivation of a hidden space within would be incompatible with misogynist paranoia, the reverse is in fact the case. The very unreadability that seems so attractive in one's (male) self seems sinister in others; one man's privacy is another woman's unreliability' (192–3). Probably because of these pervasive fears, male authors representing feminine silence as a superior virtue for the primary purpose of challenging masculine rhetoric tend to block off the dangers inherent in such silence – the dangers of erotic desire, hysteria and disobedience among others – by displacing them on to other demonic female figures. Thus in *King Lear* the anarchic potential of Cordelia's silence – clearly recognised by Lear in the play's opening – is displaced on to her wicked sisters, whilst in *Titus Andronicus* the grotesque excesses of Lavinia's silence are embodied in the evil Tamora.[2] Female writers such as Mary Wroth, however, capitalise on the polyphony of feminine silence to construct heroines at once desiring, defiant and dutiful. If, for male writers, the silent woman is often a cipher who both elicits and eludes rhetorical attempts at containing or managing her, for female writers the silent woman often becomes a complex subject in her own right.

It is far too simple, however, to suggest that male authors are misogynist and female authors are not. Complex, unknowable female subjects are the standard fare of misogynist invective; Swetnam himself asserts: 'If a man talke of any kinde of beast or fowle, presently the nature is knowne … but women have more contrary sorts of behaviour then there be women, and therefore impossible for a man to know all, no nor one part of womens quallities all the daies of thy life' (39). One might well argue,

as some critics have done, that Elizabeth Cary engages in the same sort of 'splitting' of women by projecting Mariam's defiant impulses on to Salome, 'Mariam's evil twin' (Cary 40); a recent essay has suggested that Graphina's silence may be seen as a canny and politic reticence which furthers her own social ambitions (Zimmerman 588-9). Similarly, Mary Wroth may be working out her anxieties about the potentially subversive, silent figure she has created in Pamphilia by demonizing her loquacious double Antissia (Lamb 162). Conversely I have suggested that, in *Coriolanus* at least, Shakespeare uses the lengthiest silence in his entire corpus to represent the complex subjectivities of both Coriolanus and his mother.

The complex negotiations involved for male and female early modern authors in representing feminine silence emerge especially clearly in their treatments of the mute Philomel. Ovid's *Metamorphoses* – available in England since 1567 in Arthur Golding's widely read translation – tells the tale of Philomela, whose brother-in-law Tereus rapes her and then cuts out her tongue. She is thus literally reduced to silence by a male oppressor, much like Lavinia in *Titus Andronicus*, whose story is clearly indebted to Ovid. Philomela's silence initially makes her vulnerable to her rapist, who 'did oftentimes resort / To maymed *Philomela* and abusde hir at his will' (Rouse 717-18). Yet the powerless victim rapidly metamorphoses in Golding's narrative into a more active figure. Although, as Golding puts it, 'hir tunglesse mouth did want the utterance of the fact', her silence actually facilitates her thought, for 'Great is the wit of pensiveness' (Rouse 733-4). Silent meditation leads her to devise the plan to weave the image of her rape into a tapestry and send it to her sister Progne. Just as the womanly art of the needle is reappropriated by Philomela as a means of exposing Tereus, so the impotence of feminine silence becomes charged with subversive power. When Progne receives and reads the tapestry, she replicates Philomela's complex silence:

> She held hir peace (a wondrous thing it is she should so doe)
> But sorrow tide her tongue, and wordes agreeable unto
> Hir great displeasure were not at commaundement at that stound,
> And weepe she could not. Ryght and wrong she reckeneth to confound,
> And on revengement of the deede hir heart doth wholy ground.
>
> (Rouse 743-7)

The narrative inscribes Progne's silence in several different ways. The first line with its misogynist parenthesis humorously identifies her silence with decorous womanly behaviour (a 'wondrous thing' in usually verbose women),[3] the second line invokes the trope of speechless sorrow and the final lines construct her silence as actively menacing. The menace is fully realised when the sisters in Bacchic frenzy dismember Progne's young son Itys and serve him up to his father; after this action, they are transformed into birds (Progne becomes a swallow, Philomela a nightingale) and their feathers are 'stainde with bloud' (Rouse 848). Lamb points out that 'The pathos elicited by the mute Philomela is finally lethal as she changes from sympathetic victim to brutal revenger' (217). Ovid's original narrative thus supplied early modern authors with a classical precedent for conflating feminine silence as impotence with feminine silence as agency.

Although the *Metamorphoses* were extremely popular and although 'the narrative of a violent Philomela seems to have been the object of some fascination in Shakespeare's time' (Jane Newman 316), recent critics have been quick to point out that early modern authors tend to de-emphasise or repress the violence inherent in Philomela's muteness by recuperating her as the melodious nightingale whose transmuted grief becomes a source of pleasure rather than disturbance, eliding the potential for violent female agency. Writing about Shakespeare's *The Rape of Lucrece*, Jane Newman argues that 'The repression of the full story of Philomela can be explained as the result of the ideological pressure of a postclassical gender code organized around preserving political agency for the male' (326). Lamb points to the repression of women's anger in early modern versions of the Philomela story (218–23). While a search for 'the full story' of the mute and angry Philomel in early modern texts is bound to discover its repression, an examination of early modern representations of the silent Philomel can none the less tell us something about early modern preoccupations.

In many early modern texts Philomela is robbed not only of her rage but of the silence figuring that rage – the complex muteness that informs the Ovidian tale becomes the lovely song of the nightingale whose grieving lament is offset by the joyful spring it heralds. This un-Ovidian construction of Philomela as singer is related to her appropriation as a figure for the (male) poet, as in the Arcadian shepherd's lament for Basilius in Sidney's *Countess of Pembroke's Arcadia*:

> O Philomela (with thy breast oppressed
> By shame and grief), help, help me to lament
> Such cursed harms as cannot be redressed;
> Or if thy mourning notes be fully spent,
> Then give a quiet ear unto my plaining,
> For I, to teach the world complaint, am bent.
>
> (448.9–14)

Here Philomela is clearly an instrument of the male poet; her silence, like her song, is reanimated only as a complement to his discourse. While this may be the most common early modern interpretation of Philomel, it is by no means the only one.

Like Sidney, Shakespeare in Sonnet 102 invokes Philomel as poet/singer; unlike Sidney's speaker who invokes the mute Philomel only as listener, however, Shakespeare's speaker identifies himself imaginatively with Philomel, and shares the silence which follows the end of the song:

> Our love was new, and then but in the spring
> When I was wont to greet it with my lays,
> As Philomel in summer's front doth sing,
> And stops her pipe in growth of riper days –
>
> (102.5–8)

Critics differ on the function of the allusion to Philomel here: Stephen Booth claims that Shakespeare intends 'no active reference to the myth of Philomela' (*Shakespeare*'s 330), Walter Cohen suggests that the same line contains 'ambiguous hints of the myth of Philomel' (Shakespeare, *Norton* 1957), though he does not specify what these hints might mean, whilst Helen Vendler asserts that 'Philomel is the structural base of the poem' (436). The speaker in the previous sonnet in the sequence (discussed in Chapter 1) accuses his 'truant muse' of remaining 'dumb' (1, 9); his defence of his verse is an attack on 'silence' (10). Yet in Sonnet 102 Shakespeare's speaker appropriates the silent Philomel as a figure for his own plight. Initially this Philomel, like the nightingale, ceases singing in late summer; then, unlike either Ovid's Philomela or early modern English nightingales, she silences herself voluntarily: 'Therefore, like her, I sometime hold my tongue, / Because I would not dull you with my song' (13–14). The Philomel exemplum could well evoke the subliminal suggestion that the

speaker too has suffered violation (by his friend, who demands such self-justification and by other poets, who annoy him with their cacophonous music), but, as soon as the ravished Philomel of Ovid's original is rewritten as deferential woman, these allusive possibilities all but disappear. Like Cordelia in *King Lear*, this virtuously silent female figures masculine contempt for rhetorical excess (the 'wild music' of inferior birds (poets) which 'burdens every bough' (11)); as Vendler points out, 'it is the cacophonous chorus of the other birds which leads her to withdraw' (434). This recalls the ideal early modern woman described by Dod and Cleaver: 'Let her soon break off talk with such in whom she perceiveth no wisdom, nor favor of grace ... for *silence* is far better than such unsavoury talk' (Aughterson 80). In sharing the deferential position of the early modern woman as the friend's social inferior, like other early modern males Shakespeare's speaker crosses gender lines – a fact reflected in the original's shifting gendered pronouns invariably emended by editors.[4] At the same time it is clear that the strategically reticent woman/servant has absolute confidence in the value of the 'song' which s/he would preserve and deliver at a time of her or his own choosing.[5] That the speaker's reticence – as a sign both of deference and of self-assertion – is gendered *feminine* attests to the complex potentialities of the feminine silence he adopts, though it is firmly cast in early modern rather than Ovidian terms.

Like Shakespeare, Walter Raleigh briefly activates the Philomel myth to suggest the corruption of masculine rhetoric[6] in his famous reply to Marlowe's 'The Passionate Shepherd to his Love'. To Marlowe's pastoral and seductive vision of 'shallow rivers to whose falls / Melodious birds sing madrigals', Raleigh responds:

> Tyme drives the flockes from field to folde,
> The rivers rage, the rockes growe colde:
> As *Philomel* becometh dombe,
> The rest complayne of cares to comme.
>
> (117)

As in Shakespeare's poem, Raleigh's mention of the silencing of Philomel both alludes to the seasonal change that accompanies the nightingale's diminishing song and activates a web of subliminal associations relating to the myth for a distinctly early modern agenda. Ventriloquising the nymph,

Raleigh represents her scepticism about the 'truth in every shepherd's tongue' (l.2); Marlowe's *carpe diem* trope is answered by the speaker's elegaic knowledge that 'wanton fields / To wayward winter reckoning yields' (ll. 9–10). Seasonal change is represented as sexual violation – and the cluster of notions surrounding the Philomel allusion subliminally suggest that the shepherd's seductive invitation will lead to the same kind of rape. The silenced Philomel becomes a locus of protest against masculine rhetorical coercion.

If male poets rewrite Philomel as an early modern woman silently protesting against masculine rhetoric, women writers may have had special interest in this figure. In Aemilia Lanyer's 'Description of Cooke-ham', for example, the poet/speaker is epideictic poet of the Countess of Cumberland; like male poets, she too is a singer: '*Philomela* with her sundry leyes, / Both You and that delightfull Place did praise' ('Cooke-ham' in Lanyer ll. 31–2). When, at the end of the poem, 'Faire *Philomela* leaves her mournefull Ditty, / Drownd in dead sleepe, yet can procure no pittie' (ll. 189–90), the songless nightingale in winter is conflated with the bereft poet/speaker, victim of 'blind Fortune, carelesse to relieve' (l. 126) and, by extension, of the Countess of Cumberland's indifference. It is tempting to link the 'drownd' Philomel here with Lanyer's earlier self-representation in the Dedication to Queen Anne as one

> Whose untun'd voyce the dolefull notes doth sing
> Of sad Affliction in an humble strain;
> Much like unto a Bird that wants a wing,
> And cannot flie, but warbles forth her paine.
>
> ('To the Queenes' in Lanyer ll. 103–6)

If for this speaker the song of the mutilated bird (hinting at the ravished Philomel?) is an earthbound feminine substitute for the soaring flight of an Icarus or a Phaethon (Lanyer ll. 275–88) which she later emulates, it is finally extinguished at the close of her poem. Unlike 'Those pretty Birds' who, like more conventional early modern Philomels, 'Warble forth sorrow, and their owne dismay' ('Cooke-ham' ll. 185–8), the speaker is mute. The 'pathos of the poet's silence' (Vendler 436), understated in Shakespeare's sonnet, is heightened here: this Philomel is 'Drownd', almost 'dead' ('Cooke-ham' l. 190), recalling more directly the mutilated

Ovidian figure. Yet the poet's self-silencing has an aggressive purpose – it aims to 'procure … pittie' from the Countess of Cumberland, though it fails to do so. What it does do by means of the silence trope is to effect a self-erasure which becomes paradoxically the source of poetic self-assertion: 'When I am dead thy name in this may live' (l. 206), declares the speaker/poet in the final lines. As in Shakespeare's sonnet, silence is the site of self-negation and of self-assertion.

By far the most interesting reappropriation of the Philomel myth comes in Book 3 of Mary Wroth's *Urania*. There the fictional Queen of Naples, whom critics generally read as Wroth's figure for Mary Sidney Herbert, Countess of Pembroke (Wroth, *Urania* lxxxiv), walks in the woods and composes a poem: 'the stay procured dainty imaginations, they as delicate expressions, which made, and gave birth to these Verses framed by the most incomparable Queene, or Lady of her time, a Nightingale most sweetly singing, upon which she grounded her subject' (490.2–5). Initially, as the syntax implies, the female lyric poet is conflated with Philomela, and the opening quatrain of the Queen's poem extends the analogy:

> O that I might but now as senselesse bee
> Of my felt paines, as is that pleasant Tree,
> Of the sweet musique, thou deare Byrd dost make,
> Who I imagine doth my woes partake.
>
> (490.6–9)

Despite the affinity the speaker imagines between herself and the bird, as they are both transforming mournful experience into consolatory sweet music, some discomfort is implied in the relation, for the speaker longs to be 'senselesse', insensible to the bird's song. In the lines which follow, the speaker actively *rejects* identification with the nightingale:

> Yet contrary we doe our passions moove
> Since in sweet notes thou dost thy sorrowes proove.
> I but in sighs, and teares can shew I grieve,
> And those best spent, if worth doe them beleeve.
>
> (490.10–13)

If the bird aestheticises pain through sweet song, the speaker manifests only the nearly mute, somatic signs of grief. The contrast between them then

gives way to renewed identification as the final section of the poem recalls the original Philomel story more directly:

> Yet thy sweet pleasure makes me ever finde
> That happinesse to me, as Love is blinde,
> And these thy wrongs in sweetnesse to attire,
> Throwes down my hopes to make my woes aspire.

(490.14–17)

What Wroth's Queen of Naples does here is quite revolutionary: she exposes the convention of the melodic nightingale ('wrongs in sweetnesse to attire') as a fraud, a double violation which 'throwes down' her hopes and causes her sorrow.[7] In the final quatrain the speaker recuperates for herself the silence of the wronged Philomel – rewriting herself as the Ovidian mute and grieving female subject, distinct from the melodious early modern nightingale:

> Besides, of me th'advantage thou hast got,
> Thy griefe thou utter'st, mine I utter not.
> Yet thus at last we may agree in one,
> I mourne for what still is, thou, what is gone.

(490.18–21)

Whilst it is clearly an 'advantage' to be able to mitigate one's grief by dressing it in 'sweetnesse', the Queen of Naples implies that the intensity of present suffering makes this impossible; her silence figures her inexpressible inwardness and grief. It is a mistake to contend that the speaker's insistence on her silence is simply negated by her authorship: 'in the very writing of a poem on the impossibility of authorship, she has demonstrated its possibility' (Lamb 224; see also Miller, *Changing* 199). Like the authors who assumed female pseudonyms in the contemporaneous pamphlet war and like Shakespeare in Sonnet 102, Wroth's female poet foregrounds her silence as a cogent protest against masculinist rhetorical convention.

Both Wroth and Shakespeare appropriate Philomel as a means of resisting and exposing rhetorical artifice. While Shakespeare's poet shares Philomel's silence in order to control the conditions of her song, Wroth's poet rejects her melodiousness in order to claim the space of silence for her own grieving subjectivity. The contrast suggests just how strong the pull of

traditional gender roles could be: if men could appropriate feminine silence to their own rhetorical agenda, women could inhabit the space of silence to resist such appropriation. In both cases the 'moving Rhetoricke' of silence – and its increasing androgyny – served to challenge and destabilise gender in early modern England.

Notes

1 In its inclusion of male and female writers this book joins others such as Mary Ellen Lamb's *Gender and Authorship in the Sidney Circle*, Heather Dubrow's *Echoes of Desire* and Wendy Wall's *The Imprint of Gender*.

2 Maus notes this 'splitting' of impenetrable women in *The Faerie Queene*: 'In books II and IV of *The Faerie Queene* Spenser's exaltation of Britomart, the armed figure of chastity, militantly closed to penetration, coexists with much more disturbing portraits of women who exploit their inscrutability, like Helinore or the false Florimell' (193).

3 The offhand misogyny here is not inconsistent with other parts of the text – even at the moment when Philomela's tongue is severed, it is described 'as an Adders tayle' (713). Mary Ellen Lamb comments that 'the comparison of the tongue's wriggling to an "Adders tayle" suggests that her tongue also possesses the lethal venom of that serpent' (217). It is of course conventional to liken a woman's tongue to a serpent; in his *Arraignment of Lewd, Idle, Froward and Unconstant Women* (1615) Swetnam declares: 'And if thou forbear her, it maketh her bold, and if thou chasten her, then she will turn to a Serpent' (194).

4 The 1609 Quarto gives line 8 as: 'And stops his pipe in growth of riper daies', though it gives the female pronoun in lines 10 and 13 (Vendler 433).

5 Lynne Magnusson argues about another of Shakespeare's sonnets that 'the serv-ingman's position from which the sonnet speaker "answers back" is not simply one of subservience' (54).

6 A hint of Raleigh's understanding of the complex potentialities of silence emerges in his verses to the Queen ('Silence in love bewrayes more woe, / then words though nere so witty' (109)).

7 Lamb offers a different reading of these lines: 'Expressing her grief in "sighs and teares," the Queen of Naples cannot, like the nightingale, "attire" her wrongs in sweetness; her "woes" cannot aspire so high. But her grief requires some expres-sion; and poetry provides consolation for those who can, like the nightingale, use it to express their feelings' (224). My point is that Wroth's speaker/poet finds in the melodious Philomel's ornamentation of her grief a *cause* for woe; she offers a direct criticism of the rhetorical appropriation of Philomel's silence.

References

Adelman, Janet. '"Anger's My Meat": Feeding, Dependency and Aggression in *Coriolanus*'. *Shakespeare: Pattern of Excelling Nature*. Ed. Jay L. Halio and David Bevington. Newark: University of Delaware Press, 1978. 108–24.

———. *Suffocating Mothers: Fantasies of Maternal Origin in Shakespeare's Plays*, Hamlet *to* The Tempest. New York and London: Routledge, 1992.

Affinati, Fra Giacomo d'Acuto Romano. *The Dumbe Divine Speaker or Dumbe Speaker of Divinity: A Learned and Excellent Treatise, in Praise of Silence: Shewing Both the Dignitie, and Defectes of the Tongue*. Trans. A. M. London, 1605.

Amussen, Susan Dwyer. *An Ordered Society: Gender and Class in Early Modern England*. Oxford: Basil Blackwell, 1988.

Anger, Jane. *Jane Anger Her Protection for Women*. London, 1589.

Aristotle. *Complete Works*. Ed. H. Rackham. Cambridge, Massachusetts: Harvard University Press, 1990. 17 (*Metaphysics*); 21 (*Politics*).

Askew, Anne. *The Examinations of Anne Askew*. Ed. Elaine Beilin. Oxford: Oxford University Press, 1996.

Aughterson, Kate, ed. *Renaissance Woman: A Sourcebook: Constructions of Femininity in England*. London: Routledge, 1995.

Bacon, Francis. 'Of Simulation and Dissimulation'. *The Essayes or Counsels, Civill and Morall*. Ed. Michael Kiernan. Cambridge, Massachusetts: Harvard University Press, 1985.

———. *Advancement of Learning*. Ed. Arthur Johnston. Oxford: Clarendon, 1974.

———. *Certaine Considerations Touching the Better Pacification and Edification of the Church of England*. London, 1604.

Barbaro, Francesco. 'On Wifely Duties'. *The Earthly Republic: Italian Humanists on Government and Society*. Ed. Benjamin J. Kohl and Ronald G. Witt. Philadelphia: University of Pennsylvania Press, 1978. 189–228.

Barish, Jonas. *Ben Jonson and the Language of Prose Comedy*. Cambridge, Massachusetts: Harvard University Press, 1960.

——. '*The Spanish Tragedy*, or The Pleasures and Perils of Rhetoric'. *Elizabethan Theatre*. Stratford-upon-Avon Studies 9. London: Edward Arnold, 1966. 59–86.

Bate, Jonathan. *Shakespeare and Ovid*. Oxford: Clarendon, 1993.

——. 'Words in a Quantum World: How Cambridge Physics Led William Empson to Refuse "Either/Or"'. *Times Literary Supplement* 25 July 1997: 14–15.

Bauman, Richard. *Let Your Words Be Few: Symbolism of Speaking and Silence among Seventeenth-century Quakers*. Cambridge: Cambridge University Press, 1983.

Becon, Thomas. *A New Catechism, Set Forth Dialogue-wise in Familiar Talk Between the Father and the Son. The Catechism of Thomas Becon with Other Pieces*. Ed. John Ayre. Parker Society. Cambridge: Cambridge University Press, 1844.

Beilin, Elaine. 'Anne Askew's Dialogue with Authority'. *Contending Kingdoms: Historical, Psychological and Feminist Approaches to the Literature of Sixteenth-century England and France*. Ed. Marie-Rose Logan and Peter L. Rudnytsky. Detroit: Wayne State University Press, 1991. 313–22.

——. 'Anne Askew's Self-portrait in the *Examinations*'. *Silent But for the Word: Tudor Women as Patrons, Translators, and Writers of Religious Works*. Ed. Margaret Patterson Hannay. Kent, Ohio: Kent State University Press, 1985. 77–91.

——. *Redeeming Eve: Women Writers of the English Renaissance*. Princeton: Princeton University Press, 1987.

Belsey, Catherine. 'Desire's Excess and the English Renaissance Theatre: *Edward II, Troilus and Cressida, Othello*'. *Erotic Politics: Desire on the Renaissance Stage*. Ed. Susan Zimmerman. London: Routledge, 1992. 84–102.

——. *The Subject of Tragedy: Identity and Difference in Renaissance Drama*. London: Methuen, 1985.

Benson, Pamela. *The Invention of the Renaissance Woman*. University Park, Pennsylvania: Pennsylvania State University Press, 1992.

Berry, Ralph. *Changing Styles in Shakespeare*. London: G. Allen and Unwin, 1981.

——. 'Sexual Imagery in *Coriolanus*'. *Studies in English Literature 1500–1900* 13, 2 (Spring 1973): 301–16.

——. 'Stratford Festival Canada'. *Shakespeare Quarterly* 33.2 (Summer 1982): 199–202.

Bevington, David. *Action Is Eloquence: Shakespeare's Language of Gesture*. Cambridge, Massachusetts: Harvard University Press, 1984.

——. ed. *Henry IV, Part I*. Oxford: Clarendon, 1987.

Bloom, Harold. Introduction to *William Shakespeare's* Coriolanus. New York: Chelsea House, 1988.

Boose, Lynda E. 'Scolding Brides and Bridling Scolds: Taming the Woman's Unruly Member'. *Shakespeare Quarterly* 42 (1991): 179–213. Rpt in *Materialist Shakespeare: A History*. Ed. Ivo Kamps. London: Verso, 1995. 239–79.

Booth, Stephen. King Lear, Macbeth, *Indefinition and Tragedy*. New Haven: Yale University Press, 1983.

——. ed. *Shakespeare's Sonnets*. New Haven and London: Yale University Press, 1977.

Bradbrook, M. C. 'Dramatic Role as Social Image: A Study of *The Taming of the Shrew*'. *Shakespeare Jahrbuch* 94 (1958): 132–50.

Braden, Gordon. *Renaissance Tragedy and the Senecan Tradition: Anger's Privilege*. New Haven: Yale University Press, 1985.

Brathwait, Richard. *A Strappado for the Divell*. London, 1615. Ed. J. W. Ebsworth. Boston, Lincolnshire: Robert Roberts, 1878.

——. *The English Gentleman*. London, 1630.

——. *The English Gentlewoman Drawne Out to the Full Body*. London, 1631; The English Experience No. 215. New York: Da Capo Press, 1970.

Breitenberg, Mark. *Anxious Masculinity in Early Modern England*. Cambridge: Cambridge University Press, 1996.

Brockbank, Philip, ed. *Coriolanus*. London: Methuen, 1976.

Burton, Robert. *The Anatomy of Melancholy*. Ed. Thomas C. Faulkner, Nicolas K. Kiessling, and Rhonda L. Blair. Oxford: Clarendon, 1989.

Callaghan, Dympna. 'Re-reading Elizabeth Cary's *The Tragedie of Mariam, Faire Queene of Jewry*'. *Women, 'Race' and Writing in the Early Modern Period*. Ed. Margo Hendricks and Patricia Parker. London: Routledge, 1994. 163–77.

——. *Woman and Gender in Renaissance Tragedy: A Study of* King Lear, Othello, The Duchess of Malfi *and* The White Devil. Atlantic Highlands: Humanities Press, 1989.

The Cambridge History of Renaissance Philosophy. Ed. Charles B. Schmitt and Quentin Skinner. Cambridge: Cambridge University Press, 1988.

Cary, Elizabeth, the Lady Falkland. *The Tragedy of Mariam the Fair Queen of Jewry*. Ed. Barry Weller and Margaret W. Ferguson. Berkeley: University of California Press, 1994.

Cerasano, S. P. and Marion Wynne-Davies, ed. *Renaissance Drama by Women: Texts and Documents*. London: Routledge, 1996.

Cheung, King-Kok. *Articulate Silences: Hisaye Yamamoto, Maxine Hong Kingston, Joy Kogawa*. Ithaca: Cornell University Press, 1993.

Cicero, *De oratore*. Trans. H. Rackham. Volume 2, Book 3. London: Heinemann; Cambridge, Massachusetts: Harvard University Press, 1960.

Cixous, Hélène. 'Castration or Decapitation?' Trans. Annette Kuhn. *Signs* 7 (1981): 41–55.

——. 'The Laugh of the Medusa'. Trans. Keith Cohen and Paula Cohen. *New French Feminisms*. Ed. Elaine Marks and Isabelle de Courtivron. Amherst: University of Massachusetts Press, 1980. 245–64.

Clifford, Lady Anne. *The Diaries of Lady Anne Clifford*. Ed. D. J. H. Clifford. Phoenix Mill: Alan Sutton, 1990.

Cobbett, William and Thomas Howell. *Cobbett's Complete Collection of State Trials*. London, 1809.

Colie, Rosalie L. 'The Energies of Endurance: Biblical Echo in King Lear'. *Some Facets of King Lear: Essays in Prismatic Criticism*. Ed. Rosalie L. Colie and F. T. Flahiff. Toronto: University of Toronto Press, 1974. 117–44.

Coustau, Pierre. *Le Pegme de Pierre Coustau*. Introduction by Stephen Orgel. New York: Garland, 1979.

Croll, Morris W. *Style, Rhetoric and Rhythm*. Ed. J. Max Patrick. Princeton: Princeton University Press, 1966.

Curtius, Ernst Robert. *European Literature and the Latin Middle Ages*. Trans. William R. Trask. New York: Harper and Row, 1953.

Daniel, Samuel. *Delia with the Complaint of Rosamond*. London, 1592; London: Scolar Press, 1969.

David, Richard. *Shakespeare in the Theatre*. Cambridge: Cambridge University Press, 1978.

Davies, Kathleen M. 'Continuity and Change in Literary Advice on Marriage'. *Marriage and Society: Studies in the Social History of Marriage*. Ed. R. B. Outhwaite. New York: St Martin's, 1981. 58–80.

Dawson, Anthony B. 'The Impasse over the Stage'. *English Literary Renaissance* 21 (1991): 309–27.

——. 'Making a Difference? Shakespeare, Feminism, Men'. *English Studies in Canada* 15 (Dec. 1989): 427–40.

De Catur, Louis A. 'Scolds and Griseldas in Popular Fiction: Two Fishwives' Variants of the Patient Griselda Story'. Paper presented to Shakespeare Association of America. Chicago, Illinois. March 1995.

Derrida, Jacques. 'The Voice that Keeps Silence'. *Speech and Phenomena and Other Essays on Husserl's Theory of Signs*. Evanston: Northwestern University Press, 1973.

Dessen, Alan C. *Shakespeare in Performance:* Titus Andronicus. Manchester: Manchester University Press, 1989.

——. and Leslie Thomson. *A Dictionary of Stage Directions in English Drama 1580–1642*. Cambridge: Cambridge University Press, 1999.

Dod, John, and Robert Cleaver. *A Godlie Forme of Householde Government for the Ordering of Private Families, According to the Direction of Gods Word.* London, 1612.

Du Bosc, Jacques. *The Compleat Woman.* London, 1639; The English Experience 12. Amsterdam: Da Capo Press, 1968.

Dubrow, Heather. *Echoes of Desire: English Petrarchism and Its Counterdiscourses.* Ithaca and London: Cornell University Press, 1995.

Duras, Marguerite. Interview. Trans. Susan Husserl-Kapit. *New French Feminisms.* Ed. Elaine Marks and Isabelle de Courtivron. Amherst: University of Massachusetts Press, 1980. 174–76.

Edwards, Philip, ed. *The Spanish Tragedy.* By Thomas Kyd. Cambridge, Massachusetts: Harvard University Press, 1959.

Elam, Keir. *The Semiotics of Theatre and Drama.* London and New York: Methuen, 1980.

Elshtain, Jean Bethke. *Public Man, Private Woman: Women in Social and Political Thought.* Princeton: Princeton University Press, 1981.

Elyot, Thomas. *The Boke Named the Governour.* London, 1531. Ed. Henry Herbert Stephen Croft, 1883; New York: Burt Franklin, 1967.

Empson, William. *Seven Types of Ambiguity.* London: Hogarth, 1984.

Erasmus, Desiderius. 'Lingua', *Collected Works of Erasmus* 29. Literary and Educational Writings 7. Ed. Elaine Fantham and Erika Rummel. Toronto: University of Toronto Press, 1989.

——. *Proverbes or Adagies with Newe Adicions Gathered Out of the Chiliades of Erasmus by Richard Taverner.* London, 1539; Amsterdam: Theatrum Orbis Terrarum and Da Capo Press, 1969.

Faas, Ekbert. *Shakespeare's Poetics.* Cambridge: Cambridge University Press, 1986.

Fell, Margaret. *Womens Speaking Justified.* London, 1666; London: Pythia, 1989.

Ferguson, Margaret W. 'Renaissance Concepts of the "Woman Writer"'. *Women and Literature in Britain, 1500–1700.* Ed. Helen Wilcox. Cambridge: Cambridge University Press, 1996. 143–68.

——. 'Running On with Almost Public Voice: The Case of "E.C."'. *Tradition and the Talents of Women.* Ed. Florence Howe. Urbana: University of Illinois Press, 1991. 37–67.

Fienberg, Nona. 'Wroth and the Invention of Female Poetic Subjectivity'. *Reading Mary Wroth: Representing Alternatives in Early Modern England.* Ed. Naomi J. Miller and Gary Waller. Knoxville: University of Tennessee Press, 1991. 175–90.

Fischer, Sandra K. 'Hearing Ophelia: Gender and Tragic Discourse in *Hamlet*'. *Renaissance and Reformation* n.s. 14.1 (1990): 1–10.

Fleming, Juliet. 'Dictionary English and the Female Tongue'. *Privileging Gender in Early Modern England*. Ed. Jean R. Brink. Sixteenth Century Essays and Studies 23. Kirksville, Missouri: Sixteenth Century Journal, 1993. 175–204.

Fletcher, Anthony. *Gender, Sex and Subordination in England 1500–1800*. New Haven: Yale University Press, 1995.

Foucault, Michel. *The History of Sexuality*. Volume I: An Introduction. Trans. Robert Hurley. New York: Random, 1978.

Gilbert, Sandra M. and Susan Gubar. 'Sexual Linguistics: Gender, Language, Sexuality'. *New Literary History* 16.3 (1985): 515–43.

Goldberg, Jonathan. *Desiring Women Writing*. Stanford: Stanford University Press, 1997.

——. *James I and the Politics of Literature: Jonson, Shakespeare, Donne, and Their Contemporaries*. Baltimore: Johns Hopkins University Press, 1983.

——. 'Shakespearean Inscriptions: The Voicing of Power'. *Shakespeare and the Question of Theory*. Ed. Patricia Parker and Geoffrey Hartman. London: Methuen, 1985. 116–37.

Goldman, Michael. 'Papp and Pacino in New York City'. *Shakespeare Quarterly* 31.2 (1980): 192–5.

Gouge, William. *Of Domesticall Duties*. London, 1622.

Graham, Elspeth, Hilary Hinds, Elaine Hobby and Helen Wilcox, eds. *Her Own Life: Autobiographical Writings by Seventeenth-century Englishwomen*. London: Routledge, 1989.

Graham, Kenneth J. E. *The Performance of Conviction: Plainness and Rhetoric in the Early English Renaissance*. Ithaca: Cornell University Press, 1994.

Green, Douglas E. 'Interpreting "her martyr'd signs": Gender and Tragedy in *Titus Andronicus*'. *Shakespeare Quarterly* 40 (1989): 317–26.

Greenblatt, Stephen. 'Fiction and Friction'. *Shakespearean Negotiations: The Circulation of Social Energy in Renaissance England*. Berkeley: University of California Press, 1988.

——. *Learning to Curse: Essays in Early Modern Culture*. London: Routledge, 1990.

Greene, Robert. 'Penelope's Web'. *Life and Complete Works in Prose and Verse of Robert Greene*. Volume 5. Ed. Alexander B. Grosart. New York: Russell and Russell, 1881–6.

Grymeston, Elizabeth. *Miscellanea, Meditations, Memoratives*. London, 1604.

Guazzo, Steven. *The Civile Conversation of M. Steeven Guazzo*. Trans. George Pettie. London, 1581. London and New York: Alfred A. Knopf, 1925.

Gurr, Andrew. *The Shakespearean Stage, 1574–1642*. 2nd ed. Cambridge: Cambridge University Press, 1980.

Hackett, Helen. "'Yet tell me some such fiction'": Lady Mary Wroth's *Urania* and the "Femininity" of Romance'. *Women Texts and Histories 1575–1760*. Ed. Diane Purkiss and Clare Brant. London: Routledge, 1992. 39–68.

Hallahan, Huston D. 'Silence, Eloquence and Chatter in Jonson's *Epicoene*'. *Huntington Library Quarterly* 40 (1977): 117–27.

Hansen, Elaine Tuttle. 'The Powers of Silence: The Case of the Clerk's Griselda'. *Women and Power in the Middle Ages*. Ed. Mary Erler and Maryanne Kowaleski. Athens: University of Georgia Press, 1988. 230–49.

Hanson, Elizabeth. 'Against a Synecdochic Shakespeare'. *Discontinuities: New Essays on Renaissance Literature and Criticism*. Ed. Viviana Comensoli and Paul Stevens. Toronto: University of Toronto Press, 1998. 75–95.

Harvey, Elizabeth D. *Ventriloquized Voices: Feminist Theory and English Renaissance Texts*. London: Routledge, 1992.

Hawkes, Terence. *Shakespeare's Talking Animals: Language and Drama in Society*. London: Edward Arnold, 1973.

Heale, William. *An Apologie for Women*. Oxford, 1609; The English Experience 665. Amsterdam: Walter J. Johnson, 1974.

Hedges, Elaine and Sheila Fisher Fishkin, eds. *Listening to Silences: New Essays in Feminist Criticism*. Oxford: Oxford University Press, 1994.

Henderson, Katherine Usher and Barbara F. McManus. *Half Humankind: Contexts and Texts of the Controversy about Women in England, 1540–1640*. Urbana: University of Illinois Press, 1985.

Heywood, Thomas. *The Dramatic Works of Thomas Heywood*. Volume 2. Introduction by J. Payne Collier. London: Shakespeare Society, 1850.

——. *Englands Elizabeth: Her Life and Troubles, During Her* Minoritie, *from the* Cradle *to the* Crowne. London, 1630.

Hibbard, G. R. *The Making of Shakespeare's Dramatic Poetry*. Toronto: University of Toronto Press, 1981.

Hillman, David. 'Puttenham, Shakespeare, and the Abuse of Rhetoric'. *Studies in English Literature 1500–1900* 36 (1996): 73–90.

Hillman, Richard. *Self-speaking in Medieval and Early Modern English Drama: Subjectivity, Discourse and the Stage*. London: Macmillan, 1997.

——. *Shakespearean Subversions: The Trickster and the Play-text*. London: Routledge, 1992.

Hinds, Hilary. *God's Englishwomen: Seventeenth-century Radical Sectarian Writing and Feminist Criticism*. Manchester: Manchester University Press, 1996.

Hobby, Elaine. *Virtue of Necessity: English Women's Writing 1649–88*. Ann Arbor: University of Michigan Press, 1989.

Holderness, Graham. "'A Woman's War": A Feminist Reading of *Richard II'*. *Shakespeare Left and Right*. Ed. Ivo Kamps. New York and London: Routledge, 1991. 167–83.

Howard, Jean E. 'Crossdressing, the Theatre, and Gender Struggle in Early Modern England'. *Shakespeare Quarterly* 39 (1988): 418–40.

Hull, Suzanne W. *Chaste, Silent and Obedient: English Books for Women, 1475–1640*. San Marino: Huntington Library, 1982.

Hyrde, Richard. Dedication to *Devout Treatise upon the Pater Noster* by Desiderius Erasmus. Trans. Margaret Roper. London, 1526.

Irigaray, Luce. 'This Sex Which Is Not One'. Trans. Claudia Reeder. *New French Feminisms*. Ed. Elaine Marks and Isabelle de Courtivron. Amherst: University of Massachusetts Press, 1980. 99–107.

——. *Speculum of the Other Woman*. Trans. Gillian C. Gill. Ithaca: Cornell University Press, 1985.

James I, King of Great Britain. *The Basilicon Doron of King James VI*. Ed. James Craigie. Edinburgh and London: Blackwood, 1944.

Jardine, Lisa. *Reading Shakespeare Historically*. London: Routledge, 1996.

——. *Still Harping on Daughters: Women and Drama in the Age of Shakespeare*. 2nd ed. New York: Columbia University Press, 1989.

Jones, Ann Rosalind. *The Currency of Eros: Women's Love Lyric in Europe, 1540–1620*. Bloomington: Indiana University Press, 1990.

Jonson, Ben. *Epicoene, or the Silent Woman*. Ed. R. V. Holdsworth. London: A. and C. Black; New York: Norton, 1996.

——. *The Gypsies Metamorphosed. Ben Jonson*. Ed. C. H. Herford, Percy and Evelyn Simpson. Oxford: Clarendon, 1941. 7: 565–622.

——. *The New Inn*. Ed. Michael Hattaway. The Revels Plays. Manchester: Manchester University Press, 1984.

——. *Timber; or Discoveries. Ben Jonson*. Ed. C. H. Herford, Percy and Evelyn Simpson. Oxford: Clarendon, 1947. 8: 563–649.

——. *Volpone*. Ed. R. B. Parker. The Revels Plays. Manchester: Manchester University Press, 1983.

Jorden, Edward. *A Briefe Discourse of a Disease Called the Suffocation of the Mother*. London, 1603.

Kahn, Coppelia. *Man's Estate: Masculine Identity in Shakespeare*. Berkeley: University of California Press, 1981.

Kalamaras, George. *Reclaiming the Tacit Dimension: Symbolic Form in the Rhetoric of Silence*. New York: State University of New York Press, 1994.

Kennedy, Gwynne. 'Lessons of the "Schoole of wisedome"'. *Sexuality and Politics in Renaissance Drama*. Ed. Carole Levin and Karen Robertson. Lewiston: Edwin Mellen Press, 1991. 113–36.

Krontiris, Tina. *Oppositional Voices: Women as Writers and Translators of Literature in the English Renaissance*. London: Routledge, 1992.

Kyd, Thomas. *The Spanish Tragedy*. Ed. J. R. Mulryne. London: A. and C. Black, 1989.

Lamb, Mary Ellen. *Gender and Authorship in the Sidney Circle*. Madison: University of Wisconsin Press, 1990.

Langbein, John H. *Torture and the Law of Proof*. Chicago: University of Chicago Press, 1977.

Lanyer, Aemilia. *Salve Deus Rex Judaeorum*. Ed. Susanne Woods. Oxford: Oxford University Press, 1993.

Lawrence, Karen. 'The Cypher: Disclosure and Reticence in *Villette*'. *Tradition and the Talents of Women*. Ed. Florence Howe. Urbana: University of Illinois Press, 1991. 87–101.

Leiter, Samuel L. *Shakespeare Around the Globe*. New York: Greenwood, 1986.

Levenson, Jill. 'What the Silence Said: Still Points in King Lear'. *Shakespeare 1971: Proceedings of the World Shakespeare Congress*. Ed. Clifford Leech and J. M. R. Margeson. Toronto: University of Toronto Press, 1972. 215–29.

Leverenz, David. 'The Woman in Hamlet: An Interpersonal View'. *Signs* 4 (1978): 291–308.

Levin, Carole. 'Women in the Book of Martyrs as Models of Behavior'. *International Journal of Women's Studies* 4 (1981): 196–207.

Levine, Laura. *Men in Women's Clothing: Anti-theatricality and Effeminization 1579–1642*. Cambridge: Cambridge University Press, 1994.

Levy, Leonard W. *Origins of the Fifth Amendment: The Right Against Self-incrimination*. New York: Oxford University Press, 1968.

Lewalski, Barbara. *Writing Women in Jacobean England*. Cambridge, Massachusetts: Harvard University Press, 1993.

Lipsius, Justus. *Two Bookes of Constancie. Englished by Sir John Stradling*. Ed. Rudolf Kirk. New Brunswick, New Jersey: Rutgers University Press, 1939.

Lowe, Lisa. '"Say I play the man I am": Gender and Politics in *Coriolanus*'. *Kenyon Review* 8, 4 (Fall 1986): 86–95.

Lyly, John. *Euphues and his England*. Ed. Edward Arber. London: Westminster Constable, 1904.

Mack, Phyllis. *Visionary Women: Ecstatic Prophecy in Seventeenth-century England*. Berkeley: University of California Press, 1992.

Maclean, Ian. *The Renaissance Notion of Woman: A Study in the Fortunes of Scholasticism and Medical Science in European Intellectual Life*. Cambridge: Cambridge University Press, 1980.

MacKendrick, Karmen. *Immemorial Silence*. Albany: State University of New York Press, 2001.

Magnusson, Lynne. *Shakespeare and Social Dialogue: Dramatic Language and Elizabethan Letters*. Cambridge: Cambridge University Press, 1999.

Marcus, Jane. 'Still Practice, A/Wrested Alphabet: Toward a Feminist Aesthetic'. *Feminist Issues in Literary Scholarship*. Ed. Shari Benstock. Bloomington: Indiana University Press, 1987. 79-97.

Marlowe, Christopher. *Tamburlaine the Great Parts I and II*. Ed. John D. Jump. Lincoln: University of Nebraska Press, 1967.

Marshall, Cynthia. '"I can interpret all her martyr'd signs": *Titus Andronicus*, Feminism, and the Limits of Interpretation'. *Sexuality and Politics in Renaissance Drama*. Ed. Carole Levin and Karen Robertson. Lewiston: Edwin Mellen Press, 1991. 193-213.

Marston, John. *Antonio's Revenge*. Ed. W. Reavley Gair. The Revels Plays. Manchester: Manchester University Press, 1978.

——. *Parasitaster or the Fawn*. Ed. David A. Blostein. The Revels Plays. Manchester: Manchester University Press, 1978.

Martin, Randall, ed. *Women Writers in Renaissance England*. London and New York: Longman, 1997.

Masten, Jeff. '"Shall I turne blabb?": Circulation, Gender, and Subjectivity in Mary Wroth's Sonnets'. *Reading Mary Wroth: Representing Alternatives in Early Modern England*. Knoxville: University of Tennessee Press, 1991. 67-87.

Matchinske, Megan. *Writing, Gender and State in Early Modern England*. Cambridge: Cambridge University Press, 1998.

Matheson, Mark. '*Hamlet* and "A Matter Tender and Dangerous"'. *Shakespeare Quarterly* 46 (1995): 383-97.

Maus, Katharine Eisaman. *Inwardness and Theater in the English Renaissance*. Chicago: University of Chicago Press, 1995.

McCrea, Adriana. *Constant Minds: Political Virtue and the Lipsian Paradigm in England, 1584-1650*. Toronto: University of Toronto Press, 1997.

McDonald, Russ. 'Late Shakespeare: Style and the Sexes'. *Shakespeare Survey* 46 (1994): 91-106.

McGuire, Philip C. *Speechless Dialect: Shakespeare's Open Silences*. Berkeley: University of California Press, 1985.

McJannet, Linda. *The Voice of Elizabethan Stage Directions: The Evolution of a Theatrical Code*. Newark: University of Delaware Press, 1999.

McLuskie, Kathleen. "'The Patriarchal Bard": Feminist Criticism and Shakespeare: *King Lear* and *Measure for Measure*'. *Political Shakespeare: New Essays in Cultural Materialism*. Ed. Jonathan Dollimore and Alan Sinfield. Manchester: Manchester University Press, 1985.

Mehl, Dieter. *The Elizabethan Dumb Show: The History of a Dramatic Convention*. London: Methuen, 1964.

Middleton, Thomas. *Hengist, King of Kent*. Ed. R. C. Bald. New York and London: Scribner, 1938.

——. *The Roaring Girl*. Ed. Paul Mulholland. The Revels Plays. Manchester: Manchester University Press, 1987.

——. *Women Beware Women*. Ed. William C. Carroll. 2nd edition. London: A. and C. Black; New York: Norton, 1995.

Middleton, Thomas, and William Rowley. *The Changeling*. Ed. Joost Daalder. London: A. and C. Black, 1990.

Miller, Naomi J. *Changing the Subject: Mary Wroth and Figurations of Gender in Early Modern England*. Lexington: University Press of Kentucky, 1996.

——. "'Not much to be marked": Narrative of the Woman's Part in Lady Mary Wroth's *Urania*'. *Studies in English Literature 1500–1900* 29 (1989): 121–37.

——. 'Rewriting Lyric Fictions: The Role of the Lady in Lady Mary Wroth's *Pamphilia to Amphilanthus*'. *The Renaissance Englishwoman in Print*. Ed. Anne M. Haselkorn and Betty Travitsky. Amherst: University of Massachusetts Press, 1990. 347–60.

Mish, Charles C., ed. *Short Fiction of the Seventeenth Century*. New York: New York University Press, 1963.

Moulton, Ian Frederick. *Before Pornography: Erotic Writing in Early Modern England*. Oxford: Oxford University Press, 2000.

Mueller, Janel. 'A Tudor Queen Finds Voice: Katherine Parr's *Lamentation of a Sinner*'. *The Historical Renaissance: New Essays on Tudor and Stuart Literature and Culture*. Ed. Heather Dubrow and Richard Strier. Chicago: University of Chicago Press, 1988. 15–47.

Munda, Constantia. *The Worming of a Mad Dogge*. London, 1617.

Murry, John Middleton. 'A Neglected Heroine of Shakespeare'. *Countries of the Mind: Essays in Literary Criticism*. London: Collins, 1922.

Murphy, James J. *Peter Ramus's Attack on Cicero: Text and Translation of Ramus's Brutinae Quaestiones*. Davis, California: Hermagoras Press, 1992.

The New English Bible: The Apocrypha. Oxford: Oxford University Press, 1970.

Newman, Jane O. "'And let mild women to him lose their mildness": Philomela, Female Violence, and Shakespeare's *The Rape of Lucrece*'. *Shakespeare Quarterly* 45 (Fall 1994): 304–26.

Newman, Karen. 'Cultural Capital's Gold Standard: Shakespeare and the Critical Apostrophe in Renaissance Studies'. *Discontinuities: New Essays on Renaissance Literature and Criticism*. Ed. Viviana Comensoli and Paul Stevens. Toronto: University of Toronto Press, 1998. 96–113.

——. *Fashioning Femininity and English Renaissance Drama*. Chicago: University of Chicago Press, 1991.

Niccholes, Alexander. *A Discourse, of Marriage and Wiving*. London, 1620.

Ong, Walter J. *Ramus, Method and the Decay of Dialogue: From the Art of Discourse to the Art of Reason*. Cambridge, Massachusetts: Harvard University Press, 1958.

Orgel, Stephen. 'Gendering the Crown'. *Subject and Object in Renaissance Culture*. Ed. Margreta de Grazia, Maureen Quilligan and Peter Stallybrass. Cambridge: Cambridge University Press, 1996. 133–65.

Oxford English Dictionary. Compact Ed. Oxford: Oxford University Press, 1971.

Palmer, Thomas. *The Emblems of Thomas Palmer*: Two Hundred Posees: *Sloane MS. 3794*. Ed. John Manning. AMS Studies in the Emblem 2. New York: AMS Press, 1988.

Parker, Patricia. *Literary Fat Ladies: Rhetoric, Gender, Property*. London: Methuen, 1987.

——. 'On the Tongue: Cross-gendering, Effeminacy, and the Art of Words'. *Style* 23.3 (Fall 1989): 445–65.

——. '*Othello* and *Hamlet*: Dilation, Spying, and the "Secret Place" of Woman'. *Shakespeare Reread: The Texts in New Contexts*. Ed. Russ McDonald. Ithaca and London: Cornell University Press, 1994. 105–46.

Parker, R. B. 'A Tale of Three Cities: Staging in *Coriolanus*'. *The Elizabethan Theatre* 13. Ed. A. L. Magnusson and C. E. McGee. Toronto: P. D. Meany, 1994. 119–45.

——, ed. *The Tragedy of Coriolanus*. Oxford: Clarendon, 1994.

Paster, Gail Kern. *The Body Embarrassed: Drama and the Disciplines of Shame in Early Modern England*. Ithaca: Cornell University Press, 1993.

——. 'Unspeakable Deeds: The Comic Actor and the History of Shame'. *The Elizabethan Theatre* 13. Ed. A. L. Magnusson and C. E. McGee. Toronto: P. D. Meany, 1994. 63–77.

Patterson, Annabel. '"For words only": From Treason Trial to Liberal Legend in Early Modern England'. *Yale Journal of Law and the Humanities* 5.2 (Summer 1993): 389–416.

Peacham, Henry. *The Garden of Eloquence*. London, 1593; Gainesville: Scholars' Facsimiles and Reprints, 1954.

——. *Minerva Britanna* (1612). Ed. John Horden. English Emblem Books 5. Leeds: Scolar Press, 1969.

Pearson, Jacqueline. 'Romans and Barbarians: The Structure of Irony in Shakespeare's Roman Tragedies'. *Shakespearian Tragedy*. Stratford-upon-Avon Studies 20. London: Edward Arnold, 1984. 159-82.

Perkins, William. *A Direction for the Government of the Tongue According to Gods Word*. London, 1597.

Plutarch. *Plutarch's Moralia*. Trans. W. C. Helmbold. Vol 6. Cambridge, Massachusetts: Harvard University Press, 1938.

Puttenham, George. *The Arte of English Poesie*. London, 1589; Menston, England: Scolar Press, 1968.

The Queene of Navarres Tales Now Newly Tr. into English. London, 1597.

Quilligan, Maureen. 'The Constant Subject: Instability and Authority in Wroth's *Urania* Poems'. *Soliciting Interpretation: Literary Theory and Seventeenth-century English Poetry*. Ed. Elizabeth D. Harvey and Katharine Eisaman Maus. Chicago: University of Chicago Press, 1990. 307-35.

——. 'Sidney and his Queen'. *The Historical Renaissance: New Essays on Tudor and Stuart Literature and Culture*. Ed. Heather Dubrow and Richard Strier. Chicago: University of Chicago Press, 1988. 171-96.

Raber, Karen L. 'Gender and the Political Subject in *The Tragedie of Mariam*'. *Studies in English Literature 1500-1900* 35 (1995): 321-42.

Rackin, Phyllis. 'Androgyny, Mimesis, and the Marriage of the Boy Heroine on the English Renaissance Stage'. *PMLA* 102 (1987): 29-41.

——. 'Historical Difference/Sexual Difference'. *Privileging Gender in Early Modern England*. Ed. Jean R. Brink. Sixteenth Century Essays and Studies 23. Kirksville, Missouri: Sixteenth Century Journal, 1993. 37-63.

Raleigh, Sir Walter. *The Poems of Sir Walter Raleigh: A Historical Edition*. Ed. Michael Rudick. Medieval and Renaissance Texts and Studies 209. Tempe, Arizona: Arizona Center for Medieval and Renaissance Studies and Renaissance English Text Society, 1999.

Randall, Dale B. J. *Jonson's Gypsies Unmasked*. Durham: Duke University Press, 1975.

Rebhorn, Wayne A. '"The emperour of mens minds": The Renaissance Trickster as *Homo Rhetoricus*'. *Creative Imitiation: New Essays on Renaissance Literature in Honor of Thomas M. Greene*. Ed. David Quint, Margaret Ferguson *et al.* Binghamton: Medieval and Renaissance Texts and Studies, 1992. 31-65.

——. *The Emperor of Men's Minds: Literature and the Renaissance Discourse of Rhetoric*. Ithaca: Cornell University Press, 1995.

The Revenger's Tragedy. Ed. Brian Gibbons. 2nd ed. London: A. and C. Black, 1991.

Ripo, Cesare. *Iconologia or Moral Emblems*. London, 1709.

Roberts, Alexander. *A Treatise of Witchcraft*. London, 1616.

Rogers, Katharine M. *The Troublesome Helpmate: A History of Misogyny in Literature*. Seattle and London: University of Washington Press, 1966.

Roper, Lyndal. *Oedipus and the Devil: Witchcraft, Sexuality and Religion in Early Modern Europe*. London: Routledge, 1994.

Rose, Jacqueline. 'Hamlet – the Mona Lisa of Literature'. *Critical Quarterly* 28 (1986): 35–49.

Rose, Mary Beth. *The Expense of Spirit: Love and Sexuality in English Renaissance Drama*. Ithaca and London: Cornell University Press, 1988.

Rosenberg, Marvin. *The Adventures of a Shakespeare Scholar*. Newark: University of Delaware Press, 1997.

——. *The Masks of Hamlet*. Newark: University of Delaware Press, 1992.

Rouse, W. H. D., ed. *Shakespeare's Ovid. Being Arthur Golding's Translation of the Metamorphoses*. London: Centaur Press, 1961.

Rovine, Harvey. *Silence in Shakespeare: Drama, Power and Gender*. Ann Arbor: UMI Research Press, 1987.

Rubinstein, Frankie. *Shakespeare's Sexual Puns and Their Significance*. London: Macmillan, 1984.

Saenger, Paul. *Space between Words: The Origins of Silent Reading*. Stanford: Stanford University Press, 1997.

Salmon, J. H. M. 'Seneca and Tacitus in Jacobean England'. *The Mental World of the Jacobean Court*. Ed. Linda Levy Peck. Cambridge: Cambridge University Press, 1991. 169–88.

Salter, Thomas. *A Mirrhor Mete for All Mothers, Matrones and Maidens*. London, 1579.

Sanders, Wilbur. *The Dramatist and the Received Idea: Studies in the Plays of Marlowe and Shakespeare*. Cambridge: Cambridge University Press, 1968.

Scot, Reginald. *The Discoverie of Witchcraft*. London, 1584; London: Dover, 1972.

Shakespeare, William. *The Norton Shakespeare*. Ed. Stephen Greenblatt, Walter Cohen, Jean E. Howard and Katharine Eisaman Maus. New York and London: Norton, 1997.

——. *Hamlet: First Quarto*. London: Scolar Press, 1969.

——. *Macbeth*. Ed. Kenneth Muir. London: Methuen, 1982.

Shand, G. B. 'Realising Gertrude: The Suicide Option'. *The Elizabethan Theatre* 13. Ed. A. L. Magnusson and C. E. McGee. Toronto: P. D. Meany, 1994. 95–118.

|

Shannon, Laurie J. '*The Tragedie of Mariam*: Cary's Critique of the Terms of Founding Social Discourses'. *English Literary Renaissance* 24.1 (Winter 1994): 135–53.

Shepherd, Simon, ed. *The Women's Sharp Revenge: Five Women's Pamphlets from the Renaissance*. London: Fourth Estate, 1985.

Shifflett, Andrew. *Stoicism, Politics and Literature in the Age of Milton: War and Peace Reconciled*. Cambridge: Cambridge University Press, 1998.

Sidney (Herbert), Lady Mary. *The Psalms of David*. London: Chiswick Press, 1823.

Sidney, Philip. *The Countess of Pembroke's Arcadia*. Ed. Victor Skretkowicz. Oxford: Clarendon, 1987.

——. *The Poems of Sir Philip Sidney*. Ed. William A. Ringler. Oxford: Clarendon, 1962.

Siegel, Jerrold E. *Rhetoric and Philosophy in Renaissance Humanism: The Union of Eloquence and Wisdom, Petrarch to Valla*. Princeton: Princeton University Press, 1968.

Smith, Bruce R., *The Acoustic World of Early Modern England: Attending to the O Factor*. Chicago: University of Chicago Press, 1999.

Smith, Henry. *A Preparative to Mariage*. London, 1591.

Snawsel, Robert. *A Looking-glasse for Maried Folkes*. London, 1631.

Spacks, Patricia Meyers. *Gossip*. Chicago: University of Chicago Press, 1986.

Speght, Rachel. *The Polemics and Poems of Rachel Speght*. Ed. Barbara Kiefer Lewalski. Oxford: Oxford University Press, 1996.

Spenser, Edmund. *Complete Poetical Works of Edmund Spenser*. Ed. R. E. Neil Dodge. Boston: Houghton Mifflin, 1908.

Sprengnether, Madelon. 'Annihilating Intimacy in *Coriolanus*'. *Women in the Middle Ages and the Renaissance*. Ed. Mary Beth Rose. Syracuse: Syracuse University Press, 1986. 89–111.

Stallybrass, Peter. 'Patriarchal Territories: The Body Enclosed'. *Rewriting the Renaissance: The Discourses of Sexual Difference in Early Modern Europe*. Ed. Margaret Ferguson, Maureen Quilligan and Nancy J. Vickers. Chicago: University of Chicago Press, 1986. 251–77.

Stamm, Rudolph. 'The Alphabet of Speechless Complaint: A Study of the Mangled Daughter in Shakespeare's *Titus Andronicus*'. *The Triple Bond: Plays, Mainly Shakespearean, in Performance*. Ed. Joseph G. Price. University Park: Pennsylvania State University Press, 1975. 255–73.

Stempel, Daniel. 'The Silence of Iago'. *PMLA* 84.2 (1969): 252–63.

Stout, Janis. *Strategies of Reticence*. Charlottesville and London: University Press of Virginia, 1990.

Straznicky, Marta. '"Profane stoical paradoxes": *The Tragedie of Mariam* and Sidnean Closet Drama'. *English Literary Renaissance* 24.1 (Winter 1994): 104–34.

S[tubbes], P[hilip]. *A Christal Glasse for Christian Women*. London, 1591.

Swetnam, Joseph. *The Arraignment of Lewd, Idle, Froward and Unconstant Women*. London, 1615.

Taylor, John. *A Juniper Lecture*. London, 1639. *Half Humankind: Contexts and Texts of the Controversy about Women in England, 1540–1640*. Ed. Katherine Usher Henderson and Barbara F. McManus. Urbana: University of Illinois Press, 1985. 290–304.

Thomas, Thomas. *Dictionarium Linguae Latinae et Anglicanae*. London, 1587. *EMEDD* (Early Modern English Dictionaries Database). Ed. Ian Lancashire. http://www.chass.utoronto.ca/english/emed/

Tilney, Edmund. *The Flower of Friendship: A Renaissance Dialogue Contesting Marriage*. Ed. Valerie Wayne. Ithaca and London: Cornell University Press, 1992.

Toker, Leona. *Eloquent Reticence: Withholding Information in Fictional Narrative*. Lexington, Kentucky: University Press of Kentucky, 1993.

Travitsky, Betty, ed. *The Paradise of Women: Writings by Englishwomen of the Renaissance*. London: Greenwood Press, 1981.

Trill, Suzanne, Kate Chedgzoy and Melanie Osborne, ed. *Lay by Your Needles Ladies, Take the Pen: Writing Women in England, 1500–1700*. London: Arnold, 1997.

Van Dyke, Joyce. 'Making a Scene: Language and Gesture in *Coriolanus*'. *Shakespeare Survey* 30 (1977): 135–46.

Vendler, Helen. *The Art of Shakespeare's Sonnets*. Cambridge, Massachusetts: Harvard University Press, 1997.

Vickers, Brian. '"The power of persuasion": Images of the Orator, Elyot to Shakespeare'. *Renaissance Eloquence: Studies in the Theory and Practice of Rhetoric*. Ed. James J. Murphy. Berkeley: University of California Press, 1983. 411–35.

Vives, Joannes Ludovicus. *A Very Frutefull and Pleasant Boke Called the Instruction of a Christen Woman*. Trans. Richard Hyrde. London, 1557.

Waddington, Raymond. 'The Iconography of Silence and Chapman's Hercules'. *Journal of the Warburg and Courtauld Institutes* 33 (1970): 248–63.

Waith, Eugene M. 'Words and Action in Tudor and Stuart Drama'. *The Elizabethan Theatre* 13. Ed. A. L. Magnusson and C. E. McGee. Toronto: P. D. Meany, 1994. 79–94.

Walker, Kim. *Women Writers of the English Renaissance*. New York: Twayne, 1996.

Wall, Wendy. *The Imprint of Gender: Authorship and Publication in the English Renaissance*. Ithaca: Cornell University Press, 1993.

Waller, Gary. *The Sidney Family Romance: Mary Wroth, William Herbert and the Early Modern Construction of Gender*. Detroit: Wayne State University Press, 1993.

——. 'Struggling into Discourse: The Emergence of Renaissance Women's Writing'. *Silent But for the Word: Tudor Women as Patrons, Translators, and Writers of Religious Works*. Ed. Margaret Patterson Hannay. Kent, Ohio: Kent State University Press, 1985. 238–56.

Warren, Roger. 'Shakespeare in Britain, 1985'. *Shakespeare Quarterly* 37.1 (Spring 1986): 114–20.

Watson, Robert N. *The Rest Is Silence: Death as Annihilation in the English Renaissance*. Berkeley: University of California Press, 1994.

Webbe, George. *The Practice of Quietnes*. London, 1615.

——. *The Araignment of an Unruly Tongue*. London, 1619.

Webster, John. *The Duchess of Malfi*. Ed. John Russell Brown. The Revels Plays. London: Methuen, 1964.

——. *The White Devil*. Ed. Christina Luckyj. London: A. and C. Black, 1996.

Wells, Robin Headlam. *Shakespeare on Masculinity*. Cambridge: Cambridge University Press, 2000.

Whately, William. *A Bride-bush; or; a Direction for Married Persons*. London, 1619.

——. *A Care-cloth: Or a Treatise of the Cumbers and Troubles of Marriage*. London, 1624.

Whigham, Frank. *Ambition and Privilege: The Social Tropes of Elizabethan Courtesy Theory*. Berkeley: University of California Press, 1984.

Whitney, Geoffrey. *A Choice of Emblemes*. Aldershot: Scolar Press, 1989.

Wiedemann, Heather. 'Theatricality and Female Identity in Mary Wroth's *Urania*'. *Reading Mary Wroth: Representing Alternatives in the English Renaissance*. Ed. Naomi J. Miller and Gary Waller. Knoxville: University of Tennessee Press, 1991. 191–209.

Willbern, David. 'Shakespeare's Nothing'. *Representing Shakespeare: New Psychoanalytic Essays*. Ed. Murray M. Schwartz and Coppelia Kahn. Baltimore: Johns Hopkins University Press, 1980. 244–63.

Wilson, Thomas. *Arte of Rhetorique*. Ed. Thomas J. Derrick. New York: Garland, 1982.

Wither, George. *A Collection of Emblemes, Ancient and Moderne* (1635). Columbia: University of South Carolina Press, 1975.

Woodbridge, Linda. *Women and the English Renaissance: Literature and the Nature of Womankind, 1540–1620*. Urbana and Chicago: University of Illinois Press, 1984.

——. 'Dark Ladies: Women, Social History, and English Renaissance Literature'. *Discontinuities: New Essays on Renaissance Literature and Criticism*. Ed. Viviana Comensoli and Paul Stevens. Toronto: University of Toronto Press, 1998. 52–71.

Worthen, W. B. 'Staging "Shakespeare": Acting, Authority, and the Rhetoric of Performance'. *Shakespeare, Theory and Performance*. Ed. James Bulman. London: Routledge, 1996. 12–28.

Wright, Thomas. *The Passions of the Minde in Generall*. Reprint based on 1604 ed. Introduction by Thomas O. Sloane. Chicago: University of Illinois Press, 1971.

Wroth, Lady Mary. *The First Part of the Countess of Montgomery's Urania*. Ed. Josephine Roberts. Binghamton: Medieval and Renaissance Texts and Studies, 1995.

——. *The Poems of Lady Mary Wroth*. Ed. Josephine Roberts. Baton Rouge: Louisiana State University Press, 1983.

Zagorin, Perez. *Ways of Lying: Dissimulation, Persecution and Conformity in Early Modern Europe*. Cambridge, Massachusetts: Harvard University Press, 1990.

Zimmerman, Shari. 'Disaffection, Dissimulation, and the Uncertain Ground of Silent Dismission: Juxtaposing John Milton and Elizabeth Cary'. *English Literary History* 66.3 (1999): 553–89.

Index